SCI-FI & FANTASY
OIL PAINTING TECHNIQUES

IN MEMORY OF

FRANK FRAZETTA

(1928–2010)

Korero Press Ltd,
157 Mornington Road, London, E11 3DT, UK

www.koreropress.com

First published in 2014 © Korero Press Limited

ISBN-13: 9780957664937

A CIP catalogue record for this book is available from the British Library

Printed in China

SCI-FI & FANTASY
OIL PAINTING
TECHNIQUES

PATRICK J. JONES
FOREWORD BY BORIS VALLEJO

KORERO
PRESS

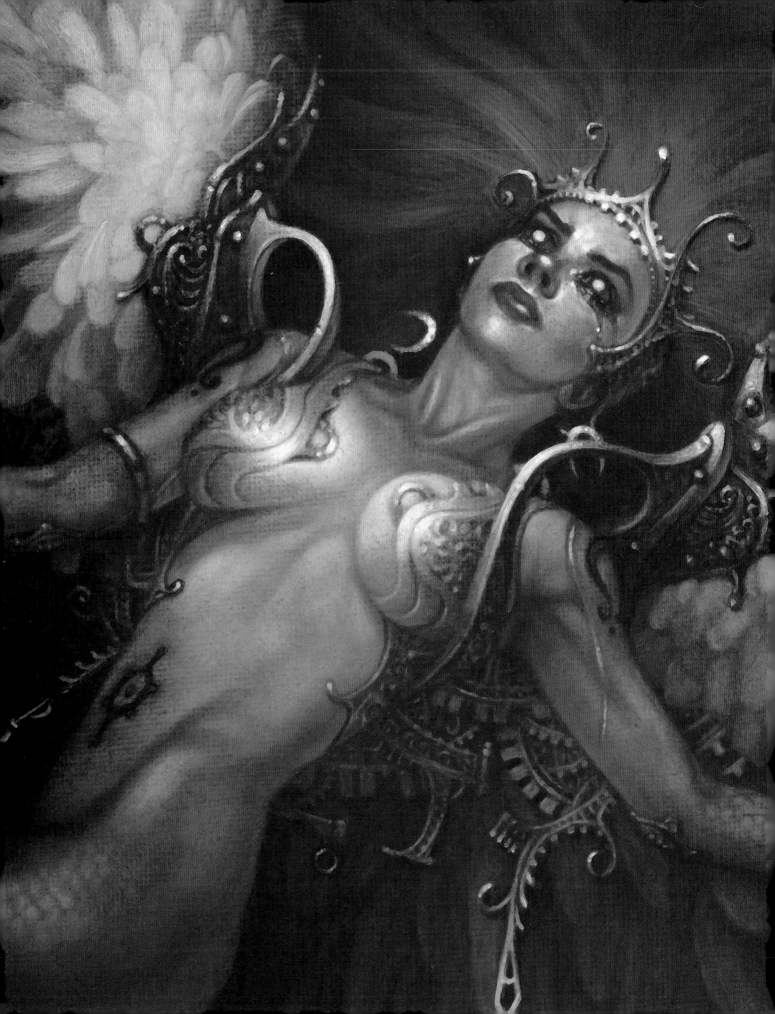

CONTENTS

FOREWORD

BY BORIS VALLEJO

I BECAME AWARE of Patrick's work a few years ago at IlluXCon, where he was one of the guests of the convention. During his presentation his lively personality and the high quality of his art were very much in evidence. I was particularly intrigued by his use of colour, which highlighted the importance of tonal values, as well as the strong composition in his paintings while maintaining a limited palette. I was most impressed by the impact that all of this had on the audience, myself included.

I am not going to make further attempts to describe Patrick's art, as you'll see the amazing skill and artistry in his paintings in the pages of this book, but I would like, however, to tell you a brief story about Patrick the person as I know him.

After our first meeting we became very good friends and ran into each other many times. In November 2012, my wife Julie and I invited him to stay with us for a few days during one of his visits to America. Patrick's visit coincided with the day that we all voted for the US presidential election, and he went with us to the polls and made a point of standing with a big, Irish smile at the doorway, greeting everyone as they entered the room. He wanted to wear a sticker that said "I voted", but we nixed that idea, worried that he might cause confusion. He seemed intrigued by the expression "okeydoke," which we use almost hourly. Every time we said it, he would laugh heartily, as if he couldn't believe we were saying it. It just made us wonder, "What exactly does okeydoke mean in Australia?"

Patrick wanted to hear each and every story that we or anyone we ran across had to tell. His curiosity was gigantic. And, in turn, he would tell us stories about his life in Australia and Northern Ireland. And the way he tells a story is so absorbing that you feel like you're actually experiencing his adventures. Everything is described in full colour and surround sound, like a Hollywood action movie. He wanted to taste and savour every experience he could find with every taste bud in his brain. This kind of receptive and open-minded approach to life is something the world could use more of.

Patrick's art, being the product of who he is as a man, brings to us a visual representation of sights, sounds, tastes, and sensations that have been processed through his mind, down his arm, into his hand, and out of his paint brush. A magnificent artist and a great man. I am very proud to call him my friend.

Digital art painted in Corel Painter for the deluxe version of *Frankenstein*. Commissioned by Easton Press.

THE LONG ROAD HOME

AN ARTIST'S JOURNEY

WHEN I WAS THIRTEEN years old my uncle, Jim, bought me a copy of *The Savage Sword of Conan,* featuring inside the fantastic pencil and ink art of John Buscema and Alfredo Alcala, and even more stunning… the incredible art of Boris Vallejo on the cover. In that moment I knew I wanted to be a Fantasy illustrator.

On a bitter winter's morning a few years later, in 1984, I boarded the Larne to Stranraer ferry from Ireland on my way to London. Alone, with a paltry £100 in my pocket and an oversized drawing board tied to my back, I foolishly set out for the big smoke with no real plan other than to be a Sci-Fi/Fantasy illustrator. It was a long journey; I couldn't sit down, and so instead I stood, frozen to the outside top deck, guiding the ship like a snowbound Frankenstein's monster across the Irish Sea.

Running on dreams, near-starvation and homelessness soon followed my arrival in an Orwellian, dank and dreary London. I sold myself into building site slavery for a pitiful weekly wage and by night painted in the dim light of a spartan bedsit. My dreams of becoming the next Boris Vallejo or Frank Frazetta looked bleakly unattainable.

Salvation literally came in the darkest hour, just as the coin-fed electricity meter shut off. It was in the form of a phone call from honey-voiced art director Janette Diamond, who held in her hand a cheaply printed, self-promotional postcard that I had mailed off months earlier, when my dreams were still kicking. Could I come see her tomorrow to discuss painting the covers for some Sci-Fi paperback books? A quick flick through my blank diary and I had a date for nine o'clock the next morning, at Orbit Books.

Smelling of cheap soap I walked into the boardroom and was treated as a human being for the first time since leaving the Emerald Isle. Dazzling them with false confidence I walked outside onto Tottenham Court Road and into the first warm day of London's long hot summer, contract in hand. At the corner of Oxford Street I sat down and stared at the contract with tears welling as the unseeing throng passed by. The fee was more than six times my weekly slave wage. I was a free man. I rented studio space with the first professional illustrators I had ever met, and, taking a deep breath, rolled up my sleeves and got down to the serious business of illustration.

One book jacket followed another. I had an agent now and rarely left the studio. As I was putting the finishing touches to one artwork, another manuscript would land on my desk. These were the glory days and I thought they would never end. Then, without fair warning, the country went into recession and the bottom fell out of the Sci-Fi & Fantasy market. I needed to find a new source of illustration work if I was to survive.

Pounding London's pavements, portfolio in hand, I tramped past the oppressed, dust-covered Irish navvies digging up the road to the tune of a foreman swearing like it was a national sport. Was this to be my fate again? I was determined not to make it so. I found greeting card work, which killed all hope of Fantasy related projects; it was also ill-paid, making it a weekly struggle to cover my bills. Worse still, even the greeting card market was drying up. Six poverty-stricken months followed as I put a new folio of ad type work together. I caught a train north to Manchester and just as the chimes of doom were sounding, I secured one of the biggest advertising artists' agents in England and rented studio space with the giants of advertising illustration. The Studio was always filled with laughter and camaraderie. I admired these new friends but it didn't stop me ribbing them unmercifully when it was my turn. I learned from them and became "A Man of Many Styles" – I was with my peers and a full-time illustrator again.

As the years sped by I watched the vast advertising machine chew up thousands of little illustrations, all forgotten save for a few fading copies gathering dust in an old "analogue" portfolio. I realized I had slowly let my Fantasy art dreams die. Optimistically I moved back to London to give Fantasy art another shot, but found a rain-soaked city in decay. I decided to backpack through the sun-baked lands of Israel and Egypt, finding adventure and romance amidst the pyramids with my future wife, Cathy, until endless summers led us to sub-tropical Australia, which I now call home.

Australia was a cultural surprise after a diet of misleading "red dust and kangaroo" Chips Rafferty movies. I was taken completely off guard by its urban sophistication and decided to aim high and apply for a job as art director/

Book jacket artworks painted in my early twenties. Awkward-looking today, but nostalgic. Top right was my first commission from Orbit Books. I posed for the conquering hero… which was exactly how I felt at the time.

studio manager in Brisbane's gleaming, glass-towered city. The CEO was impressed with the cut of my jib and led me into the studio to meet the underlings. To my horror they were sitting in front of Apple computers. All I could hear was air rushing through my head, carrying away the voice of my prospective employer, who was speaking in strange tongues about me being responsible for data backup, etc. I was sunk. With shame, I confessed I knew nothing about computers and left with my head down. All that was left for me to do was to take it on the chin, so I put on my big boy's pants and went back to school, enrolling in a digital arts course at the local college.

The college campus was peopled by bright young things taking their first steps in the big world. Still in my thirties I felt young and fit but when I entered the classroom the students looked at me as if Grandpa Walton had shuffled in. I sat in front of a dark computer screen, mortified, while the kids clickity-clicked like crickets. Peter, the instructor, asked me if everything was okay and I had to tell him that I couldn't turn the blasted thing on. However, three short months later and I was bringing digital commissions into the classroom. With cable internet I now had a toy which shrunk the publishing world into my new Mac-powered home studio. In London Sci-Fi & Fantasy book jacket work was still dead in the water, with cover illustration being almost all Photoshopped in-house, but in the land of the free great art still adorned the covers. After years of painting advertising art for a living, grasping at every Fantasy-themed ad job, I awoke from my slumber and secured an artists' agent in New York.

Then it started again, one book jacket after another, all Sci-Fi & Fantasy art. And so began my return to the genre I loved. Fate had also intervened when my old teacher, Peter Kewon, asked me to teach figure drawing to fashion students. It was a treat to be out of the studio in a country as beautiful as Australia. Before long I was teaching digital art, which in turn resulted in what is now the sixth year teaching my Sci-Fi & Fantasy Masterclass.

All this I was thankful for, but I never gave up my love of oils and was determined to keep painting traditionally when time permitted, even though the lure of digital commissions made things faster and easier. What happened next put me back on the path I started at fifteen years old, when out of the blue came… IlluXCon.

What follows in these pages are the oil paintings, insights, stories, thoughts, and Masterclass techniques used in preparation for IlluXCon, and the further commissioned work resulting from this life-changing show, plus advice along the way for every aspiring oil painter, illustrator and gallery artist following their own dreams…

Patrick Jones, Brisbane, Australia

Digital art painted in Corel Painter for the deluxe version of *Do Androids Dream of Electric Sheep?* Commissioned by Easton Press.

PART ONE

FOUNDATION

"*The artist is nothing without the gift,
but the gift is nothing without work.*"
Émile Zola (1840–1902)

The Sacrifice,
36" x 48", oil on canvas

DRAWING FROM LIFE

THE WELL OF TRUTH

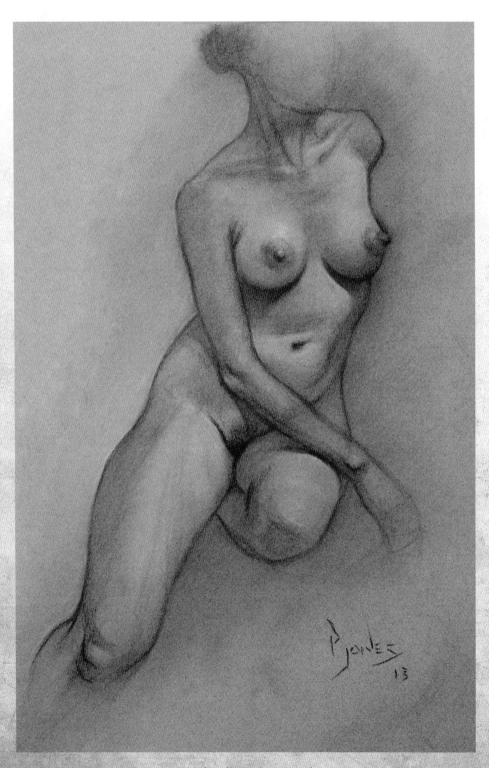

There are two kinds of artist: those who study anatomy, and those who reason, "Why study anatomy when the camera does it for me?" I can always spot the latter type. How? Because the camera lies. Lens distortion and shadows confuse the artists who rely totally on photography, which frustrates them and causes anatomical guesses and mistakes. By ignoring the foundations of figurative art they are, in short, not living the truth. There is nothing wrong with using photographic reference, but you must be aware of its shortcomings and be able to adjust for them. The shame is that not only are these artists setting themselves up for a life of artistic hardship (of which I too was once a young victim), they are also missing out on the spiritual well of artists: to simply draw the human figure for the love of it.

The main reason artists skip life drawing classes is that it takes up precious time that could be spent painting from photographs. But that kind of thinking is a time-saving false economy. Time spent on life drawing and anatomical study speeds up the painting process because of the catalogue of information your mind stores from each session.

Another reason artists skip life drawing is that it's not easy, at least to begin with, and if you are out to impress people who have only seen your photo-referenced work it can be humbling. It's best to cast the fear of judgement aside and jump in. I've never met a life drawing group that wasn't totally supportive of everyone, regardless of their skill level. So, before any painting commences, the first thing to do is pick up a pencil and draw...

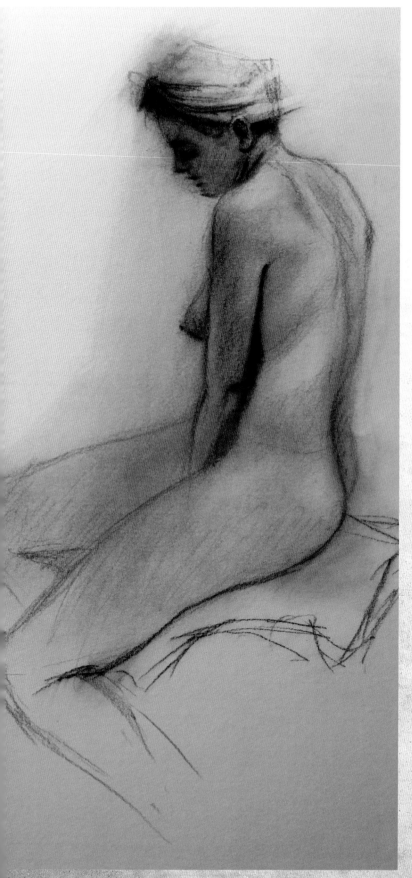

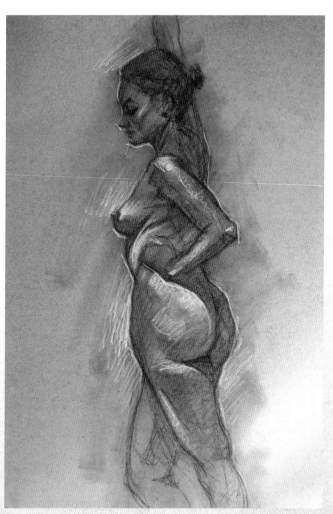

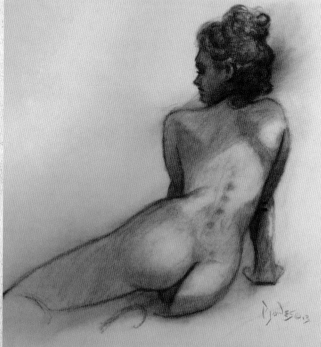

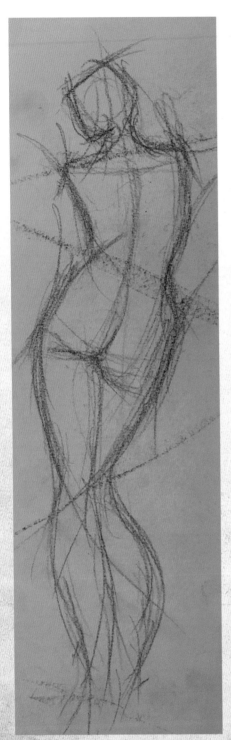

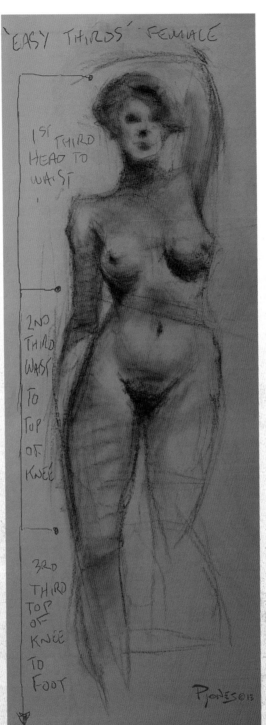

'EASY THIRDS' FEMALE

1ST THIRD HEAD TO WAIST

2ND THIRD WAIST TO TOP OF KNEE

3RD THIRD TOP OF KNEE TO FOOT

PJONES@13

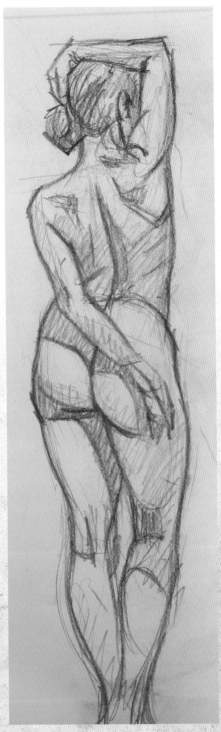

And so to technique. There are many ways to approach drawing from life. My way is an amalgamation of techniques taught by great art teachers such as Andrew Loomis (1892–1959) and George B. Bridgeman (1865–1943), plus a blend of my own discoveries. When you first stand in front of a live model the fear of empty space is daunting. Trying to tackle proportion straight off the bat is a tough challenge. It's best to first capture "gesture" – the flow of lines that run through and around a figure. Above left is a two-minute gesture drawing I did for my students. Try to capture the flowing lines without worrying about proportion, letting the lines run-through each other is key (i.e. don't try to draw a careful outline). A gesture drawing that's out of proportion will still look more interesting than a careful, outlined drawing. The middle drawing is a gesture drawing with shadowed areas added by finger smudging and erasing (note the basic thirds of a female figure to sight quick proportion). On the right is a 10-minute study started as a light gesture drawing and then refined with darker strokes.

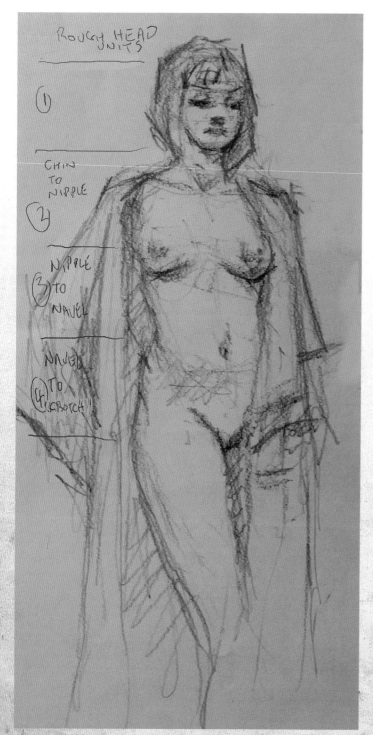

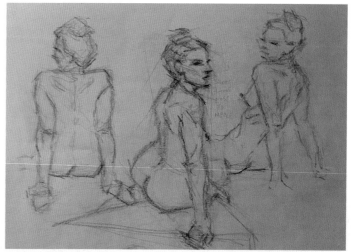

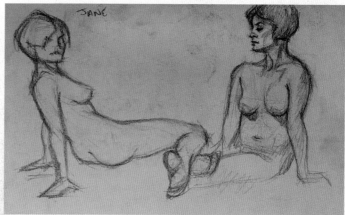

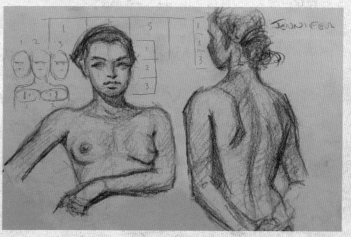

Proportion is probably the hardest challenge for an artist. Some people hold up a pencil at arm's length and run their thumb along it to measure body parts. I choose to use the head and other body shapes as a measurement; for instance, the distance from chin to nipple equals one head for most models. In the sketch on the left you can see squarish shapes still visible in the hair and can note that the torso is generally three heads high – chin to nipple, nipple to navel, navel to crotch. Top right: I've worked out proportions using square shapes and circles and then run imagined lines to find other points of reference; for example, in this case a line dropped vertically from the centre model's nose touches the nipple. Middle: the left figure has square shapes rounded off and working lines erased, and the right figure has shading added. In the bottom sketch you can see the shoulders are roughly three upright heads wide (or two heads on their sides), and that the forehead, eyebrow to nose, and nose to chin are roughly equal thirds.

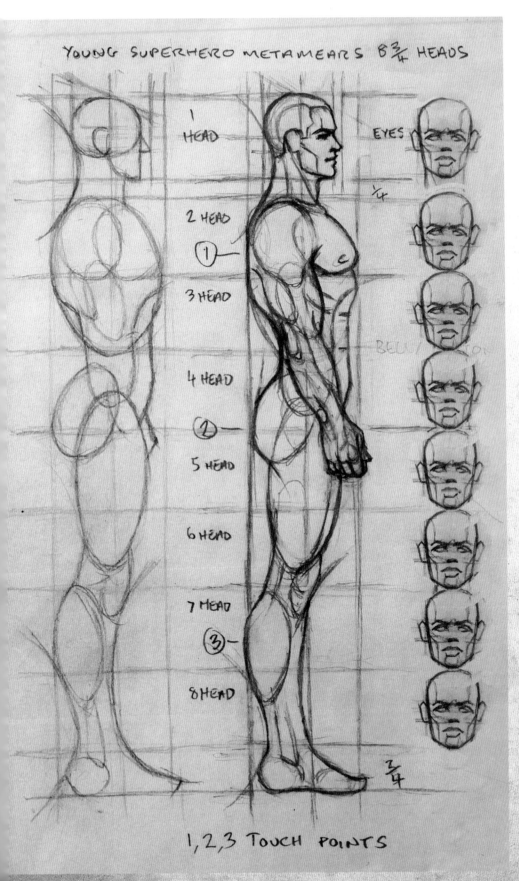

YOUNG SUPERHERO METAMEARS 8¾ HEADS

1 HEAD

2 HEAD

①

3 HEAD

4 HEAD

②

5 HEAD

6 HEAD

7 HEAD

③

8 HEAD

EYES

¼

²⁄₄

1, 2, 3 TOUCH POINTS

The ancient Greeks were the first to use the human head as a tool to work out proportion – this form of measurement is sometimes known as a metamere. In around 600 BC the Greek "ideal" form was captured in kouros statues that were precisely seven "heads" tall; at that time the average height of a man was 5 ft, 7 inches. Around 1490 Leonardo da Vinci proposed a god-like eight heads for his classic *Vitruvian Man*. Today, with people now standing taller than in any previous century, eight heads no longer seems extreme and is an ideal way to break down proportions.

On the left is my young superhero at eight and three-quarter heads. Most of the extra length is added to the leg. I have drawn the body first as a series of rounded metameric lumps, to further simplify the complexities of drawing the human form without reference.

The humble pencil is capable of producing great depth through value alone. In the sketches on the right, the object was to focus mainly on shadows to carve the human form like a statue. Rather than carrying a range of grades I used a 9B graphite pencil to simulate values ranging from HB to 9B via hand pressure. This discipline will train your sense of touch for oil painting.

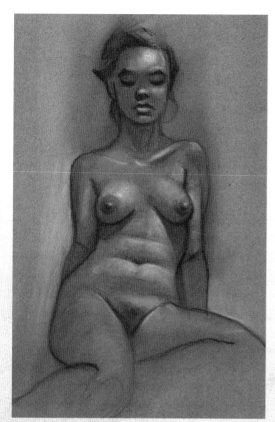

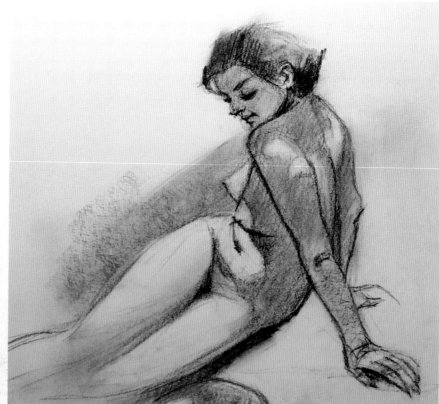

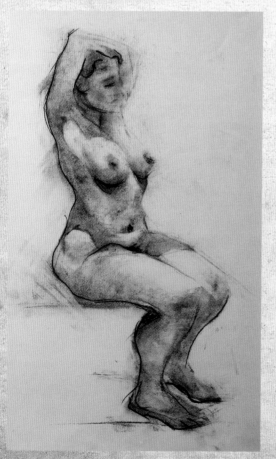

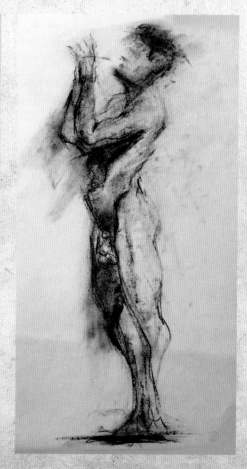

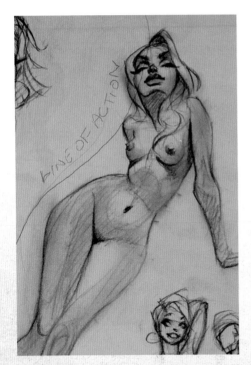

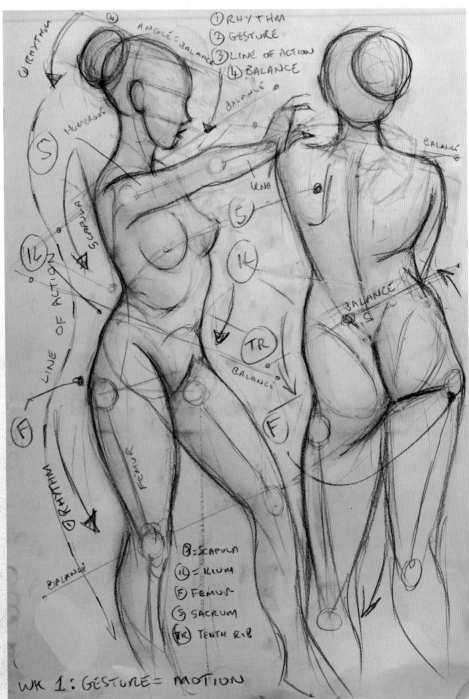

I treat life drawing as an exercise and not as a set of precious drawings (although some will turn out that way), hence each drawing running into the next. If you fear each drawing it will come out "stiff". If I've finished drawing before the model changes pose I will sometimes draw a caricature based on the model, or just from the imagination.

My materials are simple – mostly charcoal or pastel pencils from 2B upwards. It's best to teach your hand to use pressure for light lines, rather than using a pencil grade lower than 2B. Tissue paper is good for smudging and dry paper better than slick.

I teach life drawing to animation students, which has been a tradition since Walt Disney (1901–1966) first saw the enormous benefits it had on his animators in their understanding of figures in motion. Gestural drawings are great for understanding the artistic turns of the figure via the all-important "line of action". The line of action is the invisible flow of motion through the body as indicated in the sketches above, and is the longest fluid line you can find to indicate the "action" of your figure. This does not mean the figure has to be "in action", as the line of action runs through every body, relaxed or in motion. Gesture drawing is great for loosening up the hand for cartooning.

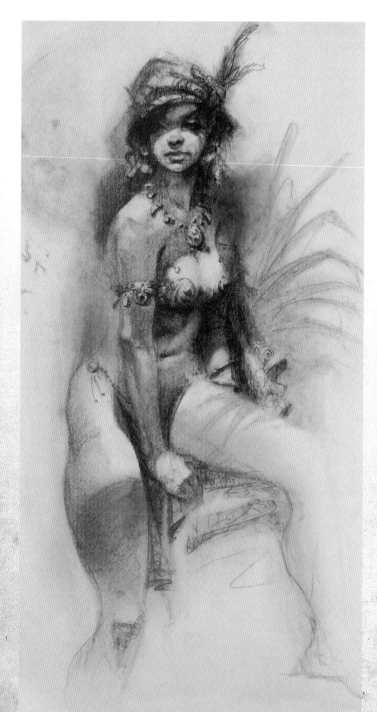

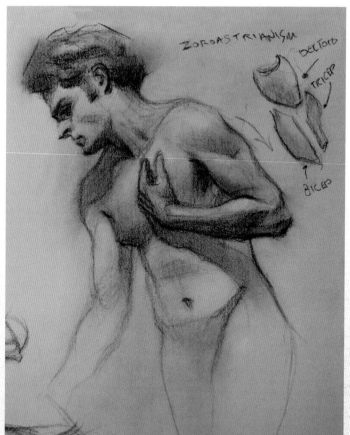

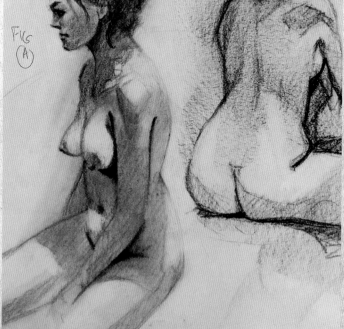

Above is a life drawing further embellished after class to create a Fantasy artwork. Bottom right shows two drawing styles: both are 9B graphite pencil drawings, but the left-hand figure has had the values smudged with paper stumps and tissue paper. Top right was done on a trip to New York; I found a class online and all I needed was some paper, a 6B pencil and a kneadable eraser. Most cities and towns will have a school or private gathering for life drawing, and there are groups on the internet that "meet-up" at art galleries and parks to draw for free.

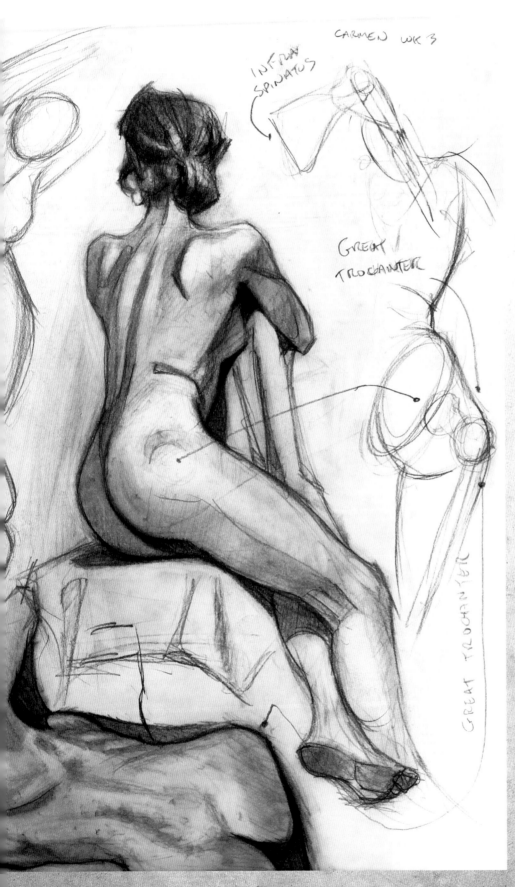

CARMEN WK 3

INFRA SPINATUS

GREAT TROCHANTER

GREAT TROCHANTER

❧ If the thought of learning human anatomy seems overwhelming, the best approach is to accept it will take a long time and enjoy the ride. Life drawing is a chance to relax from the stress of everyday life and should not be feared but enjoyed. Accept that there will be bad drawings and wear them as a badge of courage, as each one will bring you closer to your goal. By concentrating on one major muscle mass or bone structure each life drawing lesson you attend will make things easier.

On the left is a drawing I did live in front of students, showing the femur bone (the ball end is known as the greater trochanter) and hip bone as simple shapes, and how they protrude against the flesh to form a classic hip shape. Knowing the skeleton and where it protrudes is like having a road map that makes the surface anatomy less of a mystery.

❧ The drawings on the near right are torso and head studies. In the one at the top you can see the broad side of a large charcoal has picked up the sketchbook paper. Working on portions of the body can take the pressure off trying to draw the full figure within posed time periods, which in general are between 10 and 20 minutes.

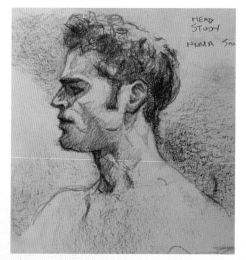

HEAD
STUDY
NUMA Sm

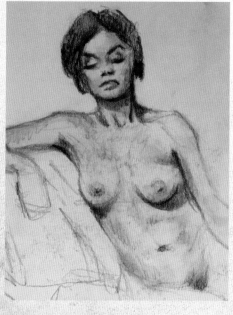

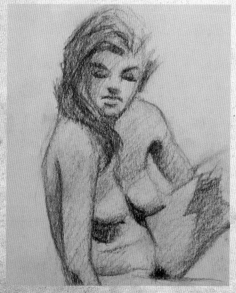

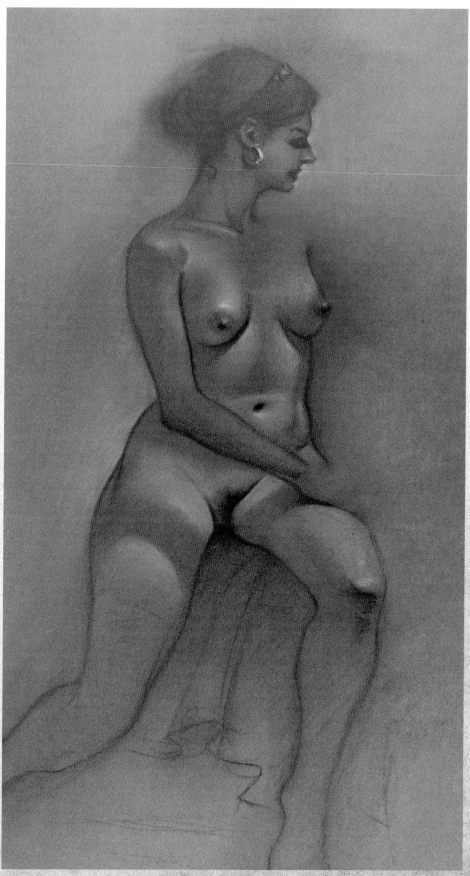

SKETCHES AND ROUGH IDEAS

VISIONS IN MINIATURE

Before a painting begins the idea must come in the form of pencil or paint sketches. Here is a colour rough painted in preparation for a possible oil painting. These ideas can lay around for years before being committed to canvas. I will sometimes fool around on a computer or use the end of the day's already mixed palette to do a quick colour sketch. This kind of painting done in one session is known as alla prima.

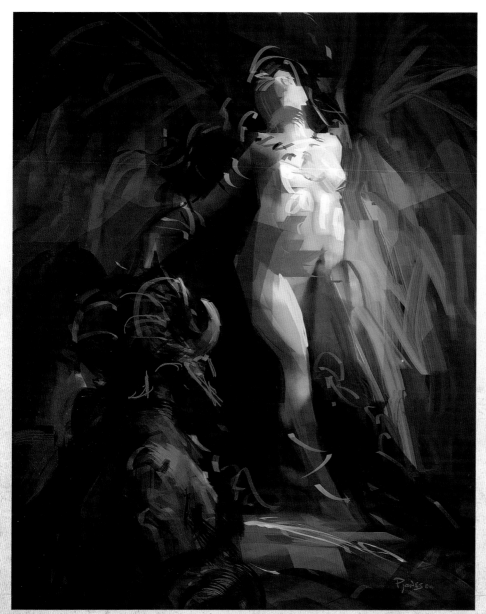

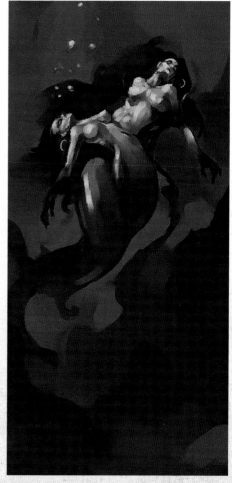

The images here are colour roughs done in Corel Painter, the best computer programme in my view for re-creating the feel of oil painting. The rough above was for a book jacket illustration.

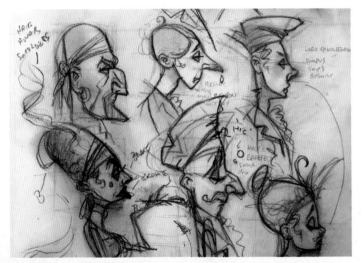

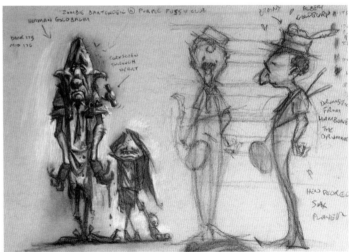

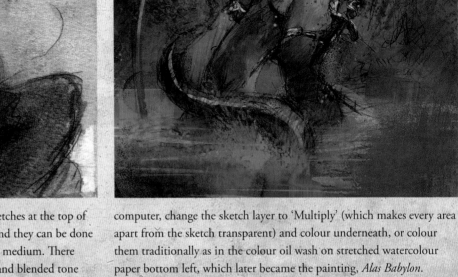

Cartoons and doodles, like the two notebook sketches at the top of the page, are a fun way to warm up with a pencil, and they can be done almost anywhere. Pencil is great, and an underrated medium. There is no faster way to get an idea complete with value and blended tone onto paper. If some doodles show promise you could scan them into a computer, change the sketch layer to 'Multiply' (which makes every area apart from the sketch transparent) and colour underneath, or colour them traditionally as in the colour oil wash on stretched watercolour paper bottom left, which later became the painting, *Alas Babylon*. Bottom right is a quick sketch scanned into Corel Painter and coloured.

❧ Above left is a mixed media colour rough idea in pencil and ink with stipple and thin oil. I'll sometimes doodle until something evolves. It may then spark the fire needed for a major oil painting. On the left is a painting created directly in Corel Painter without forethought. Sometimes it's good to just see where swirling paint around takes you.

❧ Above right is a Frazetta-style sketch drawn for fun during a spirited discussion on the Frazetta Facebook Group about Frazetta forgeries. As Mike Kaluta pointed out, there are "too many curved edges". There are lots of chat groups and forums on the internet that are useful for critique and sharing your art with your peers, which sure makes the world a less lonely place for artists.

✤ Here are some *Lost World* ideas. At bottom left can be seen the earliest germ of a composition for *Artemis and the Satyr*. Any one of these early scribbles could lead to a final oils. The main thing is to make some initial marks and open your mind to possibilities. This sketch page is 2B pencil on paper, scanned and quickly coloured on a computer. If time permits I'll work on watercolour paper using thin oil or pastel. These toned sketches are given volume by using a quick technique known as imprimatura. To do this leave the mid-toned surface as your mid tones and simply paint lights and darks to produce a value painting.

✤ More rough scribbles on a toned ground for personal work or possible *Lost World* paintings. Attacking a major oils without scribbling at least a dozen ideas down first is madness to me, as I nearly always end up with a better idea as I go. Yet I see students skip the opportunity to explore new ideas by going to finished art with the first sketch they do, and then waste hours painting a turkey!

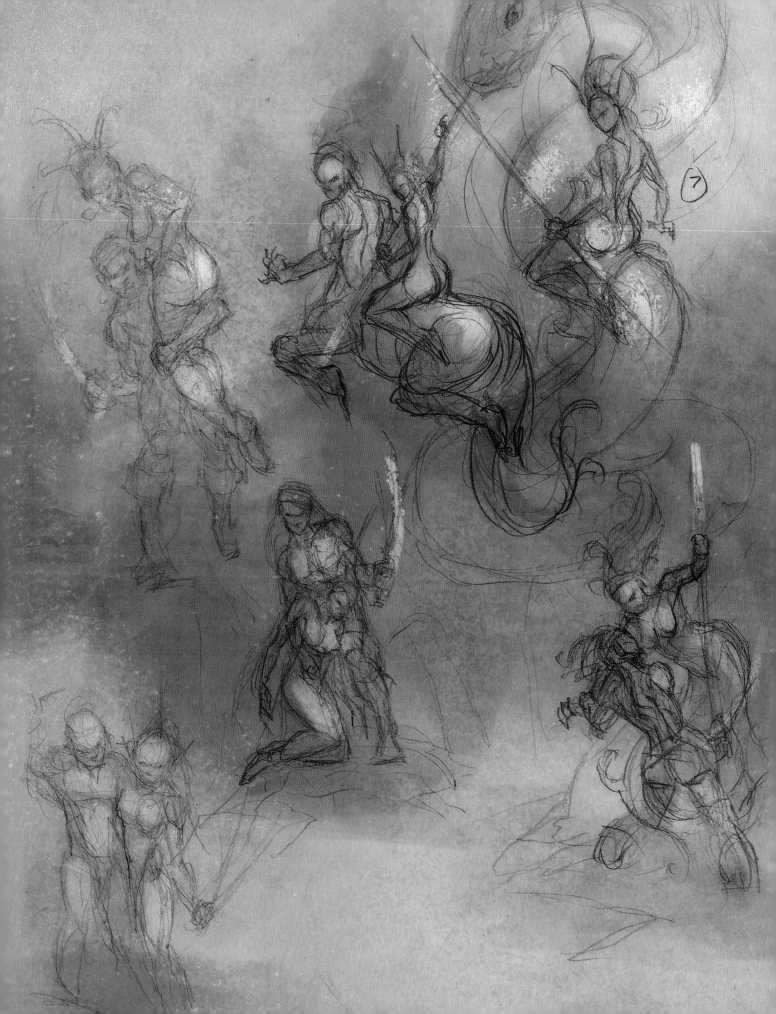

(A) DC ART TITLE: THE RECKONING

MERMAID
WARRIOR

TRANSFORM-
ING

INTO

HUMAN

ON

BEACH

WATCHING

HER

GIANT

DRAGON

EMERGE

FROM

THE

OCEAN

CLOAK DRAPED
OVER ROCKS

SCALES
FADING TO
FLESH

MERMAID TAIL
TRANSFORMING INTO
LEG

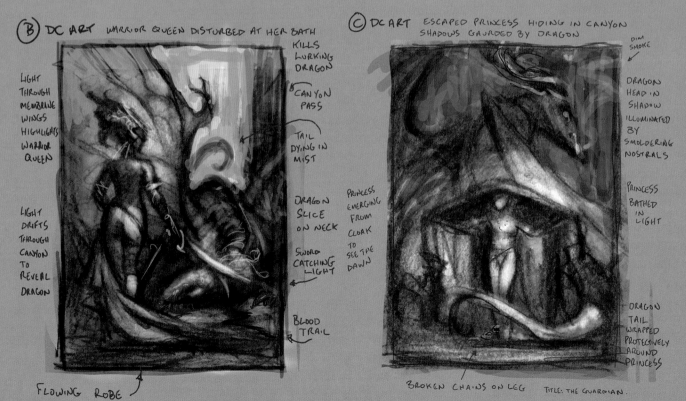

(B) DC ART WARRIOR QUEEN DISTURBED AT HER BATH

KILLS
LURKING
DRAGON

CANYON
PASS

TAIL
DYING IN
MIST

LIGHT
THROUGH
MEMBRANE
WINGS
HIGHLIGHTS
WARRIOR
QUEEN

DRAGON
SLICE
ON NECK

SWORD
CATCHING
LIGHT

LIGHT
DRIFTS
THROUGH
CANYON
TO
REVEAL
DRAGON

BLOOD
TRAIL

FLOWING ROBE

(C) DC ART ESCAPED PRINXESS HIDING IN CANYON
SHADOWS GAURDED BY DRAGON

DIM
SMOKE

DRAGON
HEAD IN
SHADOW
ILLUMINATED
BY
SMOLDERING
NOSTRALS

PRINCESS
BATHED
IN
LIGHT

PRINCESS
EMERGING
FROM
CLOAK
TO
SEE THE
DAWN

DRAGON
TAIL
WRAPPED
PROTECTIVELY
AROUND
PRINCESS

BROKEN CHAINS ON LEG TITLE: THE GUARDIAN.

❧ As Dragon Con Artist Guest of Honour 2014 I was commissioned to create the official poster. The final painting, entitled *The Changeling*, will be 36" x 48" oil on canvas. On the left are three thumbnail value comps. Above is the colour comp based on the thumbnail chosen by the art director. This spread demonstrates the basic preparation I do for every painting. Preparation can be broken down into four stages.

1. Story/sketching
2. Value comp
3. Colour comp
4. Model shoot

As stated later, in the chapter *Palace of Medusa: Creating Stories,* I place great trust in creating a "story" for each sketch to make the final painting a more engaging piece of art. The story need not be complicated or time-consuming, just little notes and imaginings. Check out the simple notes accompanying the thumbnails to see how little it takes to light the spark.

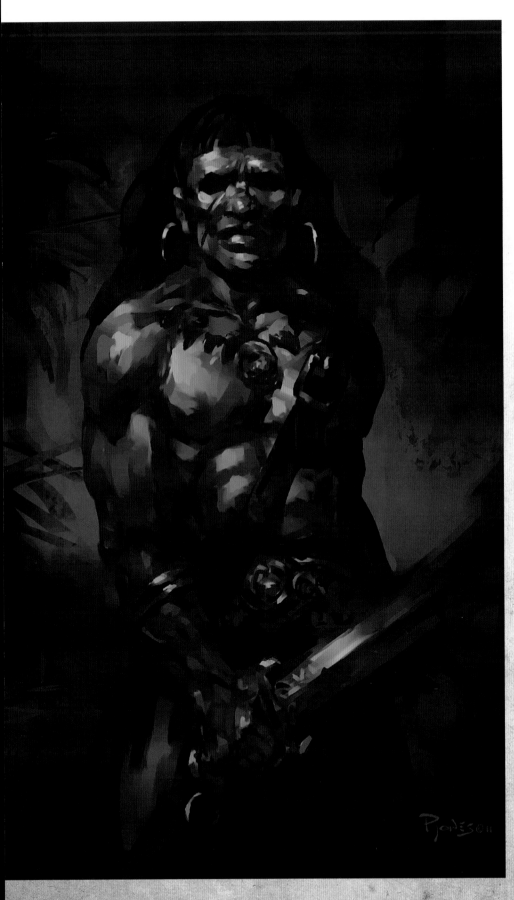

❦ The more you draw the easier it gets to work without a reference model, as in the painting on the left. Some artist/authors have written classic books that can teach you to draw from imagination. It's worth your while to seek out "PDF art books in the public domain" on the internet. When a work reaches a certain age, and the author is no longer alive, the copyright will most likely have expired, which means the books are free to download.

I've seen Andrew Loomis books online, but as his books have recently come back into print the copyright may have been renewed, so check first. The books may be old, but some are gems and will help you further with your foundation skills.

❦ On the right are two grisaille (grayscale value) roughs for *Dawn of the Dead* and *Conan and the Sorceress*. I regard getting the value (lights and darks) down first as the most important element to build on for a dramatic final painting. If you think I bang this drum a lot there is good reason for it. Ignore this foundation basic at your peril!

Colour comps are of equal importance, and in an unusual turn I have used the colour comp, far right, as an opportunity to try a last-minute change in composition, but decided to stay closer to the black and white comp for the final art. Worth a try, and with nothing lost.

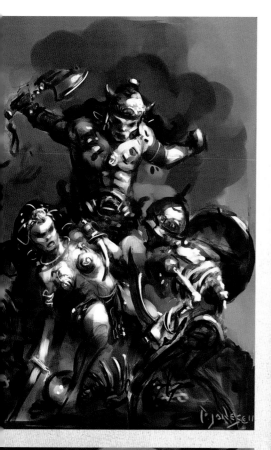

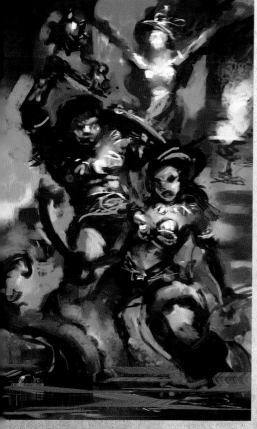

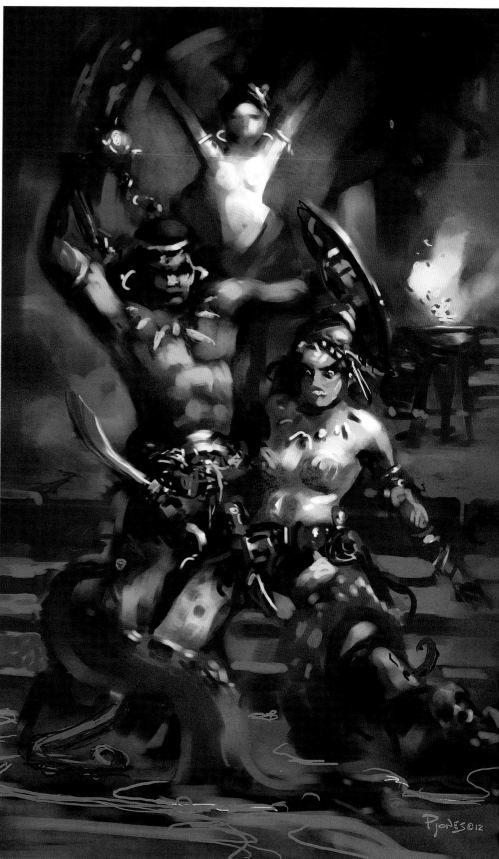

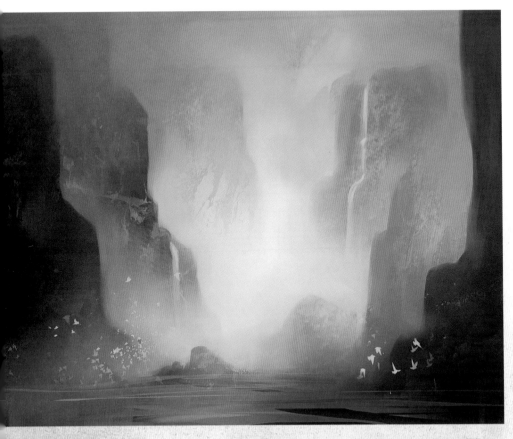

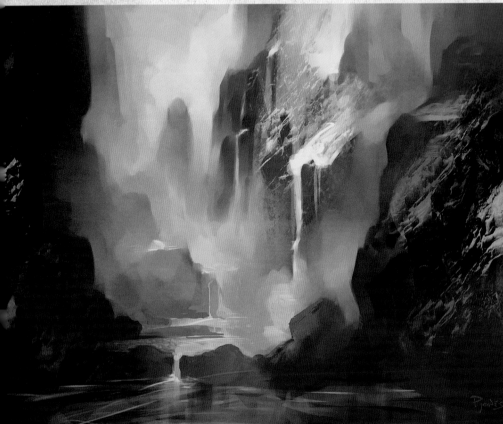

❦ Top left is one of many landscape doodles I have done as a warm up directly on the computer. Corel Painter is a great programme for re-creating oil painting techniques and is useful in freeing your hand up to be bolder when approaching a real life oil painting. It is not a substitute for oil painting, but a great sketching tool that can work hand in hand with the creative process.

❦ Bottom left is a computer sketch to keep me fresh between paintings. Alla prima oil painting takes some planning, but with my laptop and Wacom I can sketch out ideas on the road for future paintings at a moment's notice, without fear of spilling paint all over the hotel floor.

❦ Top right is a rough painting idea for a future Las Vegas where the poor live in the crime-ridden boroughs and the city is encased to protect the rich. I painted this only because I "needed" to create. Whether an idea comes to something or nothing doesn't matter; the creative journey is your reward.

❦ Middle right is an idea for an abandoned refuge built on one of Saturn's moons.

❦ Bottom right is a very rough idea of a future city built on the ocean after the ice caps have melted. Both of these were painted as demos in front of a live audience and could be regarded as "speed-painting", as they took under an hour each, but speed doesn't count for much unless you work as a concept artist, and even then it's quality that counts.

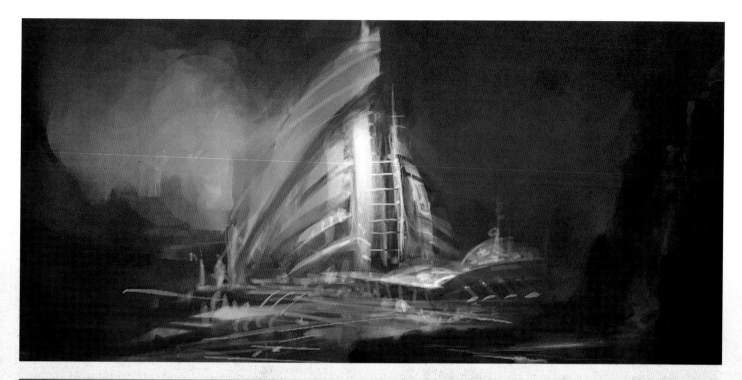

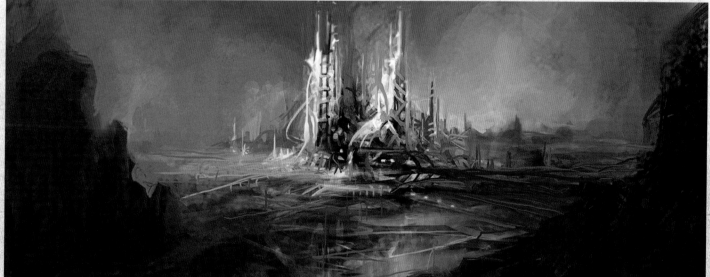

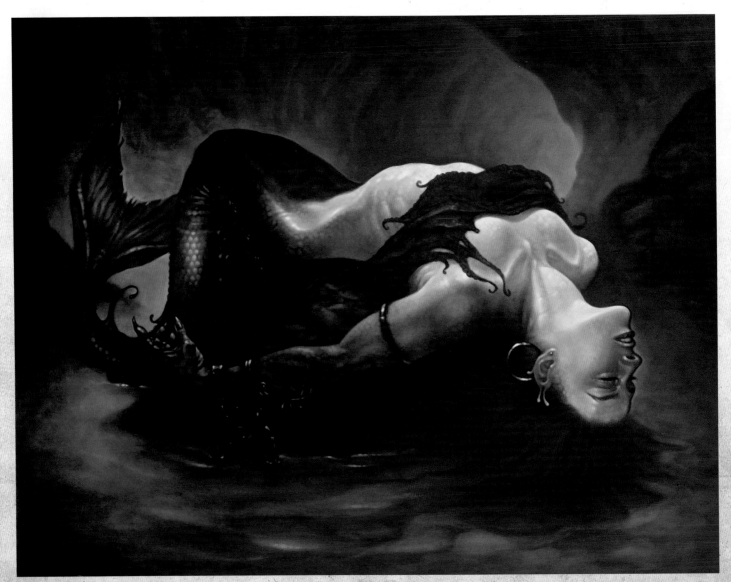

This was a big, 40" x 40" oil on canvas, and my first major oils after a 10-year hiatus. I first painted *The Oracle* back in 2005, using the computer software Corel Painter, for a young adult book on mermaids, but it went unpublished as the art director considered it too sexy when finished!? He had approved a detailed sketch, but I guess he didn't foresee the realism or life breathed into the work via light and shadow. I got paid and that was that. I put the piece aside and carried on with my other book jacket commissions. Then, in 2008, the first ever IlluXCon event was announced in Altoona, USA. The brainchild of creators Pat and Jeannie Wilshire, it featured just about every traditional fantasy artist that had ever inspired me, including my hero as a young, aspiring artist, the mighty Boris Vallejo. Right then I decided I was going – whatever it took! The hand of fate was so firm I was hardly conscious of my own say in it. I emailed Pat Wilshire from my home in Australia and was told all tickets were sold out. I slumped dejectedly before boldly asking if I could attend as an artist. To my amazement he knew my work, and said "yes". From that moment my artist's road took one of its most dramatic turns towards the illustrator's Holy Grail… fine art.

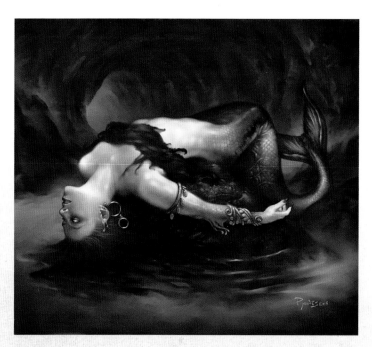

❧ I had six months to fill a 5m-square panel with new oil paintings and still complete my regular workload for clients. Using Corel Painter it would have been easy, but oils? I had to think again, boldly. I bought three very large canvases big enough to fill the panel space, and decided to revisit an old Corel Painter artwork I thought could have been done better. Since the colour scheme and mood was already established in the digital art it gave me the confidence to tackle the first oils.

SLEEPING HAIR DRIFTING IN WATER · P. JONES © ℗ DARKDREAMER

❧ I had the original sketch from three years earlier but was unhappy with the anatomy as my artist's eye had developed since then. So I called back my original model, the talented actress and theatre director Tora Hylands, who had left Australia to find roles in various Sci-Fi and Fantasy productions, including the TV series *Sanctuary* and movies such as *Twilight: Breaking Dawn*. I recommend working with actors or life drawing models over standard models for hire as they take dramatic art direction with more understanding and passion. To find one who also appreciates Sci-Fi and Fantasy is a godsend.

❧ Tora works in physical theatre and is exceptionally good at inhabiting my creations and becoming, in this case, an imprisoned mermaid, an oracle who can shape the future, chained to a rock. She dreams death for her captor, knowing it means her own end as he cannot return to unshackle her. To sacrifice life for principle is about as powerful a story as I can imagine. It's almost unbearably touching, as in the story of Jesus, Spartacus, or Joan of Arc.

A single source of light creates a dramatic range of shadow and form – known since the days of Leonardo Da Vinci as chiaroscuro. I always work from monochrome or black and white photography as I think value (tones from black to white) is the most important thing to focus on when working with anatomy.

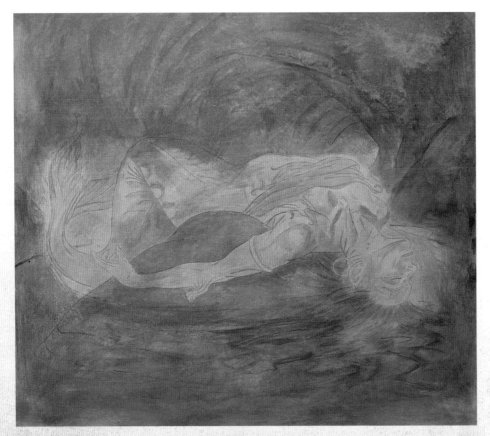

✤ The first step after the refined sketch is to transfer it to canvas. This is done by drawing the image in reverse on paper or tracing paper, taping it to the canvas and burnishing the back of the drawing with a spoon. This can be difficult, as canvas is springy and it's hard to burnish visible lines. My personal tip is to place a large hardback book behind the canvas and burnish down in blocks the size of the book, moving each time you get close to the edge of the book.

Once that's done, I thin some raw sienna to an almost transparent wash using odourless white spirit and lay down tone. I also decide the figure worked better in a mirrored pose from the first attempt, due to the fact that we (in Western culture at least) read from left to right and therefore would rest our eyes finally on the face, the main focus.

For the medium, I used white spirit to thin the paints. In the later chapters I'll be comparing the pros and cons to help you decide which methods best suit you.

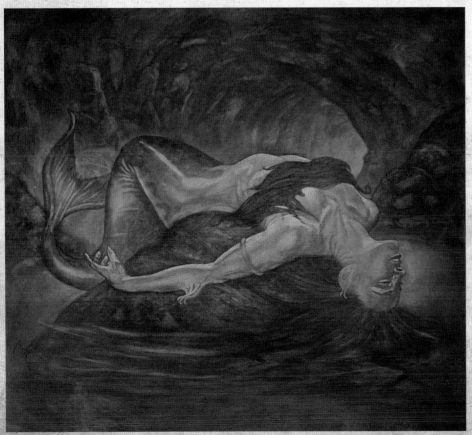

✤ After a lunch break the thin wash has already set enough for me to work into. Some of the sienna wash may mix with the umber and olive green colour I paint on top, but this is fine as it simply creates variants within the same family. One of the most freeing tips I ever heard came from the great Boris Vallejo, who simply stated that sometimes you should let the painting do as it pleases. Automatically, my work became fresher as a result of not trying to control it so much. This stage is known as the underpainting (it goes under the painting) and is usually in monotone. This kind of greenish underpainting is classically known as verdaccio. Still using thin oils, I added some white to build form.

At this stage I was amazed at how easy the act of painting was after a long absence from painting traditionally, especially at this size. Such is the power of Corel Painter that I never really gave up my painter's hand; I was simply practising all those years in virtual oils in preparation for this moment.

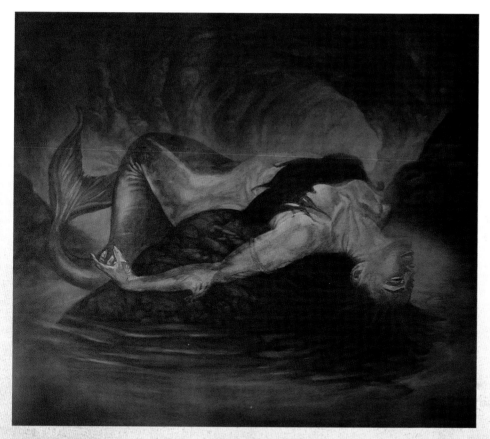

⚜ Here, I'm blocking in the background with big brushes, mostly flats and filberts, not caring too much for the edges of the figure, which I'll refine later. I use a cloth dipped in oil to smear colour around. I also use a rag dipped in solvent to pull colour back, which can create interesting textures as you crunch the rag in different combinations.

Λ sponge can also be used, but it can leave debris behind if it's poor quality. I find the sponges sold in art shops a little too expensive and small. I've collected sea sponges washed up on the beaches of Tasmania, Australia, that have worked well after a good soaking in tap water. Be creative and keep your eyes out for interesting materials to use in your art.

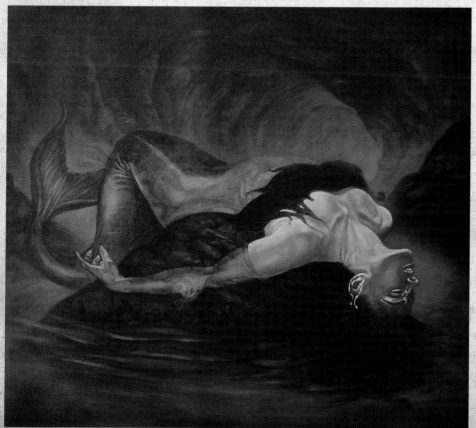

⚜ Now the real work begins. Using opaque paints (thicker paints that cover, usually mixed with white), I get to work on blocking in the anatomy in dull tones. I work in sections that will leave me enough time to blend before the paint dries. I don't worry about very fine detail here, as that is left until the end. The reason this is known as "blocking in" is that you are working out major forms in "blocks".

Think of this stage as a sculptor would, chiselling away at marble, defining big shapes first before coming back to define further with smaller chisels later, after the basic anatomy has been formed. My paint at this stage is a little thicker and is now thinned using a medium of 70 per cent white spirit with the addition of 30 per cent linseed oil mixed in to make the paints flow.

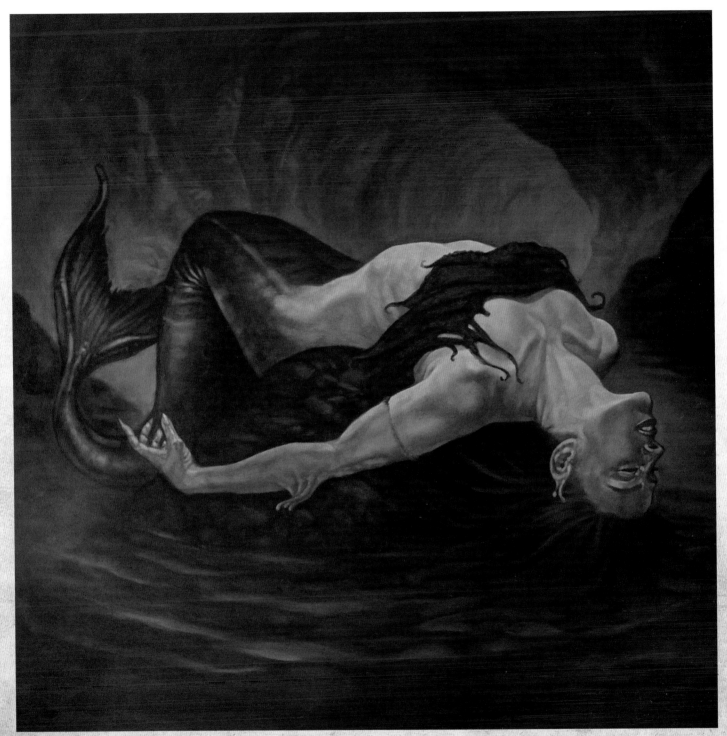

More sections blocked in and I'm getting a clearer idea of how the light will work against the background darks. At this point I'm also working into the background to create a pool of light. I leave the background at a stage that's almost finished, and then touch it up again at the very end when the figure is complete to marry them together and unify the whole picture. To labour on the background at this stage would slow down my enthusiasm for the project. It might also result in a stiff-looking artwork.

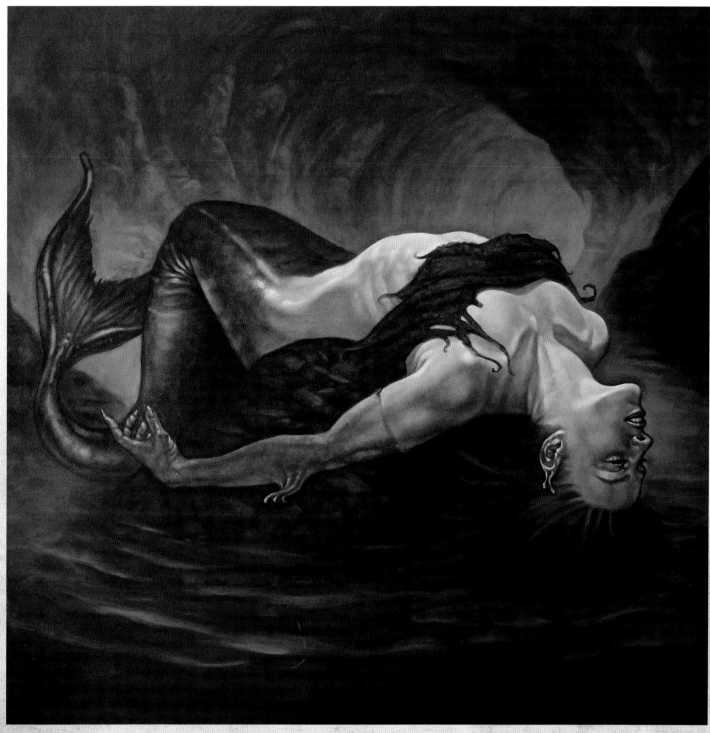

The next day I add colour on top using semi-opaque paints, thinned with 50 per cent linseed oil and 50 per cent white spirit. This mix adds colour but still shows the previous day's painting underneath. As some of the paint is opaque, you could call this "scumbling" (a way of rubbing down thin paint to harmonize colours), but as my paint is very thin it's more like glazing, which is usually done with transparent colours.

The main thing is not to hold back your artist's hand in order to get the technique perfect – just keep your eye on the artwork and the technique will get honed over time; for now it's your vision that counts most. I'm not saying throw technique out the window, just keep it second to the vision. Once you've learned the rules you can break them, but make sure you know them first. American artist Harvey Dunn (1884–1952) favoured passion above technique: "Paint more with feeling than with thought," he told his students. "When intellect comes in, art goes out." It's true, the only thing that matters is the end result, but Dunn knew his technique well enough to forget it!

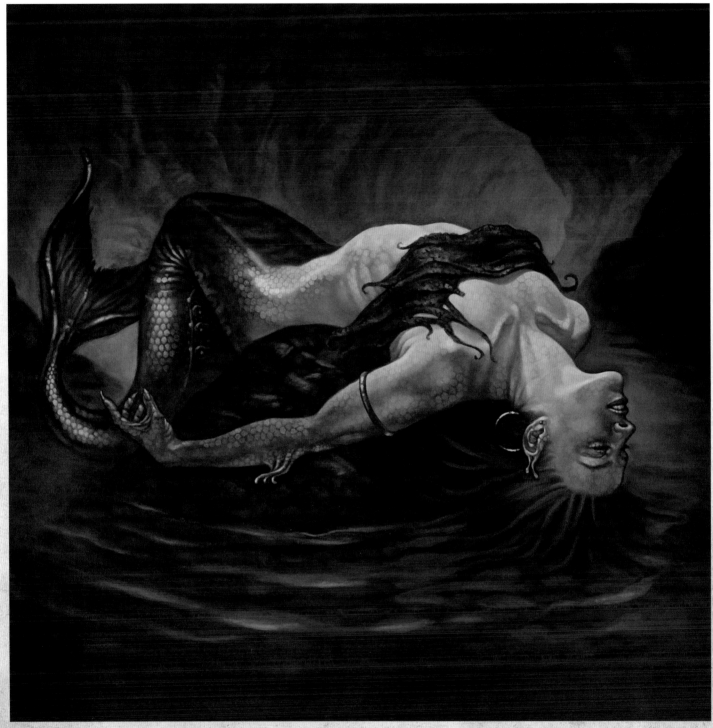

As I paint I'm surrounded by reference from the artist who started my love of fantasy illustration – the fantastic Boris Vallejo. It's important to study the work of artists like Boris, not only to be inspired but also to remind yourself of how high the benchmark can be if you have the talent and the will to work hard. I discovered Boris's art at the age of 13, and it cemented my idea of becoming a professional Fantasy illustrator (before that I'd been sold on the idea of becoming a Disney artist). At the same time, I discovered the great Frank Frazetta, and I have been enthralled with the work of both of these artists ever since. I was lucky in finding the benchmark so high, and so soon, and knowing how hard I had to work in order to reach it.

I have never drawn so much in my spare time as I did during my teenage years. Back then, there was no internet, no mobile phones, no distractions. They were great years of uninterrupted study. If you can turn these time thieves off, I recommend you do so while you're painting. They'll still be there waiting for you at the end of the day.

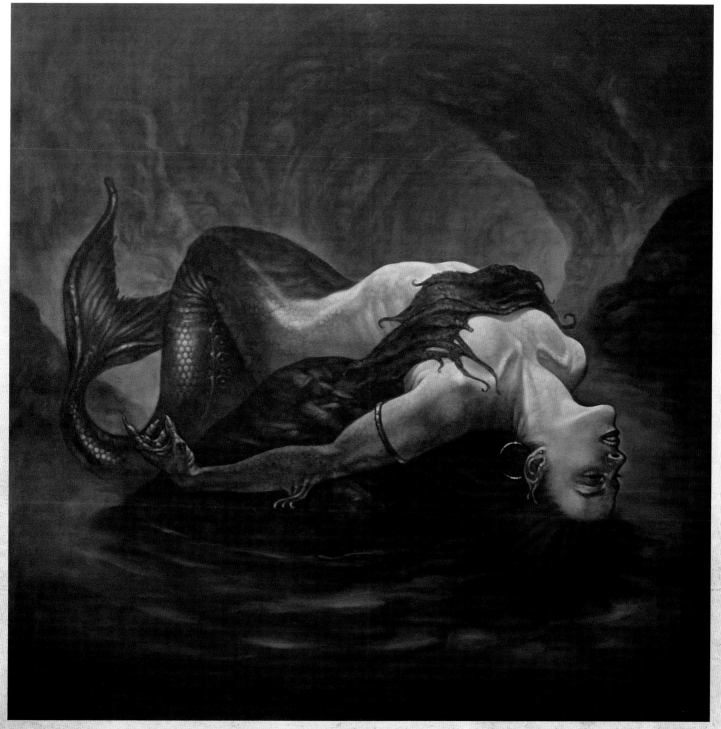

Adding still more glazed and opaque paints on top the next day, I take a soft brush and blend the colours together all the time, wiping the brush with a dry rag to keep the hairs soft. At this stage the art is almost finished. In order to keep me motivated, I've decorated the walls of my studio with artworks by my favourite artists (not the originals, of course): the majority of them are by Frank Frazetta and Boris Vallejo.

It's worth noting that my study of art is not confined to these two artists – which is evident in the hundreds of art books spilling from my bookshelves – it's just that Boris and Frank rekindle the early wonder in me, which is my strongest motivation in creating works of Fantasy.

🐚 Now, using smaller sable brushes, I get in close and concentrate on the scales and other refined detail. Even though I have photo-reference I will also refer to anatomical books and my own studies for more accurate anatomy. More accurate than a photograph? Absolutely. As discussed later in the book, I believe that photographs are for reference only and are often deceiving and obscure. I can always tell if an artist has relied on photo-reference without having studied anatomy, as it's usually horrible and lifeless work harbouring all the mistakes of the photo multiplied by the mistakes of the artist trying to re-create form he doesn't fully understand.

🐚 Here is a close-up as I blend. Each day I come back to a dry painting and add more thinned colour, which I blend as in the previous day, adding more lush colour as I go. I used to meticulously draw every fish scale on my working drawing, but now I find it more natural to paint scales and blemishes directly by eye onto the painting, as it's easier to follow the contours of the modelled flesh.

🐚 As always, I spend the majority of my time on the face and hands. As the great Norman Rockwell (1894–1978) said, "People will forgive anything but the face and hands." How right he was. I'll turn the painting upside down to get a fresh look at it, then stand back. It's surprising how many errors become apparent using this method. I'll also use a mirror to check further. If the face is wrong the painting will fail. Give this part of your painting all you've got!

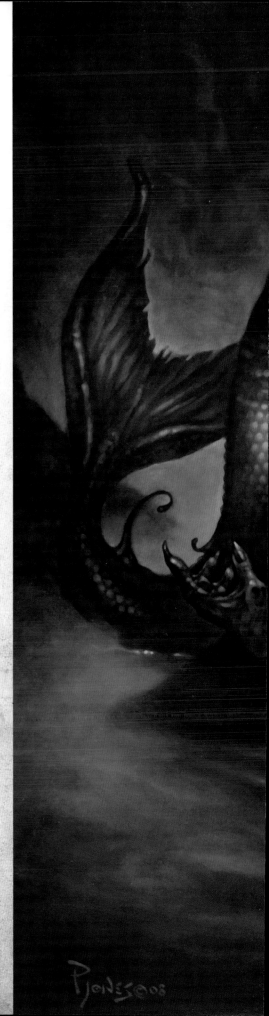

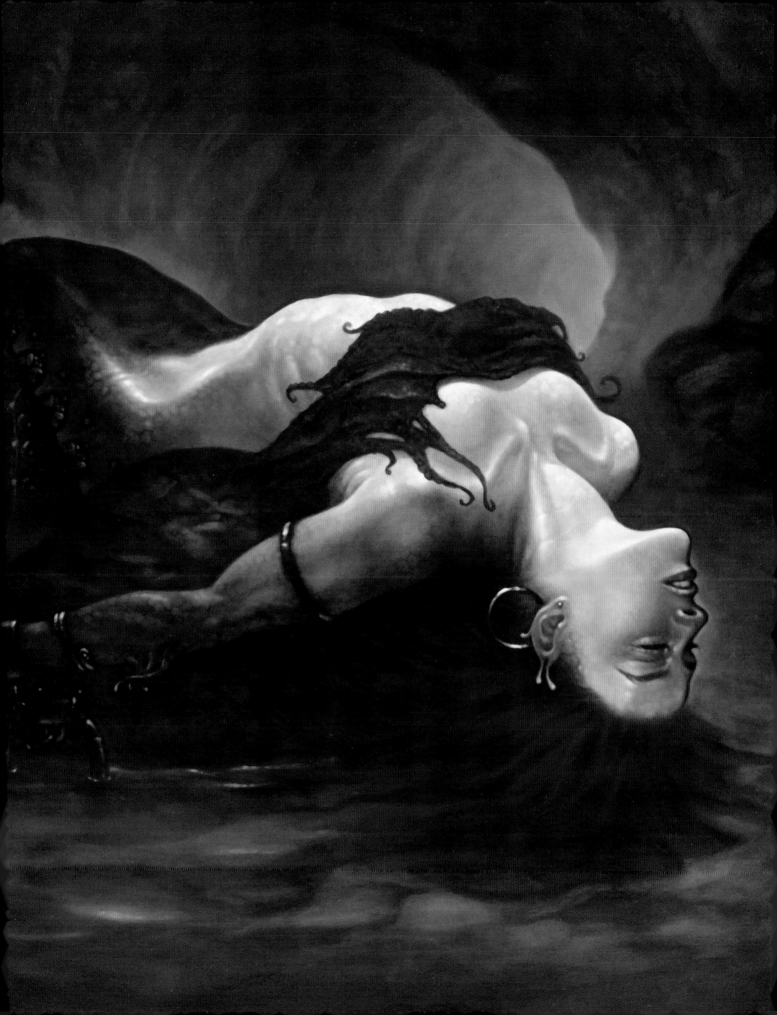

SPREADING YOUR ARTISTIC WINGS

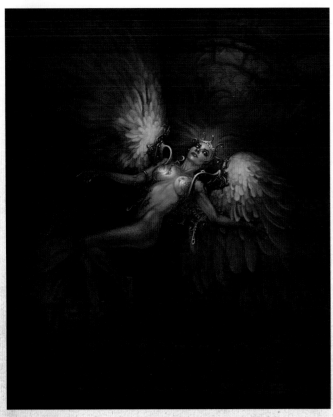

(B) AUTOMATON BROKEN & SPRAWLED ON TOP OF CHURCH RUBBLE, FIGURE FRAMED BY FALLEN OVAL CHURCH WINDOW, FLOWING DRAPERY, HAIR SPLAYED, MELDED MACHINE PARTS & FEATHERED WINGS. AERIAL VIEW

✢ My previous artwork created for IluXCon, *The Oracle*, brought an unexpected commission before the show even began. I had shown Pat Wilshire, the show's co-creator, progress shots of *The Oracle* and he asked if I would be interested in painting the first official poster. This kind of luck was incredible, but luck can nearly always be traced back to you placing yourself in its path.

It's tough to be bold if you're shy but sometimes you need to be if you want to spread your artistic wings and fly. Ask yourself the old question, "What's the worst that can happen?" It's not war – you *will* survive your bold move. The worst that can happen is a life of regret for not taking the leap of faith.

✢ So, as well as shoe-horning my way into the inaugural IlluXCon as a guest artist, I had the nerve-wracking privilege of painting its first poster. It had to be of outstanding quality as it was advertising the talents of the world's best Sci-Fi & Fantasy artists. Pat briefed me on an idea he had for a fallen cyborg angel, then left me to interpret the image. I produced three pencil sketches, scanned and coloured in Photoshop, and sent them as jpegs for him to choose one.

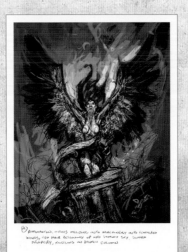

(A) AUTOMATON, MELDING MACHINERY INTO FEATHERED WINGS...

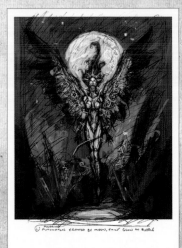

(C) AUTOMATON FRAMED BY MOON...

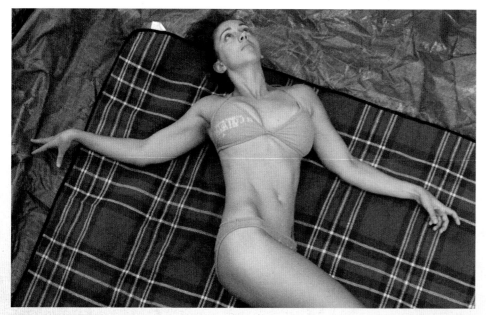

I would have been happy to paint any of the roughs but I was glad that Pat chose my favourite of the three. Keep in mind that an art director will often choose your least favourite, so make sure all are strong. My favourite model, Tora, was out of town on an acting gig so I took a chance and hired bodybuilding champ Sarah Sliwka to pose. Sarah was in great shape, and needed to be to play the part of a figure able to fly for hours on end (everything must ring true). Although I broke my rule of only working with actors, she did a great job. I photographed her from my veranda to get this overhead shot.

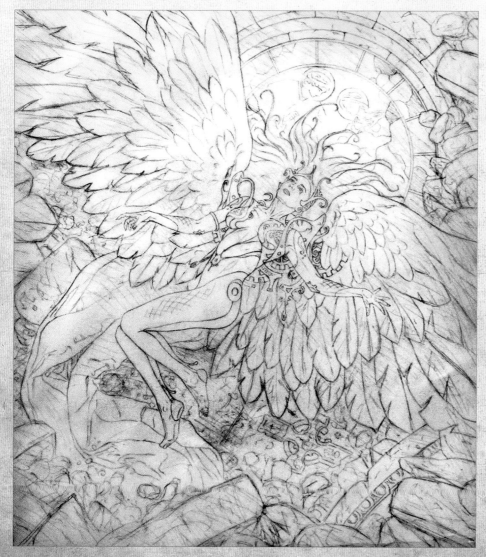

Here is the sketch on the reverse of tracing paper, ready to burnish onto canvas. A tight pencil drawing will aid confidence at paint stage. Great "loose" painters such as John Singer Sargent (1856–1925) knew this well, although it must also be noted that the sketch is still open to change at paint stage and is not the boss of the art.

I wanted to work on canvas for the prestige factor, but learned during this painting never to work on canvas smaller than 36" long if you want to do detailed work, due to the lumpy weave. This proved to be a hard-learned lesson that I overcame with lots of patience and I have since gone back to gessoed illustration board for my smaller paintings.

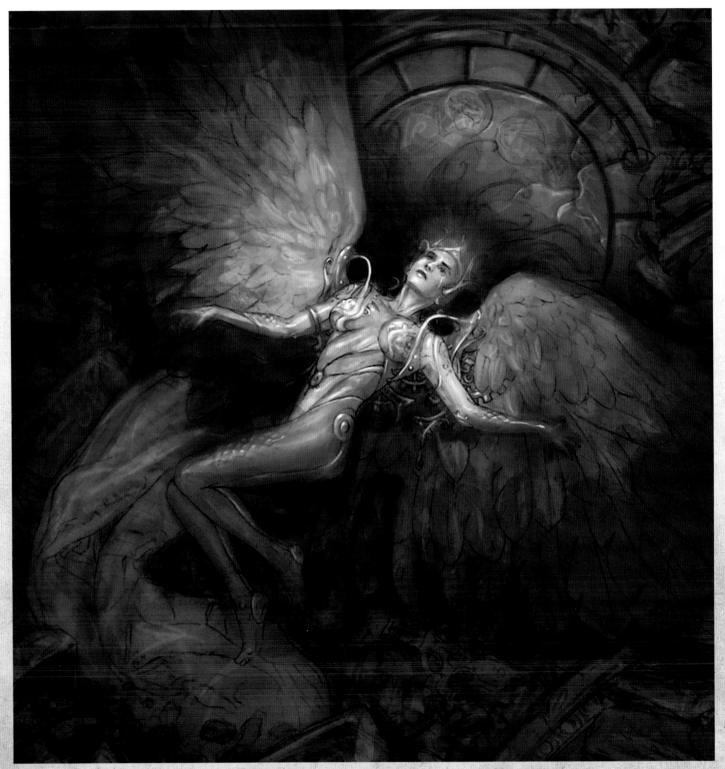

✥ Here is the colour rough stage. I hinted at a more metal form, but Pat was concerned she looked like she was wearing futuristic leggings. He was right. It's always worth asking someone with a fresh eye to look at the rough stages before committing to canvas.

Pat has an artist's eye, but even a non-artist may spot something you didn't see. With the colour rough taped to my drawing board for reference I get to work on the underpainting. As usual I pick out some large flat and filbert brushes to get started, as their bulk forces me to work out the mass instead of getting bogged down in detail too soon. When painting, make sure you keep the brushes clean and the room free of dust, or your work will attract hair and dirt, leaving your art looking like it fell on the floor.

❦ I start by getting the anatomy correct. I will consult anatomy books and good anatomy models at this stage as it's vital to get it right early otherwise it will haunt you forever. I correct the photo-reference lens distortion and burned-out detail as I work. I will enhance what I feel is needed, as real life needs a push to make it magical. If you look at behind-the-scenes video footage of the making of a movie, then view the actual movie shot on film with mood lighting and atmosphere in place, you will understand what I mean.

❦ Here I paint in some opaque colour to establish depth. I'm concerned with making this painting glow and am planning ahead to darken the outer edges to draw the eye towards the face, which will be filled with, I hope, heart-breaking emotion. One thing I strive for in my art is passion. I never want my characters to look like they are aware of the viewer or to seem blank-headed. They must appear to be totally involved in whatever world or situation I have placed them in. I approach painting like a Method actor approaches a role. Let's call it Method painting.

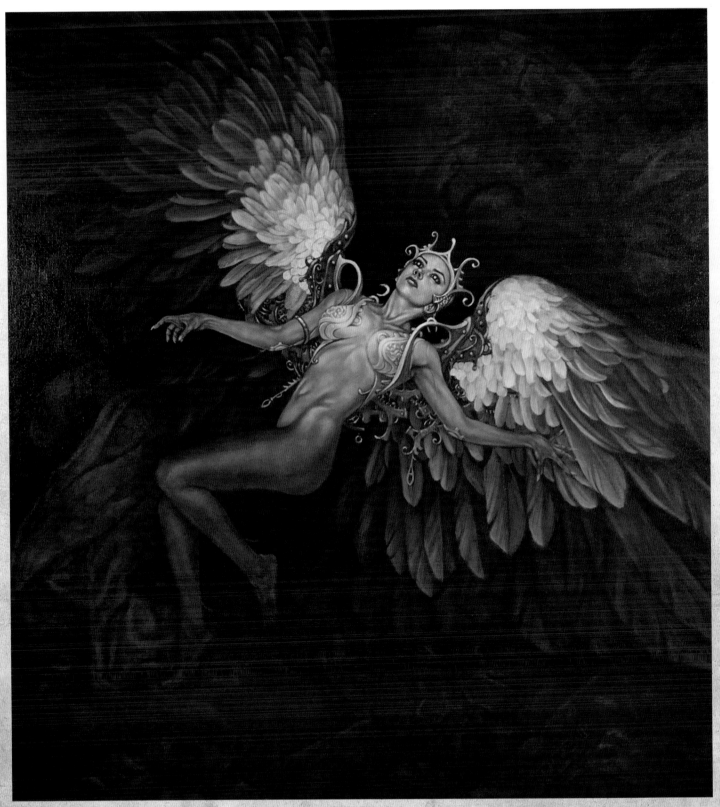

I had reference of a bird to study the feathers on the wings. It's important to build a reference file, especially at the start of your career. But I find as I get more experienced I use less and less reference and now use none for the likes of rocks or skies. However, for this style of realistic oil painting, I can't imagine going without figure reference, as just the very turn of one muscle affects another, then another. Add changing light to the mix and you will be learning about human anatomy for the rest of your life.

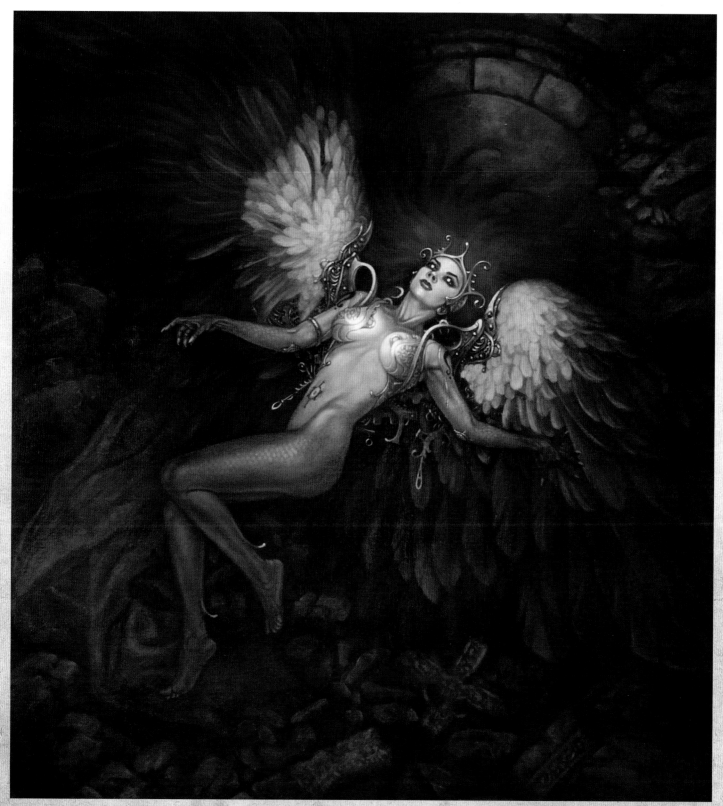

❧ Here is the entire work in progress. I paint the clockwork wings and the crown at the same time, to keep the design consistent. The whole thing is in flux and being constantly reshaped to fit my vision. All the time I'm working on the face, which on this piece I ended up repainting completely ~ twice! That's how important the face is. I'm getting a nice sense of depth here now with the values in place. Once the values are working the whole painting is heading in the right direction – on the road to success.

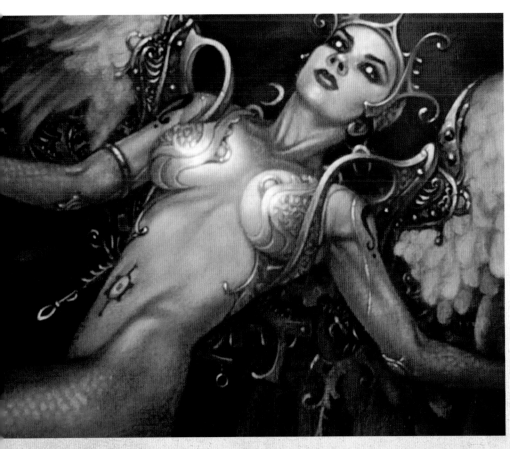

In this close-up I'm still plotting out form and light. Painting the clockwork wings was both tricky and great fun. As there was no reference used it meant I could just get lost in the workings of it. I use the light from the model to gauge where to place the highlights on the iron parts. With everything in place I move on with confidence to the colour glazing and final blending stage.

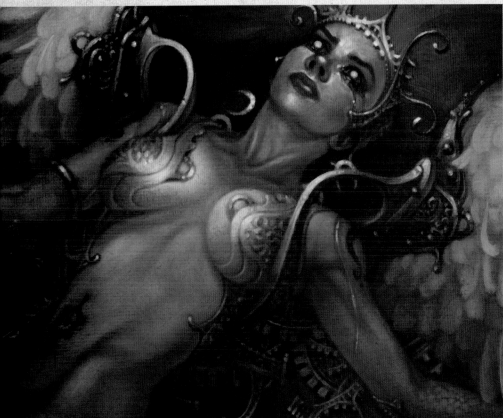

The most reflective materials are metals, and you can see I've added oranges to the underside for backlight (maybe from a fire somewhere off to the side) and blues/greens to the upper curves to reflect the sky. This is a classic light combo that I used a zillion times in my advertising days. I often consider my years as an advertising illustrator to be time wasted on disposable art, but it taught me a lot in terms of work ethic, deadlines, shortcuts, etc., and certainly kept my drawing and painting skills well honed to return to the genre I loved when the opportunity arrived again.

❦ Onto the serious work of glazing and blending. Glazing is as simple as adding a glaze medium to your paints to thin them to a transparency. For my glazing I simply use linseed oil but there are many glazing mediums available at art stores. At this stage I'll add extra bits where the mood takes me. Also be careful not to highlight everything, lest your painting looks like it's been snowed on. At the risk of sounding obvious, only highlight the highest light! See how the long, ornate handle sings out in contrast to the shadowed cogs.

❦ Here is a close-up of the scales, which I paint on top after the legs are dry. It's not important to paint every scale all the way around the leg, an impression will do the job better than a fussy mess of detail and will also be less tiring on the eye.

❦ I really enjoyed adding all the subtle colours to the wings. It's a big mistake to assume everything has the same colour hue all the way through – i.e. various shades of the colour of brown. Everything reflects the environment to different degrees so there are subtle blues and greens worked into the browns, as well as some warm colours speckled into the cool blues.

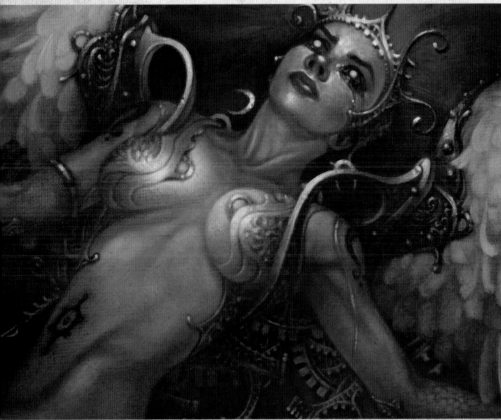

❦ I work on the face until it is right. Getting the tear to read clearly is vitally important. Although flesh is not as reflective as metal it still contains oil and is more reflective than you would think, especially if you are next to water or metal, hence the glow on the side of the face here. Hold some gold next to your skin and study hard. Study is the key to success! I consider this a charmed painting, as not only did it introduce me to my peers – as the first official poster art for IlluXCon – it also garnered me my first Chesley Award nomination.

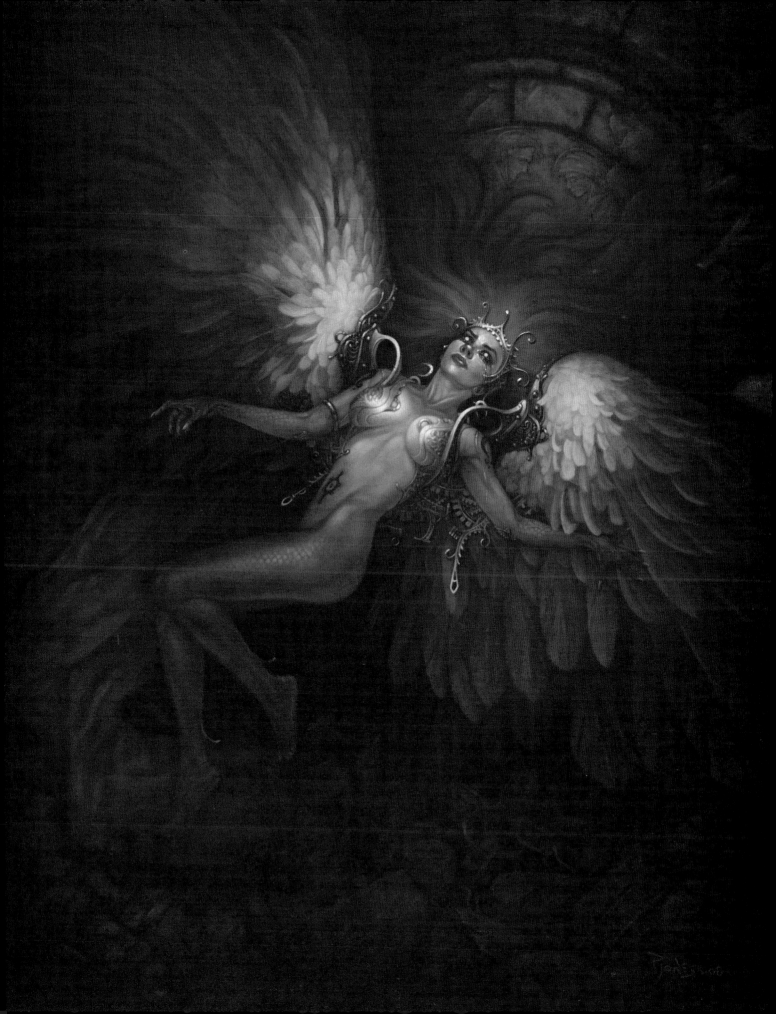

DEATH OF DIANA

THE ART OF SELF-PROMOTION

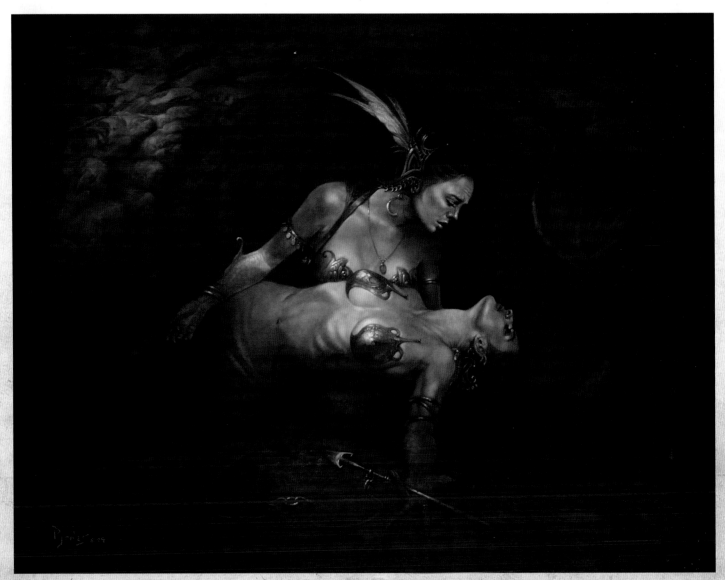

I painted this one for myself, as part of my ongoing *Lost World* series, for a proposed book of my own making (it's good to always have a project on the go to keep the creative juices flowing). The *Lost World* artworks are all connected to a story set in an undiscovered continent on a re-imagined Earth. Once the painting was started I auctioned it online and it was snapped up by an astute US collector at the colour rough stage. This painting was done on gessoed illustration board, as using canvas at this 19" x 25" size would have been too coarse to paint fine detail onto. The collector made a good decision with his bid, as the final painting was nominated for a Chesley award when completed.

When there is no commission to be had, self-promotion is the only route left and it can lead to more worthy work than the commission you were simply hoping might drop in your lap. A harsher mantra to shock a jobbing artist into affirmative action would be to whisper, "No one is aware of you." I've endured severe periods in the artists' wilderness and sympathize with the lean times all artists suffer. This, I'm afraid, is the average artist's lot. Just know you are not alone and that things will improve as your work improves. Those retirees reading this after a lifetime of work can, of course, relax and enjoy painting for the sheer pleasure.

❦ Here's the colour rough painted in Corel Painter using digital palette knives and oil pastels. You can, of course, use real palette knives and oil pastels but digital is much faster. I like to have a backstory to motivate me and add depth to an original painting. Here it is: mermaid sisters take refuge in a cave after one is harpooned. Diana releases the deadly harpoon in her open hand as her sister, Andromeda, holds her in her arms. Revenge, of course, will ensue later in the story.

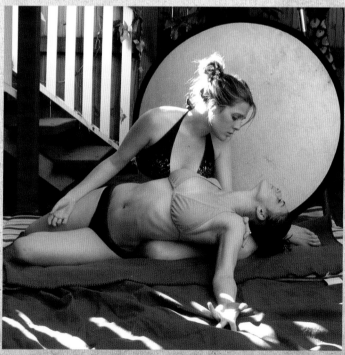

❦ I call upon Holly Underwood and Carly Rees, two actresses from the Zen Zen Zo theatre company, to pose. I pose and adjust their arms to match the rough, but the real drama comes from them understanding the backstory and my detailed art direction. Some artists might roll their eyes at the idea of a backstory but just check out their passionate expressions when these actresses hit the mark. They would look phoney if they didn't know what their motivation was. I see lots of Fantasy art in which supposed heroes of myth look like they are waiting for a bus.

Finding the right models to match your vision is a step worth taking. For instance, I think even some of the great Alma-Tadema's art (1836–1912) was severely lessened by his choice of non-actor friends posing as Roman nobility.

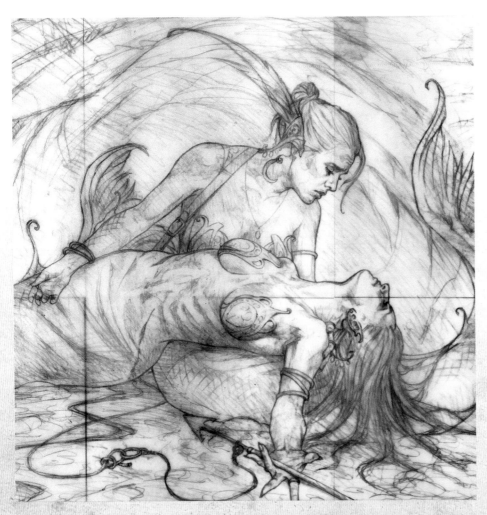

Two coats of gesso on illustration board and then I transfer the drawing when it's dry – around 15 minutes later, or half an hour in a cold climate. I made a reverse drawing with a 2B pencil on tracing paper then burnished the pencilled charcoal down. You can use anything round-edged that won't score the board. I used a large torch-cell battery to burnish this art! I've taped the board to a flat surface (my drawing board) to stop it warping when saturated with paint. Warping isn't a problem on stretched canvas, as it has no room left to warp due to the stretching process, but thin board will buckle if it's not braced.

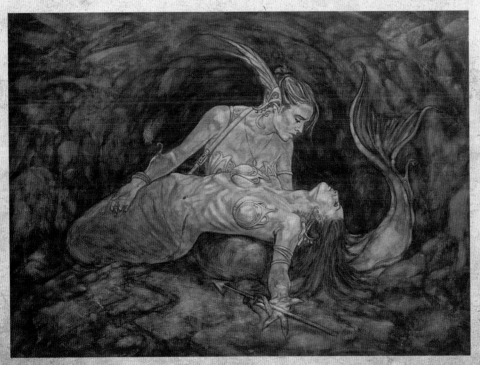

On this painting I block in using raw sienna. I used acrylic paints here for the underpainting stage. If using white spirit gives you a headache you may want to use an acrylic underpainting for every oil painting you do, as it's at the underpainting stage when the most use of spirits is applied. Note that you can put acrylic paint under oils but not the other way round as oil repels water.

I've taken out a few elements to improve the flow of the composition. Smaller details, such as the scales and harpoon line, will be added at the detail stage. If I put in all the detail now it would only get painted over during my "big brushes" stage. There's no point in painting details twice.

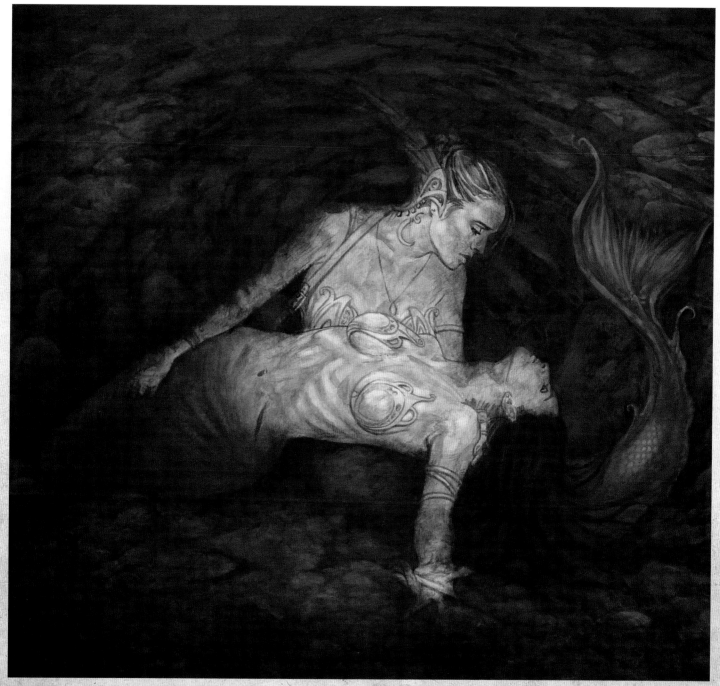

Here is the start of the block in stage. At this point I'm moving across the image without slowing for fine detail; I'm simply blocking in the lights and darks in basic monochrome colours to establish mood and form in the chiaroscuro style of the Old Masters. This will keep the overall artwork organic and flowing. The next stage will include the figures. They'll be painted in the same manner – still leaving fine detail, subtle blending, highlights and colour to be applied at the end to the whole image.

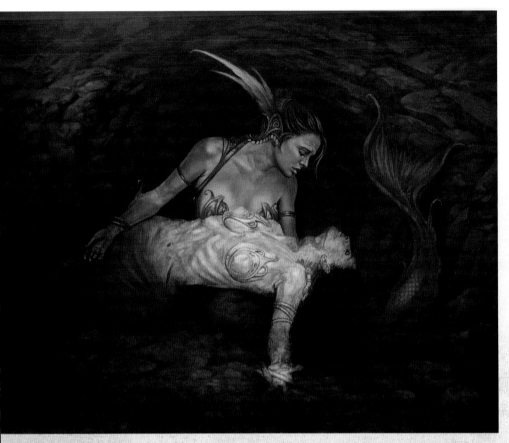

Here I'm blocking in the first figure and re-shaping the background. I'm still avoiding the urge to detail and blend until everything is blocked and balanced. Note the pool of light that's starting to form. I always work from background to foreground so as not to fuss too much on the edges.

The bluish glare at the edges is from overhead lights. When working at night or on overcast days I use two lights, the overhead light on the ceiling is fitted with a daylight bulb (blue cast) and my swivel light is fitted with an ordinary light bulb (warm light). The danger in using just one light source when painting is that it will affect how you see colour. If you work with only warm light you will tend to mix more cool colours to compensate. The next day your art may have a bluer cast than you perceived during the night. Using both warm and cool light combined will keep your colours true.

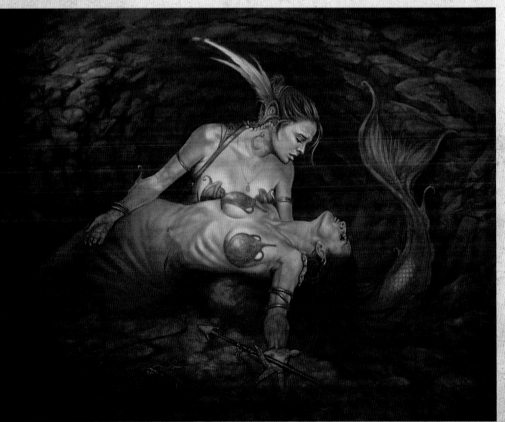

That's the journeyman stages gone. There are still lots of problems left to resolve, but most issues have now been tackled, and the hardest areas (midtones) have been addressed. The midtone is the middle tone between dark and light and is the area that contains the purest colour as it is the area least drained of colour by either shadow or light.

The next stage is turning this work into a piece of art with lighting, glazed colour, detail, blending, etc. I've used masking tape at the outer edges of the artwork, which I'll peel off at the end to give a crisp white border. If this was a canvas painting I would simply paint right to the edge, as canvas can traditionally be hung with or without a frame.

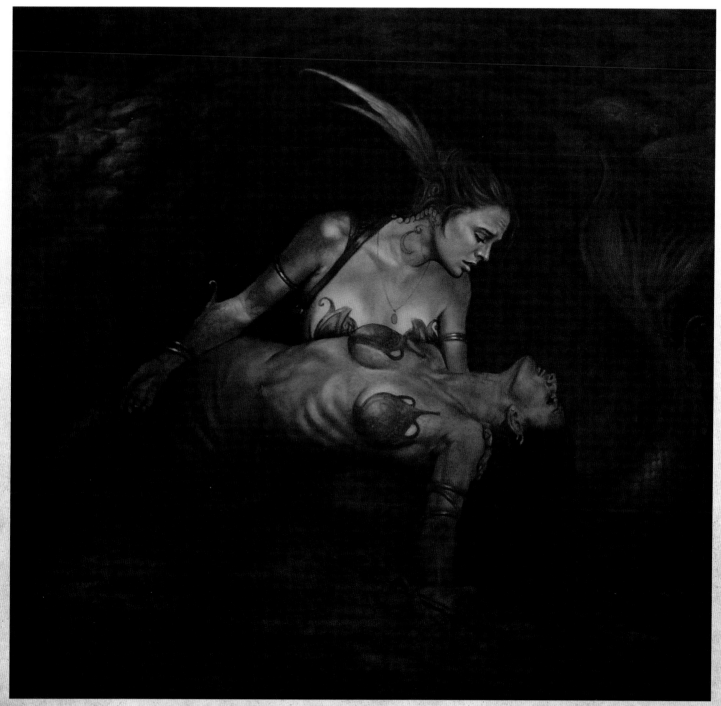

Here is the blending stage in progress. Along the top figure's arm you can see a dark outer line. This is due to me spreading a fine layer of oil medium over the dry figure before painting on top (the same 50/50 linseed oil/odourless white spirit medium I use to thin the oil paints at the blending stage).

By laying down this thin floating layer of oil I will be able to paint more smoothly on top with paint, giving me a fluid surface to blend into and also taking the drag and wear off my brushes. I believed I had invented this technique when I first started oil painting, but discovered later it had been thought of long before my Eureka moment. The technique is known as "oiling out", and is mostly forgotten in art school teaching, where it is now more traditionally used to restore sunken colours to a painting before the final varnish.

This is day 10 on the painting. Not a long time in classic oil painting terms, but all the same I'm running a bit slow on this one and I know Boris and Frank would see this as an ice age. Still, the next two working days should show more dramatic results as my paintings usually speed up as I go along and grow in confidence.

The most important part of the painting in close-up. Getting the expression of angst is very difficult and I need to use restraint here as there is a danger of it looking like amateur theatrics. The model has used just the right amount of expression, but painting expression takes a lot of skill to get right, even with the aid of a reference model. Can't rush this stage.

When I first studied original artworks up close I was under the impression that I needed to work with thicker paint, but the confusion came from the fact that I was looking at the final build up of thin layers, along with some final impasto flourishes. I was basically looking at the final strokes and believing that thicker paint was used all the way through the painting stages.

You can see how thin my paint is in this extreme close-up. If your paint is too thick you will have trouble painting detailed figures and will struggle with blending. The best way to understand the consistency of the paint I use in my blending stages is to think of the consistency of melted butter. This is achieved by adding oil mixed with thinners, such as turpentine or white spirit, as described throughout this book.

Coming to the finish line with the details, namely the fish scales. You can see the oiling out more clearly here, which is particularly helpful when painting small details as it's hard to paint fine lines on a dry surface. It's also tough on brushes working into a dry ground, so oiling out (rubbing the surface with linseed oil before painting) is recommended, if only for economic reasons. Brushes can be very expensive, especially sable brushes.

It is best to use bristle brushes for the scrubbing and blocking and the sables for blending and detail. Never use the cheap brushes you see in bargain stores as they well shed hairs all over your work and you will spend ages picking them out, or worse, discovering them dried into your art later. Cheap brushes are a false economy and not even worth mixing your paint with.

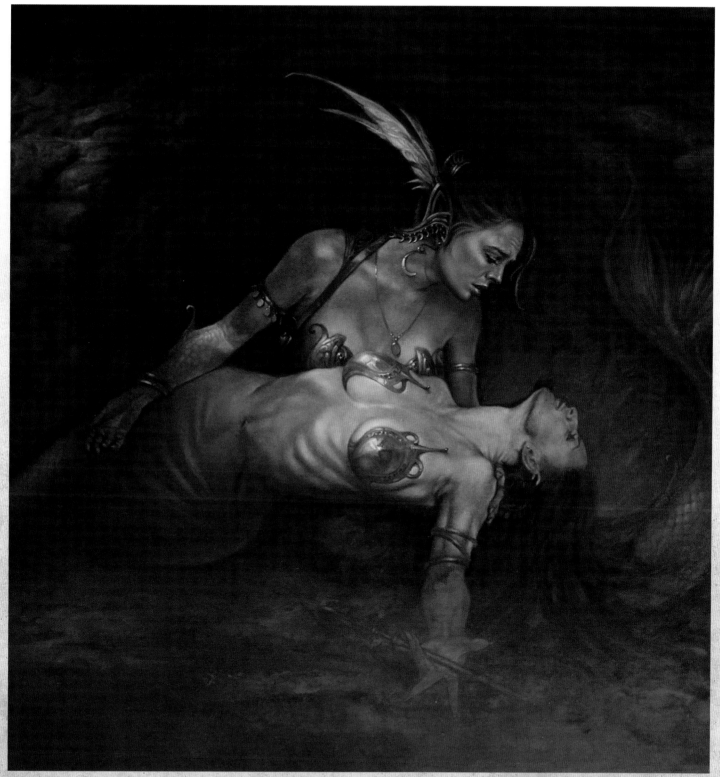

Day 12: I'm almost finished, but knowing me I'll probably spend another four painting days on this artwork before I'm satisfied. Here, I'm still blending, adding some colour as I go, and leaving the finest detail and brightest colours until the end. This is the time to get out some reference if you're new to painting metal. Good reference sources are easily found in the free catalogues available at the front of jewellery stores. Books on Hollywood epics are good too – films such as *Cleopatra* will have reference of ornate jewellery reacting to flesh. Big-budget history movies are also an inspiration, due to their high standards of production design.

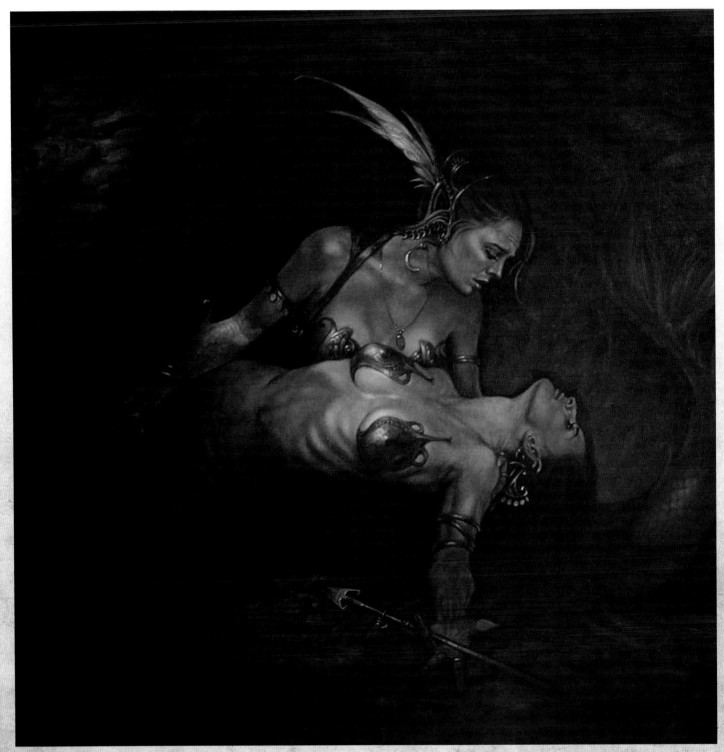

Day 13: I originally guessed this date for complete finish, but there's still some detail and colour to go in over the whole image. The dark patches of drying linseed oil will not appear on the final art. The painting shows some glare to the right, due to the touch-dry oil. Oils have a reputation for slow drying times, which is true, but working thin like this means each layer is dry enough to work on top of the next day. The slow drying may put some people off but it's the number one reason I love oil paints. Only with oils can you truly move paint around and blend colours into one another over an extended period of time.

I've taken a lot of time to get this painting how I want it. Paintings are like novels and can be tweaked forever, but at the end of the day you have to move on. As Leonardo da Vinci (1452–1519) famously said, "Art is never finished, only abandoned." Still, I'm going to squeeze more juice out of this one. Almost done.

A close-up of the penultimate art stage in progress. I'm just starting to blend in the final colours onto my freshly laid oily ground. It's amazing how you can come back to a painting after a long, hard-fought battle the previous day only to be totally refreshed and energized, ready to go again. This I put down to the fact that the final art is not only a mystery to an observer, but also to myself. I really want to see how well this can turn out. Also, the art gets easier as you go along as by this point you know the ground so well and are pretty much fearless.

That's why it's important to paint often. Leaving big gaps of time between paintings can lead to rust and the fear of failure. Once again you can see the clear linseed oil drying just outside the figure edges, due to my oiling out technique. Nothing to worry about, as you can see in the final stage completed opposite.

Spot the difference between this colour blending stage and the mid-blend stage on the left. Blending is done with soft and dry sable brushes on wet paint by "blending" the edges of the colours together. This needs a delicate touch and very clean brushes. If you study these two stages carefully, you will see lots of subtle colours, such as cerulean blue, yellow ochre and olive green, along with the obvious "flesh colours". Realistic flesh needs lots of shifts in colour hue to be convincing. Note the warmer colours at the top of the chest, providing a hot island of colour between the cool underside of the neck and the breasts. These areas read as realistic flesh because they usually receive less sunlight than the top of the chest and shoulders.

Day 14: the final painting day. I spend the entire day glazing over the painting with translucent colour using a linseed oil-rich glaze. I used to work this in with alkyd glaze medium but now use a linseed oil and white spirit mix as it dries slower and is less sticky (which also saves on the wear of brushes).

I really enjoyed painting these sea-ravaged rocks worn down by salt and wind. You've got to imagine how the environment works to make the painting not only atmospheric, but convincing. Embrace Method painting, immerse yourself into each artwork, and you and the painting will be all the richer for it.

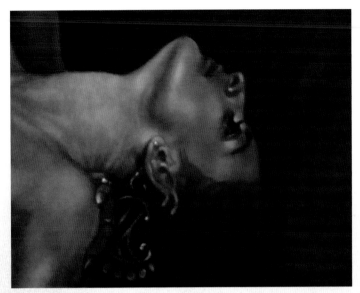

🖌 Once again, lots of time dedicated to the subtle colouring of the face and the many colours reflected there. Study faces, especially pale faces, and note the nose is pinker than the cheek; also, under the eyes, where the flesh is thin, the colour is more bluish. The ears are pinker, too, though not in this Fantasy figure.

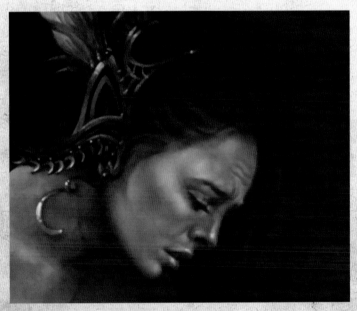

🖌 The final touches. Compare this stage to the earlier close-up to see the increased depth possible with layered colour. Now we're finished and ready for a coat of varnish when the painting is completely dry (as opposed to touch-dry). A coat of varnish will replenish the dark colours that tend to "sink" on drying, especially in spots applied with mostly spirit-diluted colour. I use a mix of 80 per cent matt varnish and 20 per cent gloss varnish (Winsor & Newton) to get a nice satin finish that is neither too dull nor too glossy. If you really want to go the whole traditional route you could oil out the entire surface first before drying, and then go to the varnishing stage later.

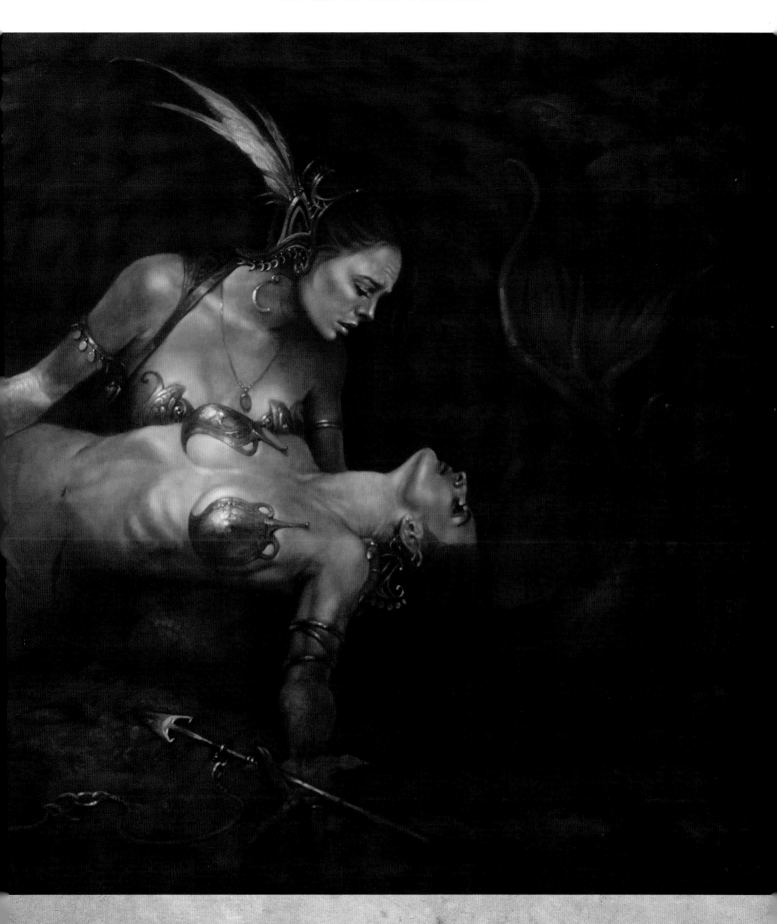

PALACE OF MEDUSA

CREATING STORIES

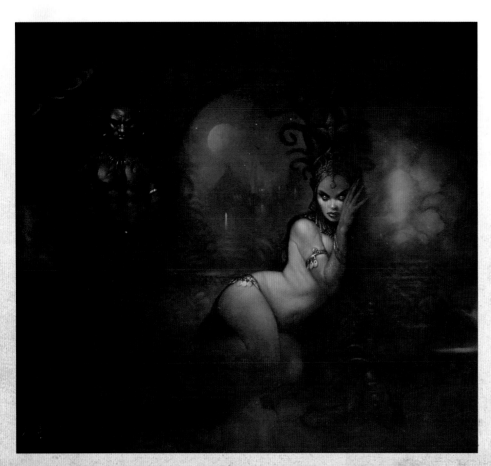

✤ *Palace of Medusa* is another piece in my *Lost World* series. In my version of re-imagined myth a young Medusa (whose gaze turned men to stone) is held captive in the king's palace – guarded by blind slaves – where she waits to be unleashed on enemies who would invade the city. Of course this will no doubt backfire on the king and his kingdom. As I've said, creating stories for your paintings is a great way to get more passion into your art. It's important here to make sure Medusa has the right amount of both allure and sinister intent.

The painting was subsequently bought by a private collector in the UK. Knowing art painted with passion is always sellable gives me the incentive to paint every day, even though the work may not have been commissioned.

✤ I started with a colour rough painted in Corel Painter and printed out for reference. This is where I work out all the hardest problems, which to me are value (light to dark tones) and an atmospheric colour scheme. This is a stage that a lot of amateurs skip; they then end up abandoning the painting because they lose direction. Preliminary sketches and colour roughs can save a lot of frustration later on. They are, I think, essential if you hope to produce something special.

✤ In an unusual step I turned to an old photo session for my reference of two models, and repositioned them in the painting to play separately. Originally I was sure I was going to paint them as they were, but then I realized how close the pose was to a Frank Frazetta painting of Conan. Once again I use black and white photography for my reference shots so as not to be influenced by colour, but more importantly to concentrate on value. Unless you want your paintings to look like foggy scenes you must learn to see contrast in values.

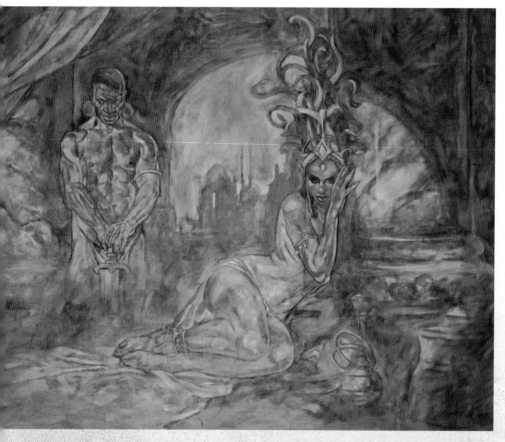

❧ Somewhere along the line I lost the original sketch for this, but it can be clearly seen here in the underpainting. I wanted to paint a full-fleshed Medusa here instead of the usual stick-thin model. This doesn't mean she won't be attractive; in fact she may be more so because of the reality of such a woman – that is apart from those deadly eyes.

You'll notice at this stage that Medusa is a little more heavy around the hips than the final art will show. The face will also go through a lot of change. I thought the face was a little small and enlarged it later. It's best to get this stuff right at the sketch stage, but if you see it at the painting stage you only have two choices – either start again or change it on the fly. I feel confident in my skills to carry on, but this is only due to my previous tip of painting constantly and leaving not too much time between paintings, thus losing the fear of the painting process.

❧ Here's the first block in with big brushes. The oils are thinned down with white spirit and dry quickly but I can still drag them around and do so here with a cloth wrapped around my finger to manipulate the marble textures on the columns. I also use a dabbing motion with the cloth to create the mist. Marble is particularly easy to do using the rag and wipe method – much easier than trying to paint it with brushes.

By wiping the wet paint I can create more random marbling than if I meticulously tried to render it with brush strokes. Once I see the marble emerge I can then add detail with brushes. As usual I work from background to foreground, not worrying too much about the edges overlapping the figures. Try it the other way and experience a whole world of pain.

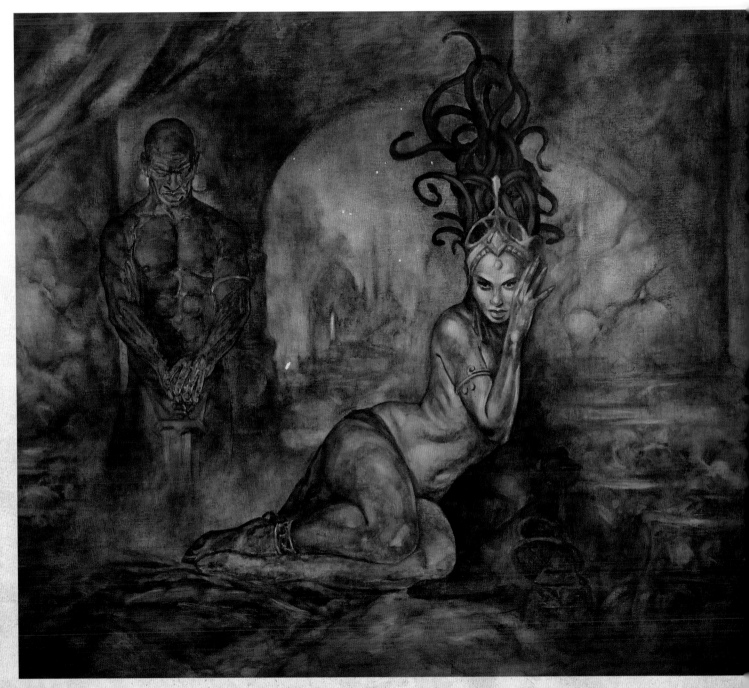

I take a huge brush loaded with a sepia/umber mix and wash over the entire painting to get harmonious tone before blocking in the figures. You can see how much more refined Medusa's face is now, compared to the previous stages. It's good practice to constantly review your paintings to see what can be improved, rather than simply painting by numbers based on your original sketch.

The danger of sticking religiously to the sketch can lead to boredom and stiff-looking artwork. After every break I turn the painting upside down or sideways, so that when I come back into the room I immediately see new ways to improve the art due to my fresh perspective. The face of Medusa is now more sultry due to what I saw on returning from a break, which was a face much too innocent.

Keeping the story true is also important and you must keep asking questions about the characters – such as, what kind of flesh will Medusa have? No doubt she will be very pale as she is a constant prisoner in the tower, therefore I treat her flesh with lots of cool colours. It's worth getting to know your characters to make them believable, otherwise your work may be overlooked as lifeless and superficial.

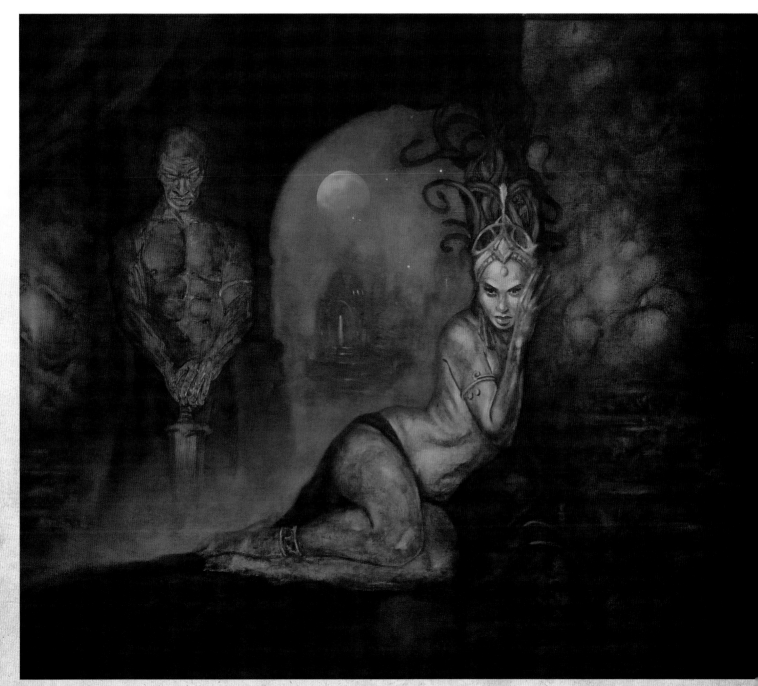

Here I'm working hard on getting the values strong enough to create a light source centring on Medusa. I've also placed a sheen on the pillars to indicate their roundness and solidity. All the time I'm reworking the face to capture a sinister but inviting expression. You may cry out that I'm breaking the rules here by working on the foreground figure before painting the background figure, but they are far enough apart that one does not overlap the other. As stated previously, you must know the rules well before you can break them. Working without rules will sometimes yield interesting results, but art painted without basic foundation training in solid technique will more often end in disaster, especially academic styled painting such as this.

An interesting note on this artwork is that it has become attributed to Frank Frazetta due to its elements: a girl by a pillar, an archway, and a slave. I freely admit the influence of Frank's *Egyptian Queen* here, as it's one of my favourites. I think the misunderstanding began with an article in *ImagineFX*'s tribute magazine to Frank when he died, citing this as his version of the Medusa myth. I had written a few words on Frank for the same magazine, which must have started the confusion. Then, somewhere along the line, someone on the internet produced bootlegged prints by superimposing Frank's signature onto the prints! Talk about the blind leading the blind. The spell of Medusa I guess.

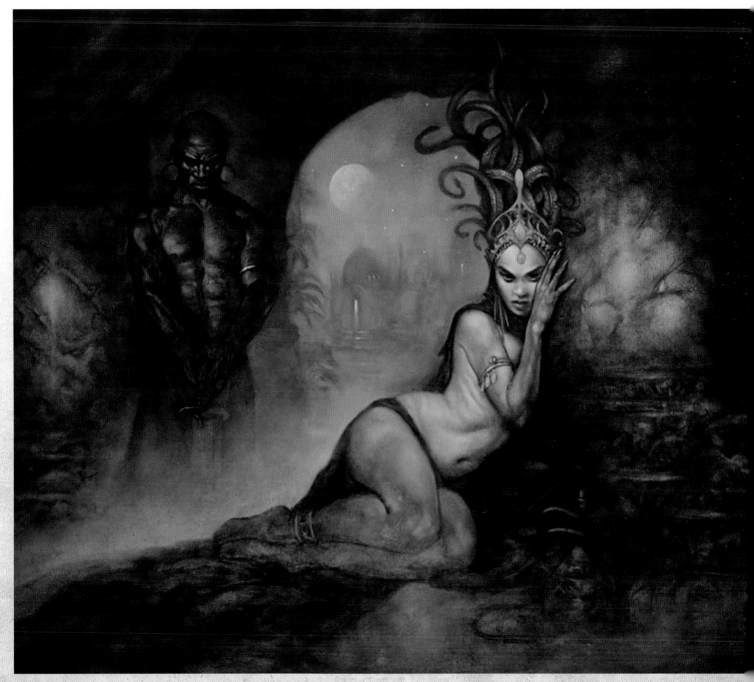

I'm adding more opaque colours to Medusa, and the mist, to bring her forward. The expression on the figure is getting closer in menace and I can leave it for a while and concentrate on the rest of the painting, safe in the knowledge that all is well and on course. I work on the background figure with a "thick milk" paint consistency and blend with soft brushes.

When blending, remember to wipe the brush you're blending with on a rag to stop it becoming a reloaded paint brush. You will be thinning out the paint as you blend, thus picking some pigment up into the hairs. If you don't wipe the brush you'll end up laying paint down again. I also get a rag out to rub some paint around onto the pillars.

I work more on Medusa with slightly thicker oils thinned with 70 per cent spirit to 30 per cent oil. When I say thicker I mean the thickness of face cream. Now I can leave the art to dry until tomorrow. Time-wise I spent two days on this stage and this is usually the stage where most time is spent. Painting is like writing a novel: the first words come blazing out in the opening scene then the middle is all character development and staging before the grand finale picks up the pace again.

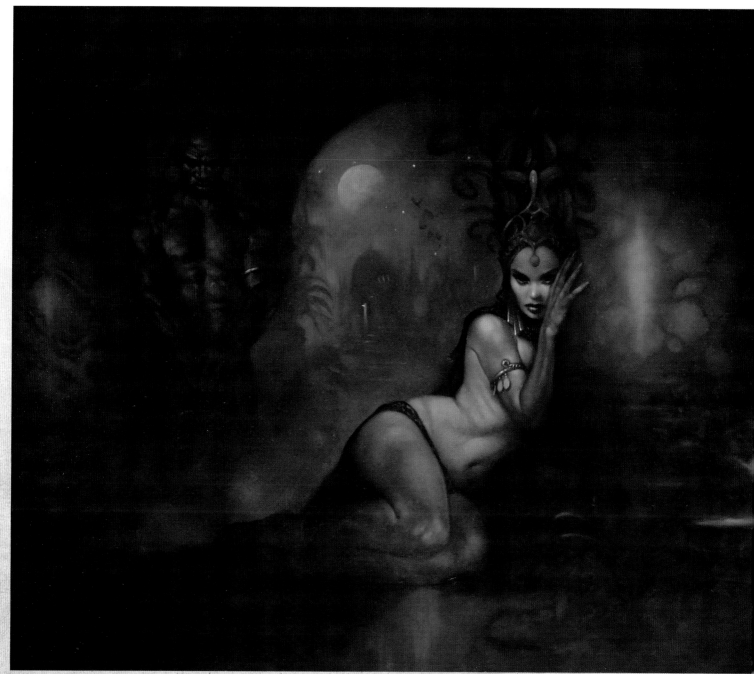

Medusa is almost finished at this stage. The painting is dry to the touch and I can spread a film of 50/50 oil/white spirit mix with a large brush (oiling out) over the entire surface of the art board. I then start to paint onto the glossy surface. The addition of a shadow across Medusa's face adds a nice mystery to her lurking nature. You can see the benefit of glazing here on the smoothness of both the pillar and the face. This stage moves faster that the previous stage, even though it yields finer results; this is due to the fact that all the figurative problems are already solved and I'm working more on creating harmony than reworking anatomy. I've balanced everything with darker colours around Medusa and therefore made the light more intense on her figure. Compare this in atmosphere to the stage before to understand the importance of getting the journeyman work correct, and the power of glazing to produce lush colour and rich darks.

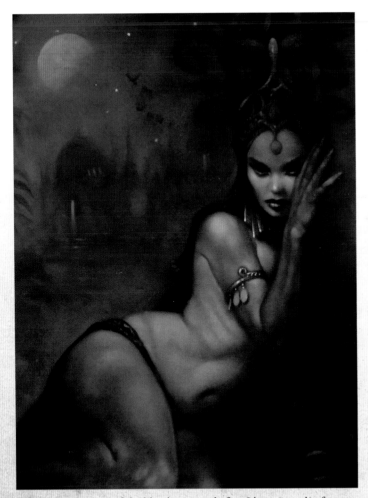

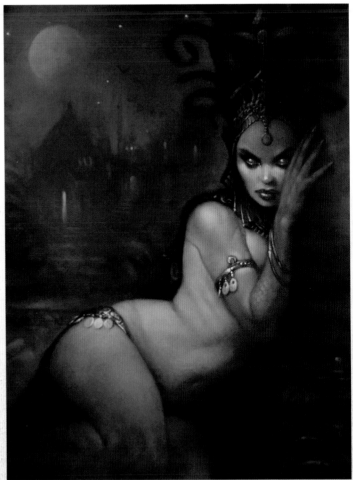

❧ Here's a close-up of the blending stage before I leave it to dry for tomorrow's final glazing session. With paint this thin an overnight period is time enough, as long as I don't go too heavy with the brushes the next day. Try to finish a major stage if you can each day, so you can return with a fresh eye and a fresh challenge. I'm planning to work in sections tomorrow, as there is a lot of detail to add and I'll be working slower. So instead of coating the entire art I'll work on sections I can finish in a session, such as this portion of the art, before moving on to another portion. It's good to have a plan worked out for each day so you are constantly motivated towards the end goal rather than entering the studio and simply scratching your head. If you have a game plan it can stop any thought of giving up or losing interest.

I use my usual trick of turning the art on its head and see that the addition of some gold coins on Medusa's toga would not only help give a graceful arc to her thigh but also add detail to a large area. I've always liked art that has detail concentrated in small spaces surrounded by less detailed mass. Adding details in these areas is a good way to direct the viewer's eye around the painting. If you look at the next stage you can see I've created stepping stones for the eye to travel – from the gold on the hip up the curve of the body, resting for a moment on the bejewelled arm before resting on the face. This method is a good tool to use in creating interesting composition.

❧ It's all about subtlety and detail at this final glazing stage. Here I'm working on the figure of Medusa and have coated the area on and around her with glaze medium. This time the mix is 50 per cent linseed oil and 50 per cent turpentine, and onto this glossy surface I paint transparent colours on top and touches of opaque colours in the highlight areas. Then, with a soft brush, I blend the colours together.

The reason for the shift from using white spirit as a thinner to using turpentine is two-fold: firstly, turpentine is a superior flowing, yet more toxic, blending medium, but if I was to use it in a large application (such as I did with the white spirit the previous day) I'd be risking my health. As I'm working on smaller areas there are fewer fumes and I paint with no ill effects. The second reason is that turpentine is less likely to pick up previous layers of paint. Turpentine and oil mixed together create that "buttery" quality that oil painting is so famous for. In my glazing stage the consistency is that of "melted butter". When using turpentine it's essential to work in a room with good ventilation.

This is a big day of work but it is no stress as I'm so involved with the project that I sometimes don't even know when I'm hungry. In this state you can accomplish much more than an artist who sees his work as merely a means for making money.

❧ I've already added some dull opaque colours to the flesh, so the underpainting of the slave is more dense than usual. I did this as the skin will be ethnic and very dark. Also, we need to balance the picture and keep this character from visually competing with Medusa. You can see here that I have changed the ethnicity of the original model by studying reference from African tribesmen. This kind of reference search is easy to do on the internet but I tend to compile folders of photographs and magazine cut outs named and filed – i.e. landscapes, animals, etc.

❧ As I had a sepia underpainting I can add lots of complementary colours on top. Complementary colours are "opposite" colours on the colour wheel, and when placed close to each other give the artwork a living vibrancy. Don't fall into the trap of ignoring the fact that black flesh contains warm and cool colours in the same areas as white flesh. I add a tooth necklace and some scars to give the slave a history. As I said before, get to know your characters and the art will gain more depth.

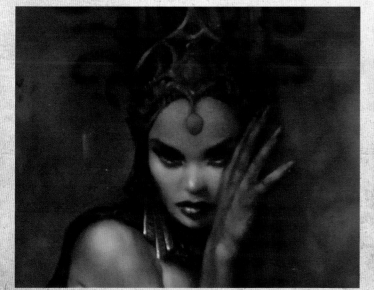 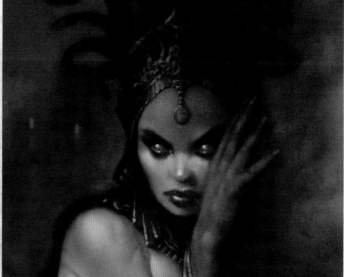

❧ It's worth studying these two close-ups to appreciate how delicately the face should be treated. As stated before, this is the one area where the painting will succeed or fail. Originally I toyed with the idea of the eyes being empty voids but it wasn't dramatic enough. I decide that the eyes should be glazed and colourless orbs. On the right you can see the dramatic difference this last-minute decision has made to the final artwork. Art should always be open to any change beyond the sketch if it improves the final painting.

❧ Lots of sable brushwork was used on the headdress and eyes here, and lots of blending with a soft, dry brush. It's important to keep your brushes clean as oil paint attracts hair and dust like a magnet. Sometimes when the painting is almost dry I'll pick out stuck hairs with a piece of masking tape. You need to judge this right to avoid picking up the paint, but if you paint every day this kind of devil-may-care attitude will not seem as crazy as it sounds, as anything is easily fixed again with a swish of a brush.

❦ Creating stories as you sketch is the fuel required to make your paintings soar. To simply draw pictures without direction will lead to the abandonment of one sketch after another. Or worse – a final painting based on a forgettable sketch. If it sounds like a waste of time to give a backstory and motivation to each character in your painting then you are not only diluting the painting's emotional power but you are denying yourself the full artistic experience.

Next time you are in an art gallery, take the time to study each character in any Old Master painting and you will see each of them clearly has, or had if they are dead, a purpose and a motivation. Jean-Louis André Théodore Géricault's (1791–1824) *Raft of the Medusa* is a good start.

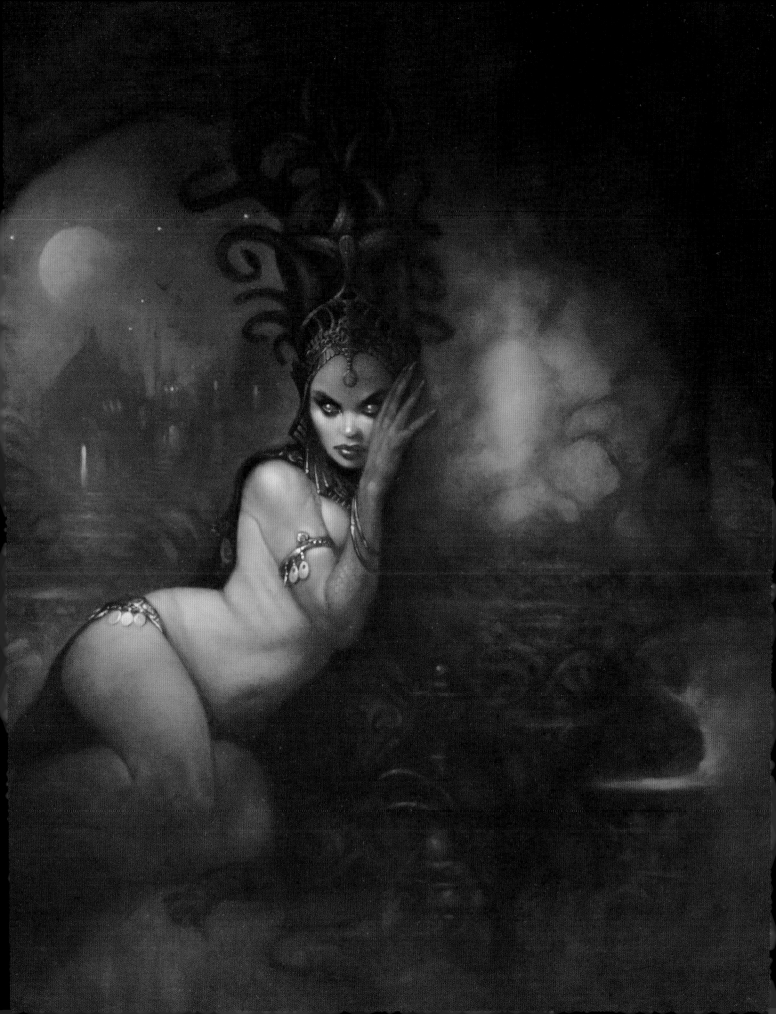

EXPERIMENTS WITH PAINT

This is the title painting for my *The Lost World* series of paintings. Even though I had painted it for IlluXCon, I still plan alternative reproduction usage. Remember – to be fair and clear to the buyer – you should always retain the copyright of any painting you sell and write it on any invoice.

Each painting in this series will feature an exotic story of betrayal, lust, revenge, and treasure – and mermaids and prehistoric creatures that all live in a world lost to time only to be discovered by a band of cut-throat pirates. Having a story in mind as you paint will absorb you more, and possibly lead to other ideas for paintings. I wanted to show here the anticipation of some great upheaval to a way of life that will be changed forever by the coming of invaders.

On this piece I have chosen to work in Winsor & Newton's water-mixable oils, for easy cleaning and a less hazardous work environment. Painting is dangerous? Can be if you breath the chemical fumes, especially in a poorly ventilated room. I'll also touch on other hazards encountered during this painting. This was my first major experiment with water-mixable paints.

The paints feel a little too "dry" so I will be adding water-soluble linseed oil as I go to help the paints flow from the brush. Above right is the underpainting in thin sepia oils. At this stage I see no difference between traditional oils and the new variant. Once the water has evaporated they are returned to their oil state. Strange but true, and I am very impressed.

❧ Thin oils dry quickly and are ready for a second coat the next day. Here I'm laying in dull versions of the final colours, and dragging back to the undercoat with rags and dry brushes to get texture on the rocks. It looks like I've wiped away the previous day's work, but this is just a mix of lighting from the morning sun in my studio and the contrast of the second coat. The streaky lines are from the coat of gesso underneath. Gesso is used to seal the surface so that the oils won't be sucked into the porous board. Working on unprimed board is not recommended for figure work as the oil is sucked away before you can properly blend.

❧ Another coat of thin, dry paint is used to "scrub in" the anatomy with bristle brushes. This is an unorthodox use of scumbling, which works faster than blending. Scumbling is usually used with a rag to scruff in lighter tones over a dark area, such as highlights on water. I go back with a dry sable brush and blend to soften the muscle rendering.

At this point I am no longer thinking about the new medium, as it is behaving and drying as oil. Amazing! If the product hadn't been Winsor & Newton I may not have tried it out, but with their sterling reputation I guessed it would be something special, and it is.

❦ I lay down a thin coat of water-soluble linseed oil, further thinned with water, and refine the painting before blending with a soft brush. I am getting the lighting right here, and want to play with shadows to help with the ominous atmosphere. The mix feels stickier than regular oils and I am starting to notice the limitations of this strange new medium, especially in the blending. On the plus side it's clean, and the brushes rinse out easily in water.

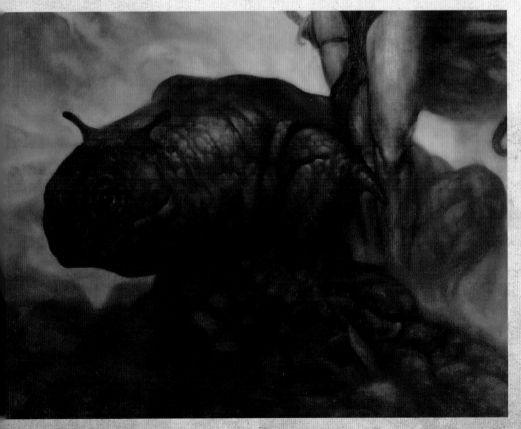

❦ I'm working on the lizard here and grounding it with shadow. I don't want to draw attention away from the woman so I add mist to keep the detail vague, and also to add atmosphere. The water-soluble oils are working fine on the lizard but I feel the paints "tug" on my brush as they dry, and I wonder if they'll be up to the task of blending flesh.

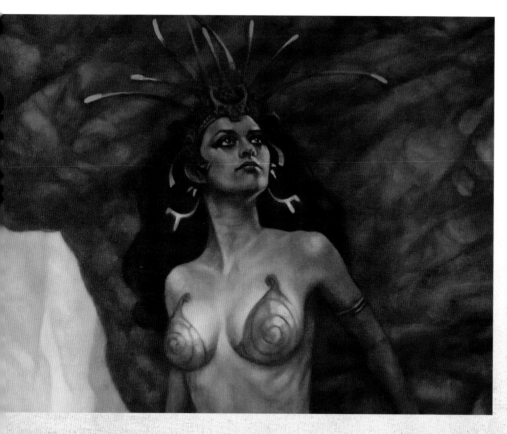

This is a big day – all the problems of light and dark are solved and the low-key colour scheme is in place. Now I start to blend in subtle colour. I need to pay attention to the difference in skin tone and texture of each character, as it's contrasts that keep the viewer's eye lingering; contrasts in colour, texture and value. The model is Carly Rees from Zen Zen Zo Physical Theatre, and she has pushed her anatomy to the point of anticipation personified.

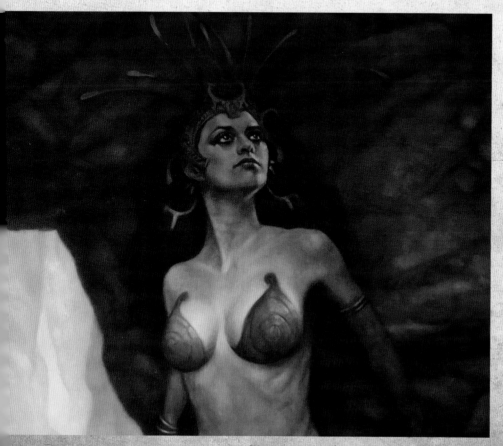

Darks are added behind the figure to bring it into the light, and the background is knocked back to create distance. For the darks I mix phthalo blue and burnt umber. A mix of blues with other dark colours will give richer darks than pure black, which tends to sink and look dull. The woman's flesh is now reading as soft against the rocks, and in comparison to the reptile. As I feared, the woman's flesh was a tougher task to blend than if I'd used traditional oils, which makes me re-think the use of water-soluble oils. I'll keep going and see if I can alter it somehow.

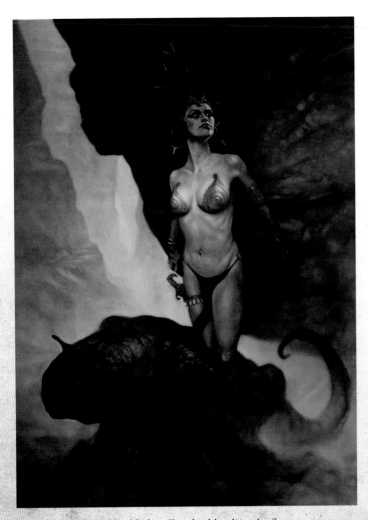

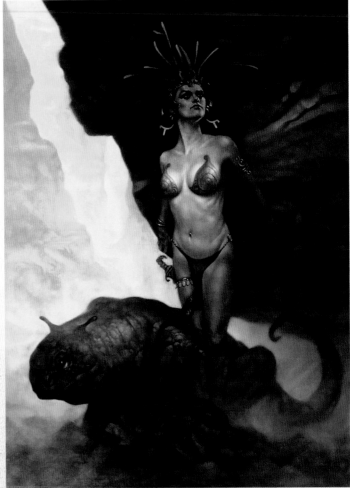

More colour and highlights. I'm also blending the figure more to make the flesh softer. The metal breastplates are a good contrast against the skin. A word of caution here about the use of particular colours. Cadmium yellow is used at this stage – cadmium is a toxic chemical and should never be sprayed, eaten, or rubbed with bare skin. Some Old Masters would use their thumbs to blend paint – which is a great method – but no doubt many died from poisoning as human skin can absorb poison into the bloodstream. My cadmium yellow tubes are now labelled "non-toxic" so I guess they are no longer "true" cadmium. Some artists use surgical gloves when painting; although I don't wear gloves I remain aware and keep my hands off the paint, washing them after every session.

Here, I've added the gold thread in the quartz rock. This adds an exotic element and a new story feature – something for the pirates to find and kill for. It also leads the eye to the figure. I've lightened the shadow on the beast and darkened the torso of the woman to lend weight to the breasts. I start adding "odourless" white spirit to the water-soluble linseed oil instead of extra water, to help eliminate the sticky paint feeling as I go, and it does the trick somewhat.

At this stage I start to really notice the difference between traditional oils and water-based oils in that the latter tend to dry more slowly, which was the oddest thing, then end up a bit sticky. Still, the fresh air and lack of headaches associated with pure thinning solvents are a massive plus, as is the cleaning up with water.

I'm detailing with smaller brushes at this stage. I keep the small brushes until the end, so as not to fuss with the painting too early. That way I can treat the artwork as a whole instead of as "bits". I also decide the breastplates need a more feminine touch and so add a little flourish in the design. I decide not to mix any more water with the water-soluble linseed oil and continue mixing only odourless white spirit to complete the picture. With the ratio of spirit being below the total mix of 50 per cent, I can still clean my brushes in ordinary soap and water.

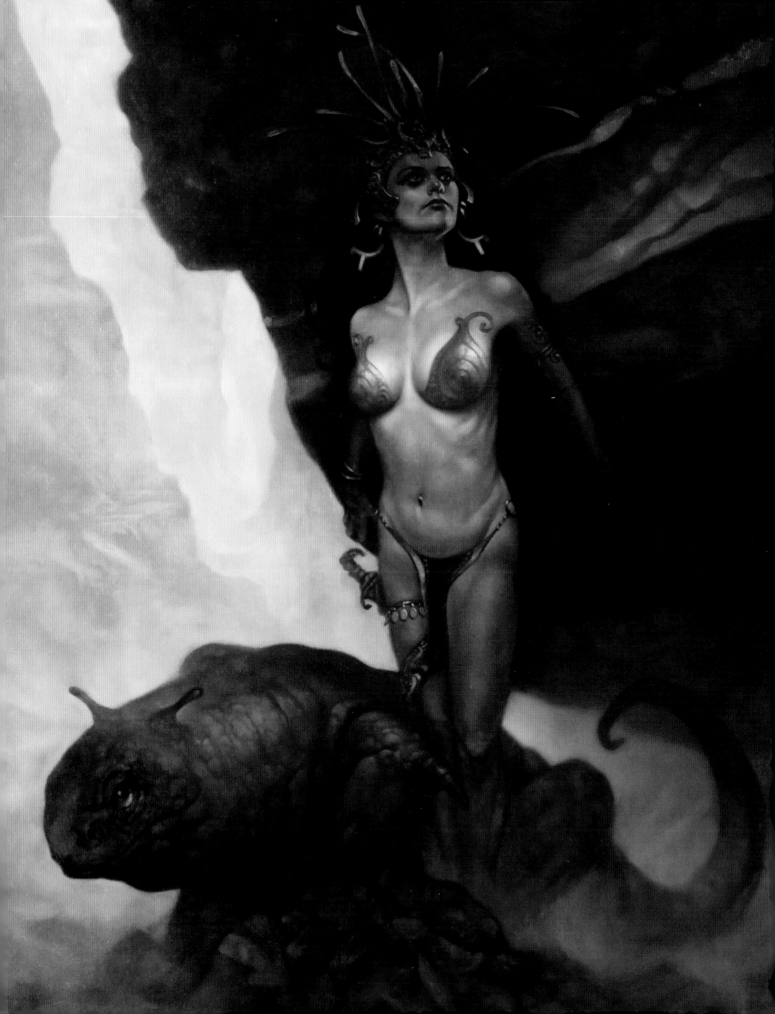

I had great fun painting the lizard: getting lost in its scales and veins, the shiny skin, etc. At this point I'm using a lot of scumbling – laying down very dry oil and scrubbing it in with a dry brush or cloth – which is odd since I am getting a shiny effect. Just proves it's the eye and not necessarily the technique that get us where we need to go. This also gives me the chance to work with one of my favourite colours, olive green. This is also a time when the much-maligned colour black can be mixed with yellows and sepias to get a wide range of dirty and realistic greens.

I scumbled some dark umbers under the rib cage as I was starting to see the figure flatten. As the brushwork was very subtle I used a cloth wrapped around my finger to rub the paint on. It's very important that the paint underneath has had at least a day to dry, and even then you need to be light-handed.

I then leave the paint to take for a while, and come back with a soft fan brush to soften further. These water-based oils have proved a new and interesting challenge, although in blending they were a little frustrating. In future I'm guessing I'll use them in the early painting stages, due to their harmless qualities. Once the water evaporates completely the painting is pure oils again and so continues to dry by oxidation.

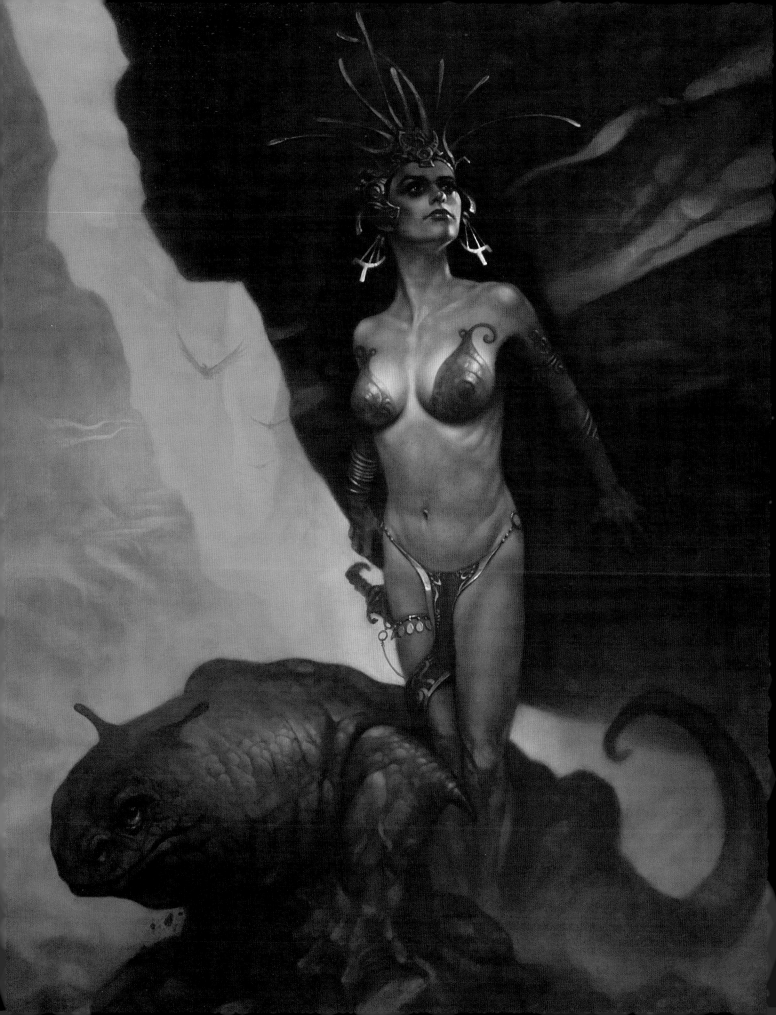

ARTEMIS AND THE SATYR

ART AS A LIFESTYLE

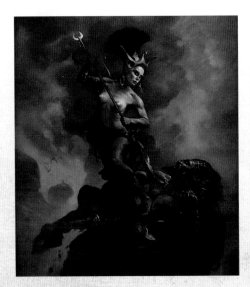

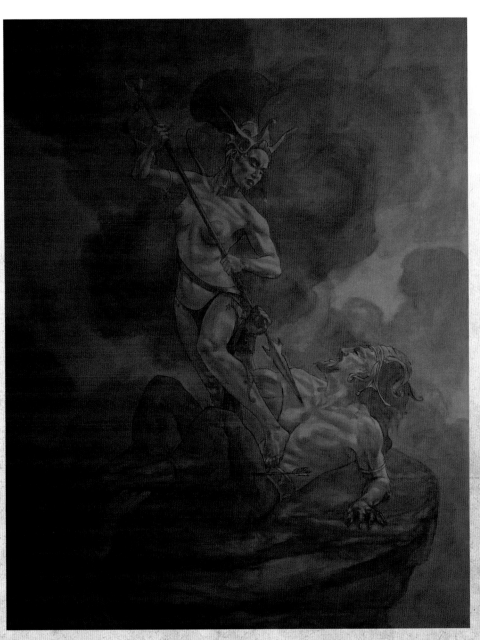

 Another painting in *The Lost World* series, completed with IlluXCon in mind. In this painting, as with *Palace of Medusa*, I have drawn loosely from Greek myth. Here, Artemis has wounded the Satyr with arrows to slow down his flight, before capturing him atop a rocky pinnacle. This was a large canvas, at 36" x 48".

Another note regarding painting without commission: it may seem a waste of time to some, especially a large piece like this that is unlikely to sell, but I consider my art a lifestyle that also makes me an income, meaning I will continue to paint, rich or poor. Selling a piece as large as this is a challenge, but the interest it caused led to some large canvas commissions – one being for an artwork of equal size.

 It's worth studying this underpainting next to the final painting on the left, to observe how art is not just a paint-by-numbers exercise. There is no doubt that the more pre-planning before a painting, the more chance of its success, but even then, as seen in *Palace of Medusa*, when all seems perfect, you should still keep your eyes open for chances of improvement – no matter how small. With the sketch on the canvas, the underpainting is applied with very thin Sepia oil mixed with white spirit, and then left to dry overnight. I consider the battle half won when the underpainting is finished.

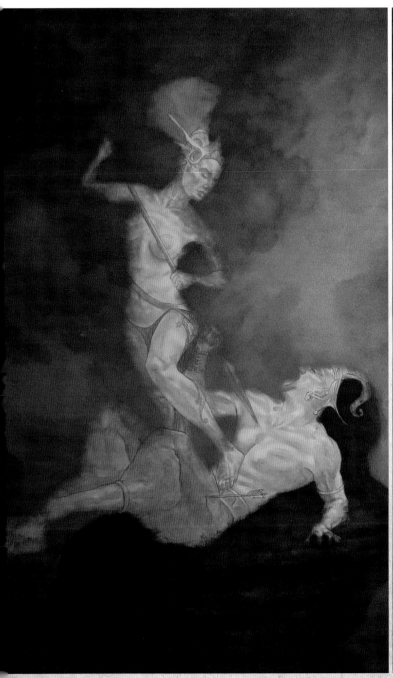

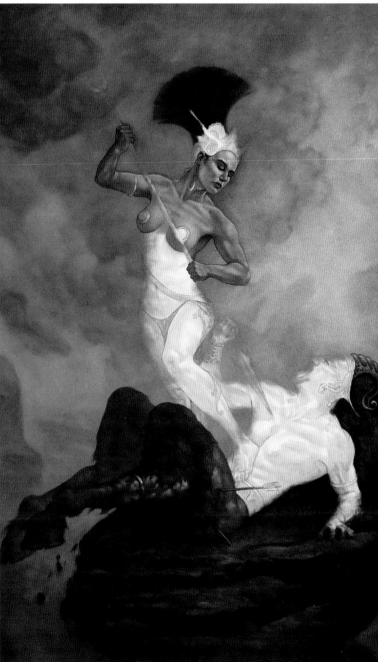

The next step is getting the background in. Working the background first means you don't have to worry about the edges of the foreground figure. If you painted the foreground figure first, the background would be stiff and fiddly to do, and would take a long time.

That said, I recently had the honour of watching the great Donato Giancola paint at his studio in Brooklyn, USA, and he did the opposite. He wanted to get the main element down first, as the deadline was tight. This meant that the background could be as loose or as tight as he had time for, but quite rightly, the figure had to be perfect. For *Artemis and the Satyr* I was my own client, so time was not a concern.

Working the background first does not mean you have to get it perfect before moving on to the figures. I like to work the painting as a whole, and then return to the background near the end to pull the painting together. It's just important to get in those big bold strokes that overlap the figures first, and it's also a good gauge to judge the lights and darks needed for your figures.

Figures painted on a white background might look very washed-out when placed against a dark background later. Here, I'm working with more opaque colours over the top of my dry underpainting.

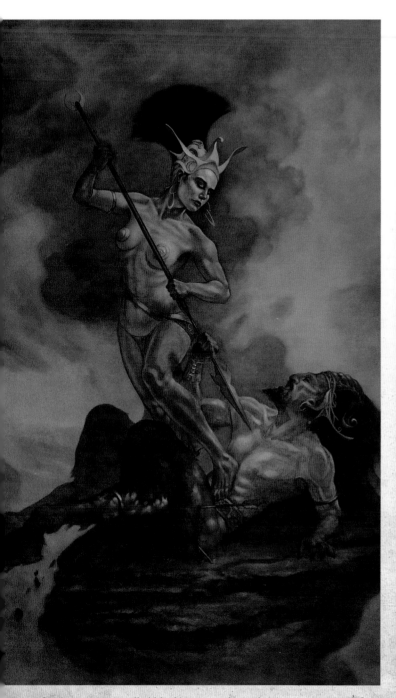

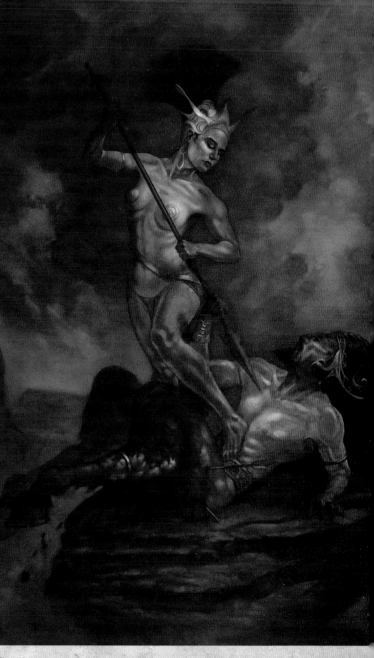

❧ This process is called blocking in, and it is the journeyman part of painting. At this stage I am constantly referencing anatomy books, my own sketches and my photos of models. I paint more detailed anatomy than I will eventually show in the finished art, as it's more important to know what's under the skin than how the skin's surface looks. Relying purely on photo-reference, as touched on earlier, will result in amateur- looking art. This is because, without anatomical knowledge, you will just be painting shapes that you don't understand, and this will ultimately tire your eyes and lead to major mistakes. Also, different light sources can create shadowed shapes that can be confused with anatomy.

❧ When painting Fantasy creatures it's worth referencing the real world. Here I studied reference of goats in order to make the legs ring true. I also faded the hooves into the background to keep the viewer's eyes from leaving the painting, and to bring the focus back to the central figure. The eye will always seek out contrast and detail, but too much of that will be tiresome, leading to a laboured and stiff-looking artwork. Knowing when to detail, and when not to, is key to good composition and confident-looking art. You could try 90 per cent mass to 10 per cent detail as a working model then use your eye to add more detail until you get to the point where the art is no longer improving.

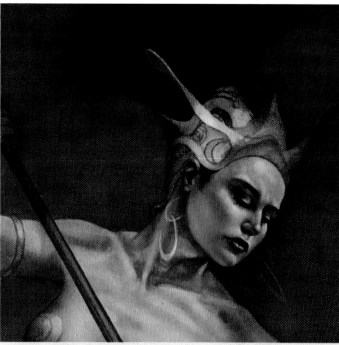

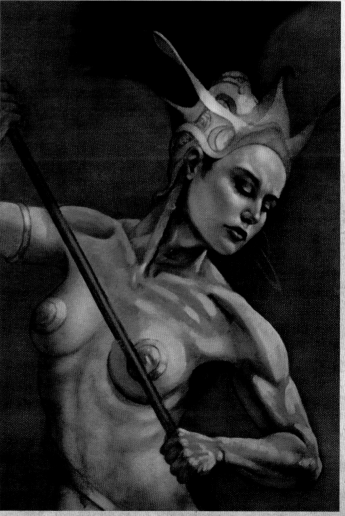

🐾 With the painting blocked in with monotone colours it's now time to think about colour and blending. I will continually consult my little 8" x 5" oil colour rough during the rest of the painting. Lots of artists don't bother with this stage, which I think is a huge mistake as the very essence of the final painting is contained here: the contrast, the colour, the mood – all the problems worked out in miniature beforehand. To try to work out all those problems on the final 36" x 48" canvas is just making a rod for your back.

🐾 As I started the painting in earth tones I now work in the cooler tones on top. This makes it easier to see what I'm doing, as well as creating a nice vibrancy which will show through the thinner paint. At this stage I add more linseed oil to my thinner to make the paint flow better and stay wet longer for the blending stage. This may look like I'm simply blocking in again, but what I'm doing is using the anatomy in the block in stage as a guide to more subtle blending.

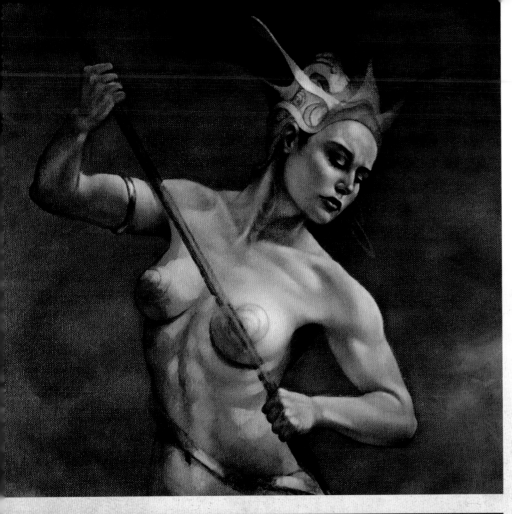

With a soft, dry brush I blend the edges of the anatomical joints and muscles to create realistic flesh. If I'd done this without the block in stage – where I plotted the muscle underneath – I would have ended up with a painting more in the style of bad airbrush art where the artist has worked purely from photos: i.e., working with less information, without the knowledge of what is under the skin. During my studio days we referred to such artists as "surface painters". Ouch! Knowing what's under the skin leads to a figure with proper weight and life.

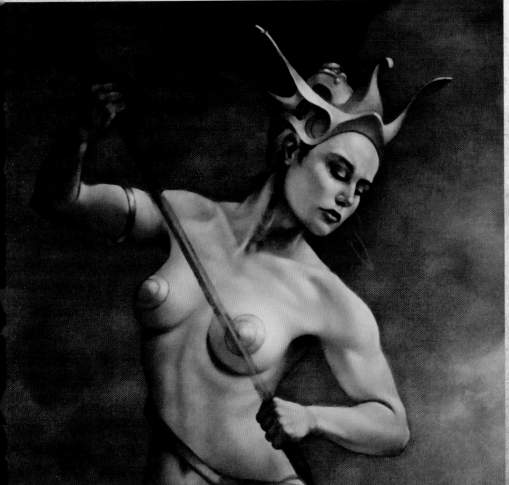

At this stage the oils are starting to dry, and it is the perfect time to add more white to the colours I have already mixed. I then gently paint in the highlights and blend again with a soft brush into the paint already on the figure. At this point we are truly painting and the figure starts to step out of the canvas.

Here I also work outside the figure on the edges, painting into the background to further pop the figure forward. The lighting I used when photographing my reference models was pre-planned to make the painting dimensional. I used a one-point light source, as used in the theatre and throughout art history, to carve out a human form recognizable even at a distance. This is called chiaroscuro.

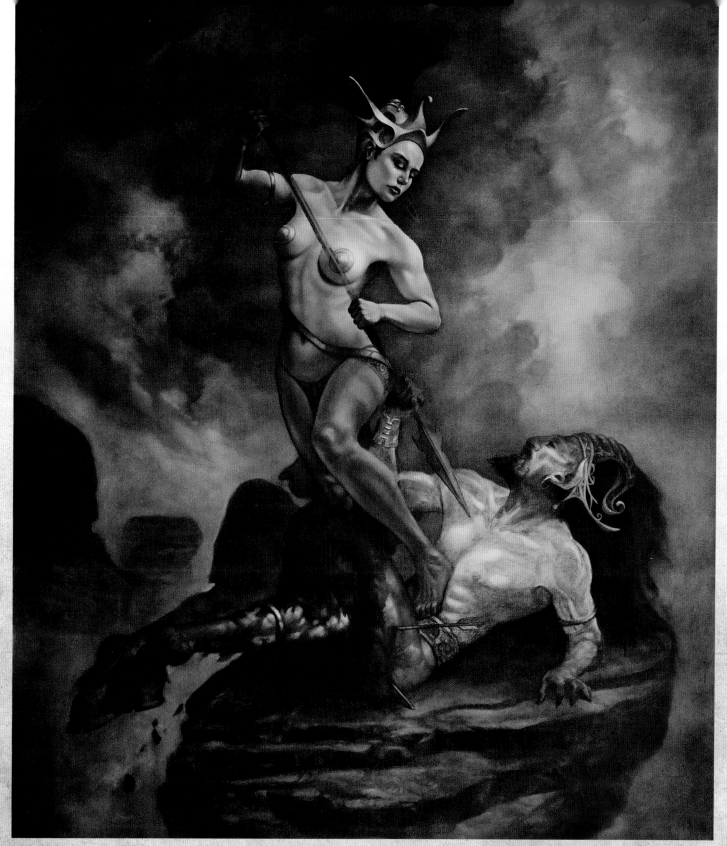

It's crucial to step back from your art at various stages – to gauge if you are going in the right direction. Sometimes it's possible to make the art worse if you don't take time to revaluate. A good tip is to look at it in a mirror. This old trick will show up any mistakes you might have made. With Artemis almost complete I work in more of the background around her. Holding up your hands like a film director will block out the less completed areas and give you a confidence boost by showing the painting partially finished – which will spur you on. At this point you will find a new speed takes hold, as you will be deep in the creative zone, looking forward to the next day's painting rather than dreading it.

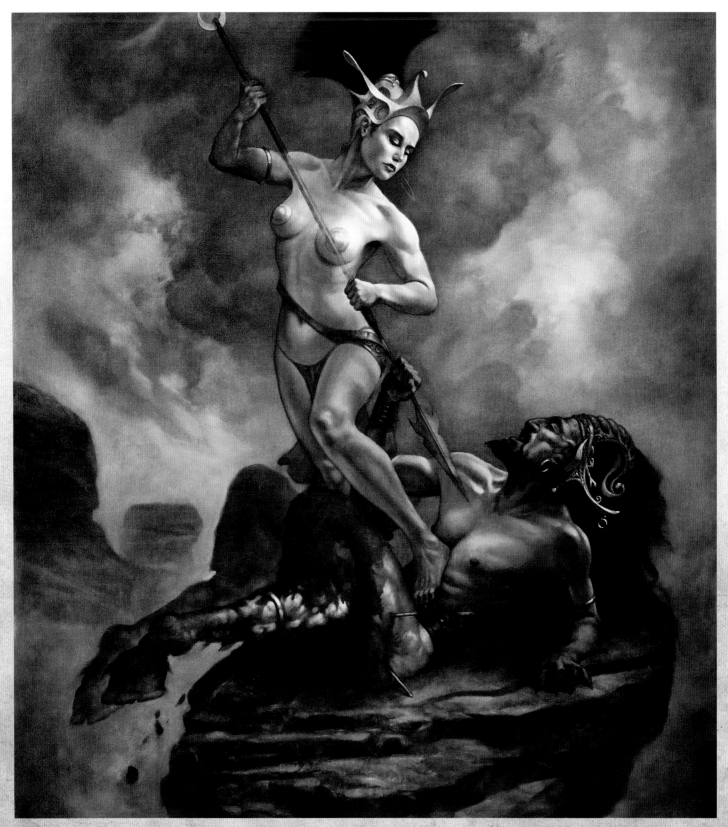

With one figure under my belt the next one goes in twice as smooth as I now have a complete figure to study and compare for strength of shadow and highlight. Until now there was a lot of search and find. But with most problems already worked out I can use the same methods for the Satyr. At this stage I also paint the rock around him as I work on painting his flesh.

❦ With everything painted I move in for the final layer of paint. It might seem like a daunting task to start painting on top of work that is already finished to the eye of the viewer, but it can make the difference between an average piece of art and a sensational finish when the colour glazing goes in.

To make a glaze, mix up some medium – your choice of white spirit or turpentine plus linseed oil at 50/50. I choose turpentine. Now I tint the medium with a mix of green and sepia, then glaze the figure with a large brush.

❦ Glazing is the fastest stage as the colour is transparent for the most part and so all the work you have done still shows through. This is what gives oil painting the kind of depth that simply cannot be reproduced in print or on screen. The reason being that light bounces back through the layers, creating a luminescence that can only be appreciated by seeing the original oils. I add thin blue variants for the thinner flesh and red variants for the nose, cheeks, and ears.

❧ I glaze the helmet and add detail, then tackle the spear. I've left the spear until last; I needed the body finalized first as I only want to do this once. Using a raised, straight-edged stick, I run a loaded paintbrush along the edge for support and very carefully work the straight lines. This is probably the trickiest part of the painting as you need a very steady hand. The best brush for this is a long-haired brush known as a "rigger", as it will hold a lot of paint for a long, uninterrupted stroke.

❧ After a few hours of work the glaze will begin to dry, and this is the perfect time to add some highlights to the flesh. With a dry brush the edges will blend perfectly into the glazed colours without leaving brush strokes. Remember to have a rag handy to wipe the dry brush on, as it will pick up a little paint during each blending stroke, which you don't want to lay back down again. So the method is: dry brush blend, wipe on rag, dry brush blend, etc.

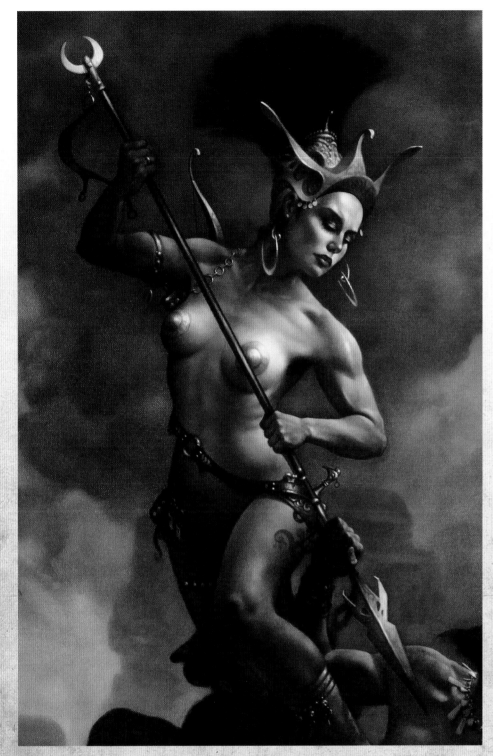

❧ As before, with one figure glazed the next goes in twice as smooth. Note that, when it comes to hair, it's best not to try and paint every strand as the hair will end up looking greasy (unless that is the intention). Also note the hair will tend to show more colour at the edges, where light passes through.

❧ Most of my ornamentation is created without reference. Just imagine where, say, the necklace would fall by judging how gravity would pull each link of it over the bones and muscles. If the "imagine gravity" method proves too difficult then reshoot wearing a necklace, or plan all costume and jewellery needed at the original photoshoot stage. I spent years studying gold and jewellery until I no longer had any reference in front of me. Painting without reference is one of the most freeing experiences in painting, but you will have to study hard to earn this freedom.

❧ Only now do I concern myself with detail and add the bow, which adds a nice diagonal to complement the downward thrust of the spear. The links of the chain were painted with very thin paint and a fine sable brush. Special attention is given to touching up the face and helmet, as this is the most critical part of any painting containing a figure. Everyone, artist or not, will linger on the face, especially a woman's face, so it better be good. I take the time to dab and blend some subtle flesh tones and the highest highlights. Once this is done I continue to add detail throughout the figure.

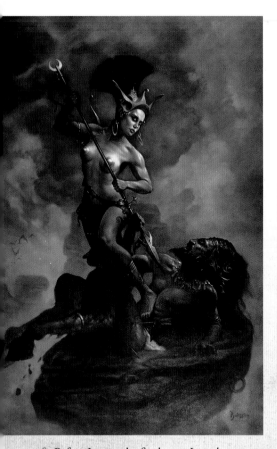

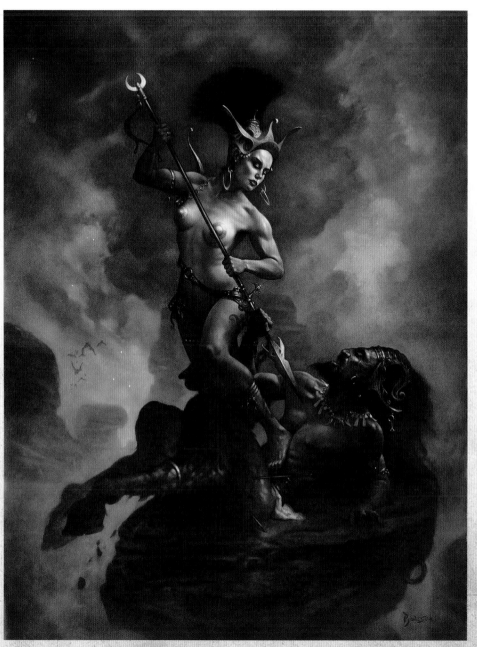

🌙 Before I go to the final stage I need to know that I'm not leaning on colour to give me value. I photograph the art and print out a black and white version of this stage to study before adding more colour. The reason for this is that weak values – the darks and lights running from black through grey to white – can sometimes be compensated for by rich colour glazes.

A viewer may not know why they prefer another painting with less colour but with the same drama. Most likely they are drawn to the better painting due to the secret strength gained by the true value. As a young artist I remember seeing book jacket art printed in black and white catalogues and wondering why the art, so impressive in colour, was so flat in grayscale. The reason was the values were weak.

🌙 After a day's break I oil out the entire painting and glaze in colour. First off, I add an overall glaze of golden greens to add more lushness to the art, plus some dull blues to the Satyr's flesh and the heroine's helmet and skin. I also decide to add more sheen to Artemis's muscles. Even if your figure is anatomically correct with regard to your reference, you should still do what you can to improve it, even if it means veering away from reality. Remember, you will eventually throw away all reference, leaving the final art to stand alone. The reference is there only to serve – it is not the boss of your art.

I decide to place a weighted bangle on Artemis's right arm, as the arm not only looked plain but also a bit stiff. I also boldly add a cloak to balance the figure and give her more flow, and glaze more colours into the background. It's good to add some colour from the background into the flesh tones, as flesh will reflect the environment. The human body is more reflective than you would think, especially when sweat is involved. To depict sweating there is no need to create big blobs of comic book droplets. A flushed face and reflective skin will do the trick.

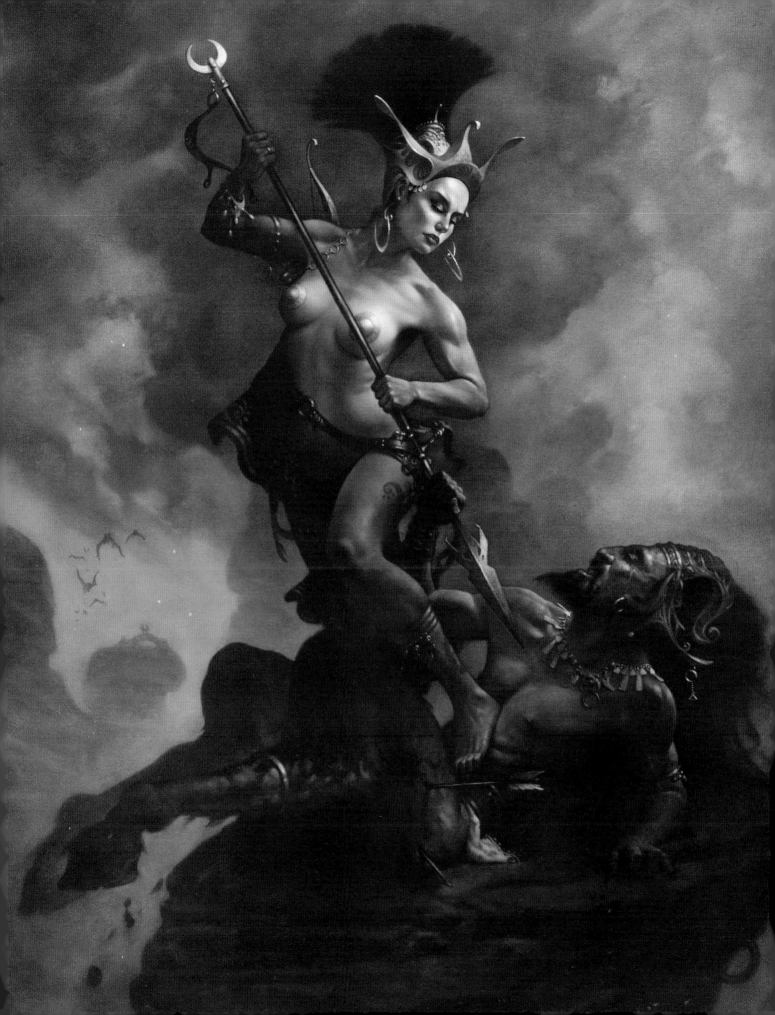

THE SACRIFICE

THE SECRET OF UNDERSTANDING LIGHT

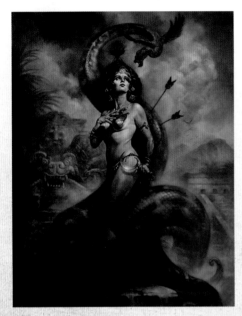

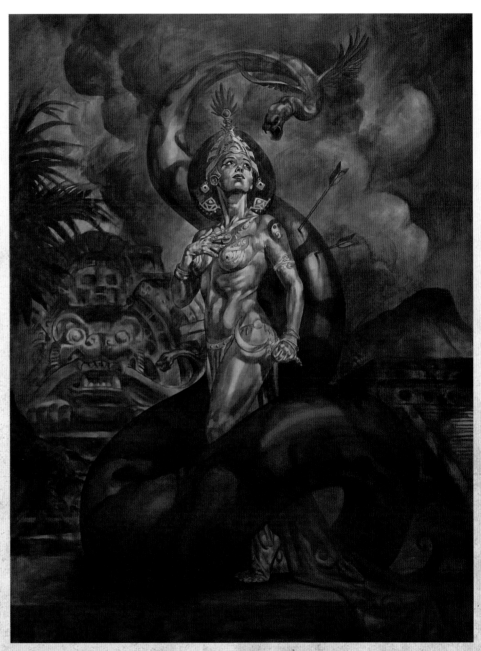

I mentioned earlier, creating a large canvas for exhibition and possible sale is a high-risk venture, as selling large paintings is hard. The first obvious reason is that they are priced higher and fewer people have that kind of money to spend. Another reason is that not everyone has the space available to hang a large painting. So why take the risk? For me, the main reason is to make an impression.

When the annual Archibald Prize for portraiture is held in Sydney, Australia, my running joke is to predict the winner by calling out: "Which one is the biggest?" People automatically head towards a large painting before moving to smaller works. Large doesn't mean best of course, but when it's large and good it is a great magnet. It also requires a great deal of confidence as there is no hiding bad workmanship at this scale.

My previous painting, *Artemis and the Satyr*, made the right impression when exhibited at my second IlluXCon, in 2010, and although it didn't sell it did lead to a commission of the same scale. Here, at 36" x 48", is the

underpainting for *The Sacrifice*. This size would be no big deal to an abstract painter splashing paint around, but most Fantasy artists paint at around 18" x 25" because of the fine detail and finesse required for this kind of art. For me, painting large has its downside in that my output is not as prolific due to the time spent on large works, but the sense of satisfaction and pride when a large work is completed makes it worthwhile. The buyer for this approached me as I was packing up in the final minutes of the exhibition.

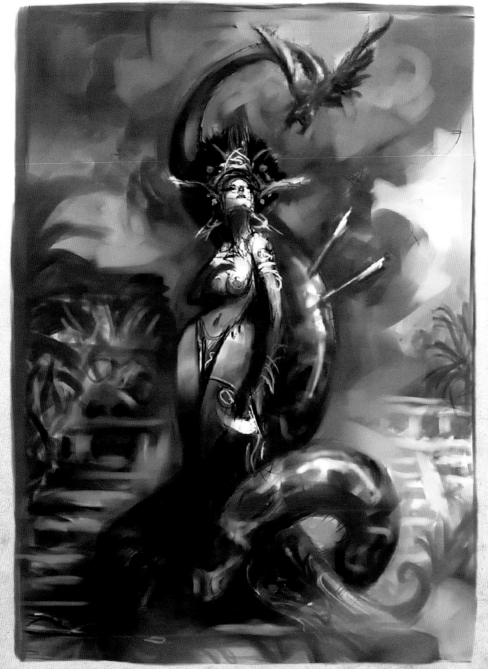

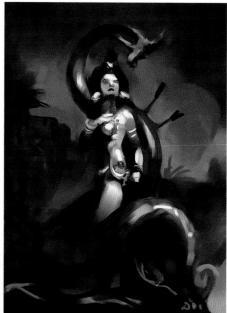

Here is the colour study. These little studies are often referred to as thumbnail sketches. I usually do them A4 size or smaller. The great American Fantasy artist Roy Krenkel (1918–1983) would take the term literally, painting his book jacket thumbnail sketches at postage stamp size.

Perfect anatomy is not a major concern at this stage, and I use no reference, only imagination. Solidity and mood are what's important here; I should be able to squint my eyes and foresee the impact of the final painting. If you can afford a good skeleton and an anatomical model for the major painting stages to come, they are a worthwhile investment. At the time of writing the best anatomical models I've seen (and own) can be found at: www.thegnomonworkshop.com

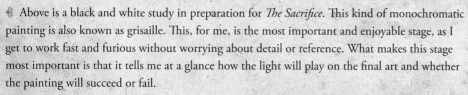

Above is a black and white study in preparation for *The Sacrifice*. This kind of monochromatic painting is also known as grisaille. This, for me, is the most important and enjoyable stage, as I get to work fast and furious without worrying about detail or reference. What makes this stage most important is that it tells me at a glance how the light will play on the final art and whether the painting will succeed or fail.

Once again, the fact that a lot of artists skip this stage is astounding to me, as it takes so little time compared to the many hours they'll spend trying to work this out on a large scale as they paint. Remember: if you make a mistake at the first stage it will be compounded in the next stage, and so on. This is why these preliminary stages – the sketching, anatomy study, the value and colour studies – are known as "The Foundation", without a solid foundation the art will fail just like a house built on a swampy slope.

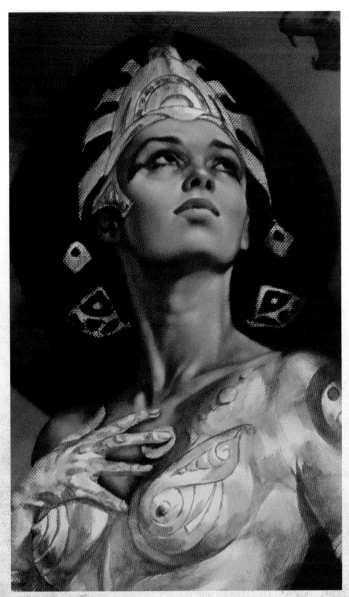

This is a great stage to study for the difference between the underpainting and the covering of more opaque paint on top. The paint on top is not much thicker than the paint below – it simply contains more white and raw sienna in the mix. Burnt umber doesn't cover so well, but it's great at adding richness to shadows. The only time I add thick paint is for texturing, as thick paint isn't fluid enough to blend using this kind of smooth skin technique.

The 20th century's art masters, such as Lucian Freud (1922–2011), painted flesh with thick paint, and it's a marvel to study, but that was his style. Freud's kind of brushwork is rarely seen in Fantasy art because fans like to get involved in the scene, rather than be distracted by the technique used. This is not to say your work should look photographic – you should always be improving on your reference via colour and more fluid line and composition, then adding a bit of bravura brushwork in the background and the outer edges.

One stage further and you can see the very subtle changes that I'm talking about. The expression on the female figure's face has been intensified slightly, adding a further depth of emotion. Look at the eyebrows and compare them to the previous stage. It's hardly noticeable, but keep going along that path and you will break the shackles akin to the uninspired slaves of photo-rendering. I have also lightened just outside her right arm, to bring the figure closer, and made every effort to get the right combination of soft form versus hard edge.

Note the hard shadow under her left breast, as opposed to the soft form shadow of the shoulder muscles and ribs. A common flaw with artists who have skipped the basics of light and shadow will be that their work looks "fuzzy" – simply because they hide their indecision in soft shadow. Hard shadow will drop from protruding objects (drop shadow); soft shadow will turn on soft forms (form shadow). Remember that simple formula and your work will have weight and dimension.

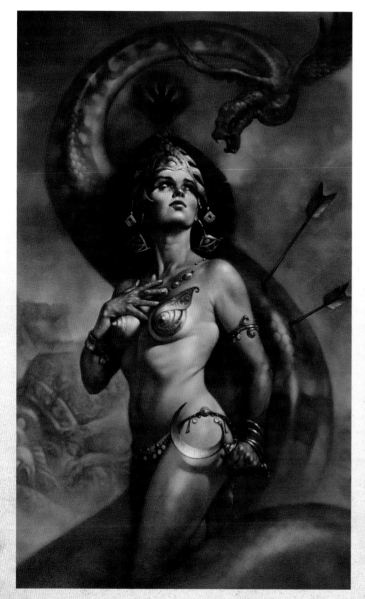

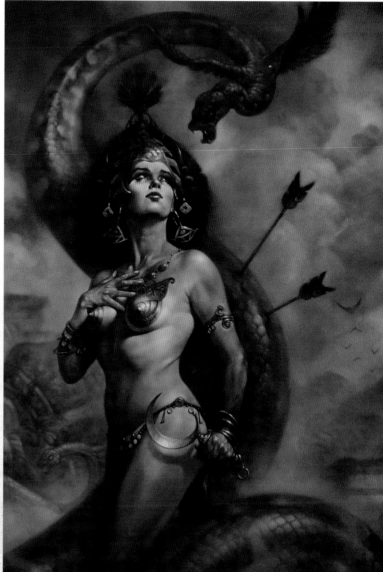

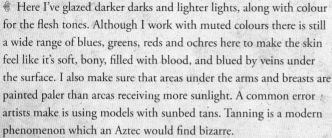 Here I've glazed darker darks and lighter lights, along with colour for the flesh tones. Although I work with muted colours there is still a wide range of blues, greens, reds and ochres here to make the skin feel like it's soft, bony, filled with blood, and blued by veins under the surface. I also make sure that areas under the arms and breasts are painted paler than areas receiving more sunlight. A common error artists make is using models with sunbed tans. Tanning is a modern phenomenon which an Aztec would find bizarre.

To make your art come alive you need to understand the subject you are painting – how they live and work, how their environment affects them, whether they are fictional or real... Method actors call this "The Truth" and you should strive for that same truth if you want your art to last. Take a look at some Fantasy art from the 1980s, in which Amazon women sport perms and gaudy makeup, to get what I mean.

A new day and another round of glazing. With a glaze of oil medium applied to the surface and spread out with a soft brush, I work on top while it's still wet, adding more blues in the pale areas, blending them into the white areas I laid down in the last stage. Some students misunderstand rules such as: "You should never use white straight from the tube." I know this because I was once in fear of white too.

What this particular rule really means is, "Don't just leave it there to dry as pure white." You can see how bleached-out Artemis would look if I left her with the dazzling white flesh of the previous stage. When mixing colour there is no need to mix all your paint on the palette; sometimes it's hard to judge colours until they are applied. Here I mix the colours as I blend, picking some colour from one area and applying it to another for even more colour variations, all the time taming the white as I go.

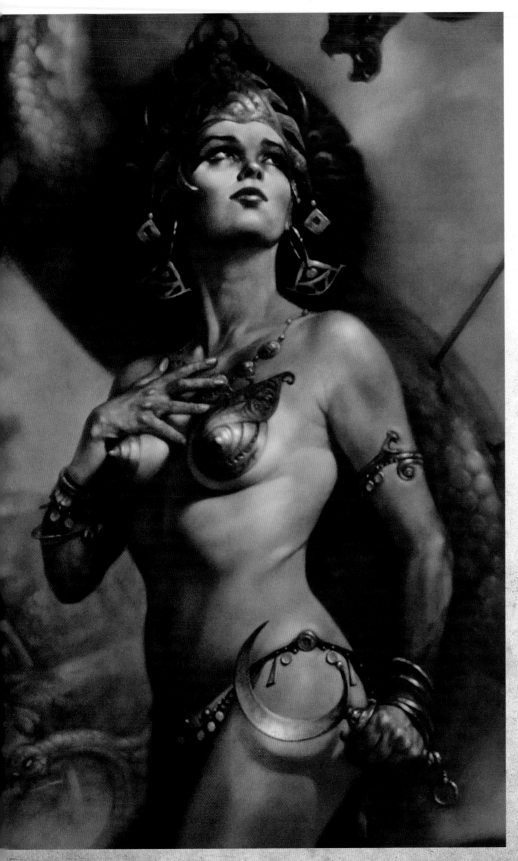

Now we are composing not only with form but also with light – to draw the eye to what's most important...the face! Great artists through the centuries have used light to compose pictures and create magic. Walt Disney called it the "Pool of Light". The Old Masters such as Rembrandt (1606–1669) and Caravaggio (1571–1610), who pioneered the method, knew it as chiaroscuro. The eye follows light, contrast and detail, which is a good reason to keep non-essential detail to a minimum. Over- detailed artwork is tiring on the eye and can look amateurish. Some artists try to impress with dazzling detail, filling every square inch of canvas in an attempt to hide their lack of foundation skills. Don't be one of them.

It is interesting to note here that Caravaggio's violent behaviour – he once killed a man in a brawl – was recently attributed to lead poisoning caused by handling lead-heavy, flake white oil colour. Lead is rarely found in paints today, apart from traffic markings, although I can remember true flake white, warning intact, being sold in art stores a mere decade ago, so beware.

On a large painting I'll use a mahlstick to keep my arm from dragging across the wet paint, and to keep my hand steady when painting fine detail. A mahlstick is simply a stick with a cotton rag bunched into a ball and tied to the end. You hold the stick end in one hand with the ball end resting outside the painting, then use the raised stick to balance your arm on. Professional sticks can be bought from art stores, and sometimes have a leather pouch attached, but I have always made my own. An old cane, or a stick with a hook, make handy mahlsticks that you can hang from your drawing board. Another good idea is to use the swivel braced clamp from a discarded swivel lamp to fashion a semi-permanent mahlstick to the top of your easel or drawing board; this requires no ball end.

Here is the finished art – proving that solid foundation skills and an understanding of light are powerful allies in the war against flat art.

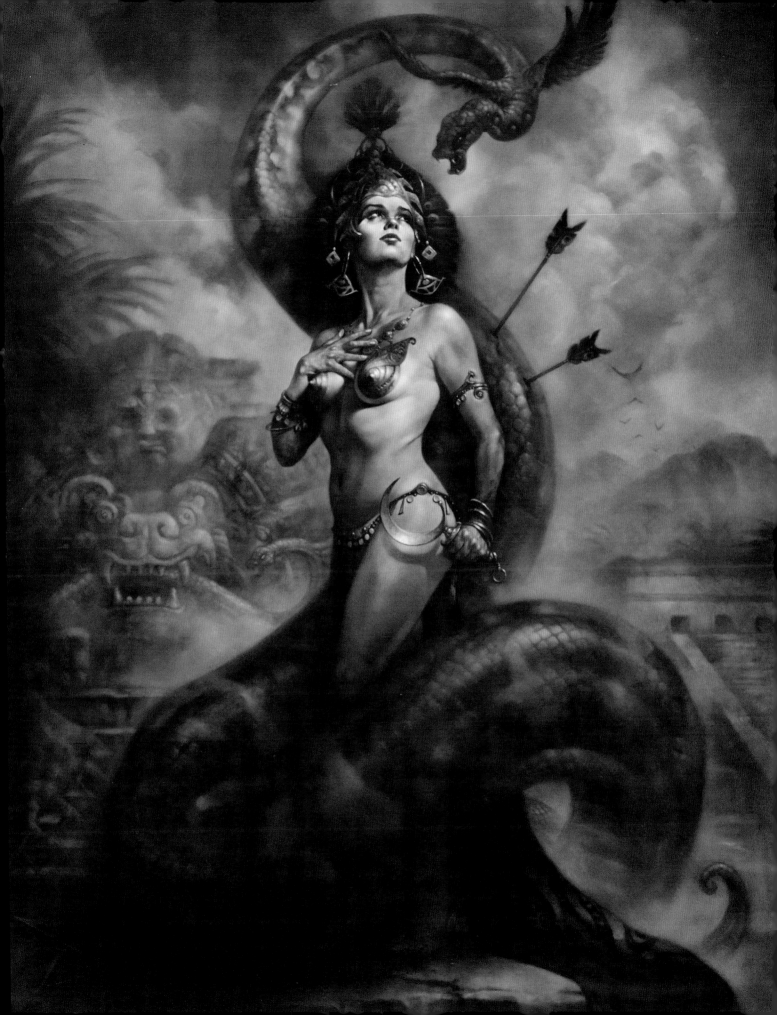

ADVANCEMENT

"He who loves practice without theory is like the sailor who boards ship without a rudder and compass and never knows where he may cast."

Leonardo da Vinci (1452–1519)

Dawn of the Dead,
36" x 24", oil on canvas

THE FORBIDDEN KINGDOM

THE FRUITS OF SELF-PROMOTION

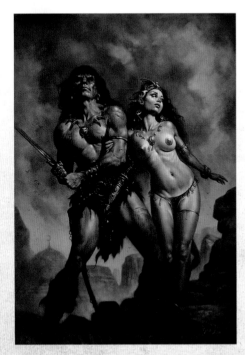

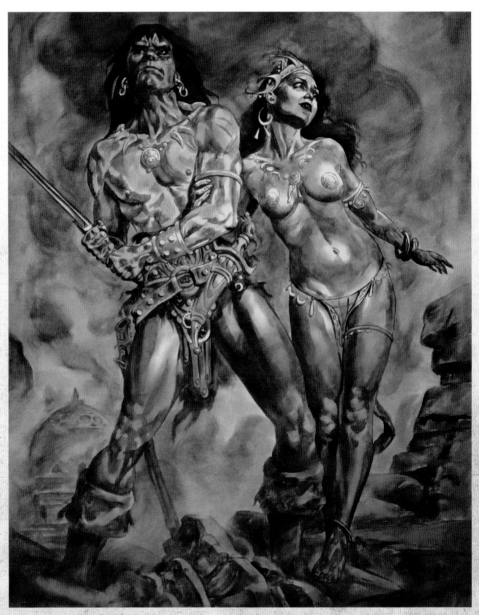

🎐 This 36" x 24" canvas art was commissioned by Canadian brothers and publishers Neil and Leigh Mechem, who share a lifelong love of Conan. They had seen *Artemis and the Satyr* at IlluXCon 2010 and wanted the same colour scheme and mood, proving once again the power of self-promotion.

So now the uncommissioned *Artemis and the Satyr* had convinced two more collectors to trust me with commissions for larger than usual oil paintings; in fact the boys told me they would have bought *Artemis* but didn't have the space for it. Painting Conan was an end to a path I'd been walking down since I was ~~fifteen~~ thirteen old.

🎐 The crucial key to strike here is in making Conan recognizable to fans of the books. There's no doubt now, though, that the world considers Frank Frazetta's painted version, rather that writer Robert. E. Howard's description, to be the definitive Conan. I also see John Buscema's Conan as a great source of inspiration. This step by step will be the model exercise in how an understanding of anatomy is essential when using photo-reference.

I will be standing in as the model for Conan. I find that bodybuilders tend to look too unnatural as models and prefer to see a figure hewn from a hard life rather that a gym. For that I will have to add muscle to my own puny body until it fits the Conan ideal.

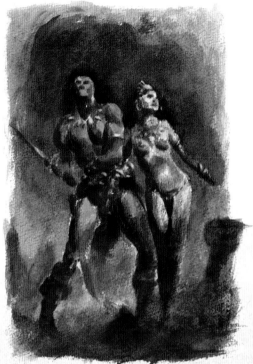

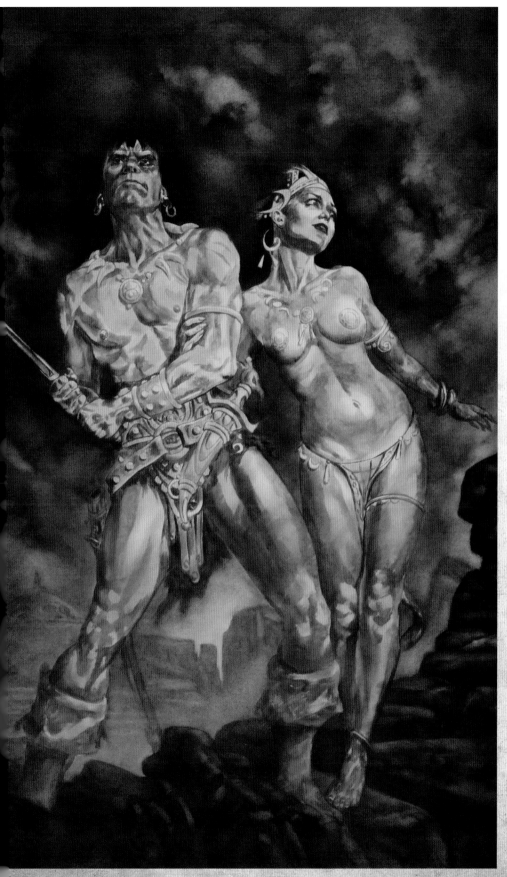

❧ At the point I made this painting I got rid of my drafting board and replaced it with the biggest easel I could buy. The benefits of an easel over a drafting board is that it can hold large canvases and can be elevated up and down to reach the best position for painting.

Above right is an A4 colour rough, done on watercolour paper. It's the perfect size for taping beside my easel for reference – in order to do this I've bought a large sheet of MDF board from the local hardware store and placed my canvas against it on the easel, leaving the board sticking out each end. You can see this set up in the chapter An Artist's Studio.

I start on the background with the biggest brushes I own, sometimes even using a 5-inch household brush to begin with. Once I've blocked in the various cloud shapes I use a dry rag to wipe away areas, or to softly blend with. Other times I'll use the rag itself as a painting tool, using the oil I've wiped from one area to transfer the paint to another area. Since the colours are similar in hue and value this is a great way of painting in a natural, organic way.

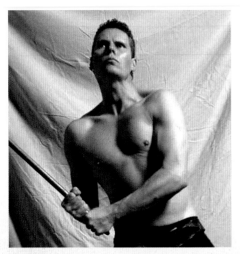

Here's a shot from the posing session I did. A pretty tricky process in which I worked off the reverse drawing and used a two-second remote to take the picture and match the pose. I usually take about 50 shots to get the perfect one. This ends up as a Pilates workout as it's much harder to strike intense poses like this than you would think. I open all the shots in Adobe Bridge and choose the best until I've culled it to around five. Sometimes I'll use elements of all five and piece them together in Photoshop to get the best reference. Note below the change in anatomy, bulk-wise.

Time to block in one of the most iconic characters in fantasy history. I surround myself with Conan reference and work on the task of turning myself into the ideal of Conan. I enjoyed painting the scar on his cheek. It is very tricky to paint a brawny character with a scar who is also the hero, and make him look like someone we trust. The fact that the girl is clinging to him for dear life makes this work. Note that I have also changed Conan's eye focus to give him a more purposeful look, rather than the introspective expression I have in the reference photograph.

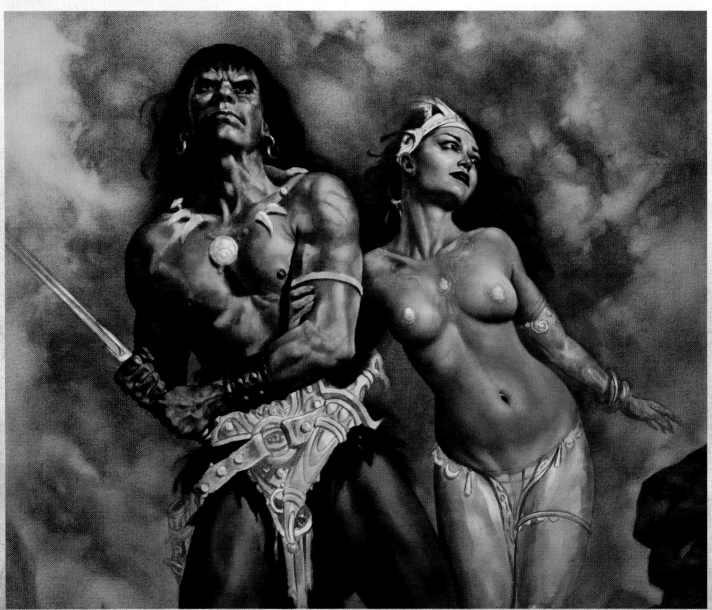

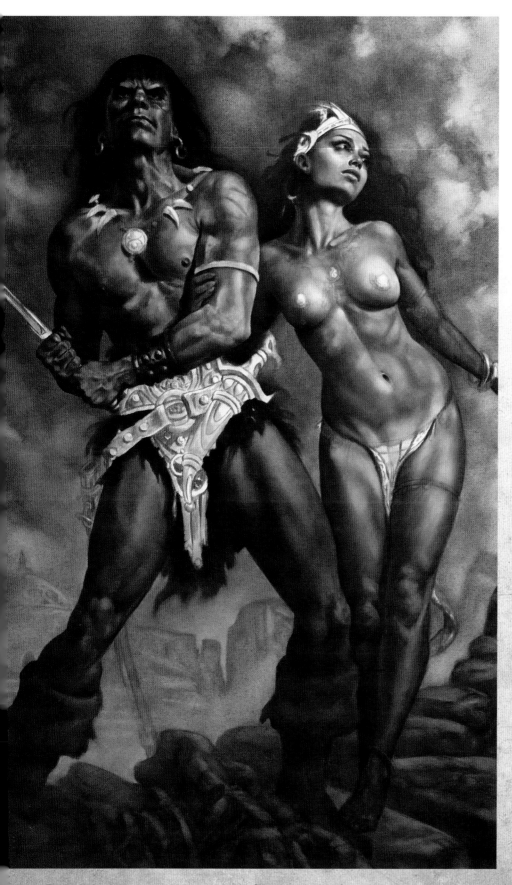

Here I've blocked in the figures with a second layer of paint, establishing them in a rough fashion rather than trying to blend them to perfection in one hit. The reason I do this is to work the painting as a whole. It's very easy to lose sight of the overall image if you slave away in parts at the beginning.

This way I can step away from the art and see what needs fixing here and there without it being a big deal to slap some more paint on to correct errors. For example, I felt the girl's lips looked a little "mean" in the underpainting and so I have plumped them up here to much more attractive effect.

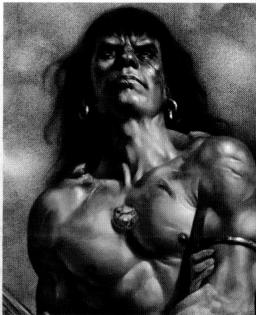

With everything blocked in I can now work in stages. I plan for the head and torso in one sitting – stopping at natural bridges such as the arm ring. This is an interesting stage to study as it shows blended paint on top of the blocked in stage. This may seem like a lot of work, basically painting the figure twice, but it moves fast as I'm laying the semi-opaque colours on top of established groundwork, making improvements as I go with a lot of confidence as I'm already familiar with how the anatomy sits from the first pass. Notice how much more solid and fleshy the figure looks compared to the blocked in forearm still awaiting its fresh layer of blended paint. To my mind, it's well worth the effort.

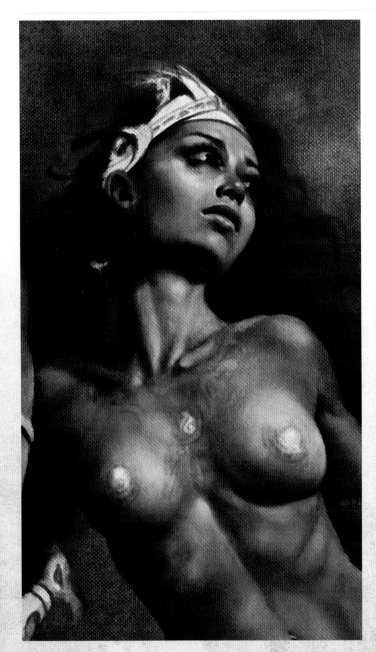

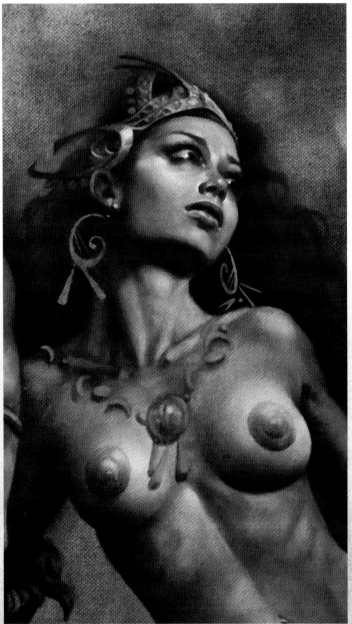

❦ This is another good stage to study. Compare these two close-ups to appreciate how delicately the face should be treated. As always, remind yourself, as I do, that this is the main area the painting will succeed or fail on. This stage of the face shows the block in compared to the third pass opposite, where I have added more opaque paint after this stage has dried, which is usually overnight. I could call the painting finished at the stage on the opposite page by leaving out the glazing, but that wouldn't be my style.

One of my favourite artists, Jeff Jones (1944–2011), would leave many paintings at this block in stage to meet the deadlines he took on for publishing houses in the 1970s, but I like my paintings as lush as I can possibly make them. Private commissions usually pay more than publishing commissions, which leaves me more time to indulge.

❦ Lots of sable brushwork was used on the headdress and eyes here, and lots of blending with a soft, dry brush. As a side note while we're discussing blending, as already noted it's important to keep blending brushes clean as oil paint attracts hair and dust like a magnet, so a studio with wooden floors is better than a carpeted studio. Wearing woollen clothes is also a very bad idea, and make sure you keep your pets out of the studio!

I want to keep the girl's skin pale – which is a hell of a lot harder to paint than a tan – to create a more interesting contrast with Conan's tanned torso. Normally, being right handed, I would work on finishing the left figure first, but the girl's face is so much more delicate to paint that I need to tackle it in some finished degree so I can relax.

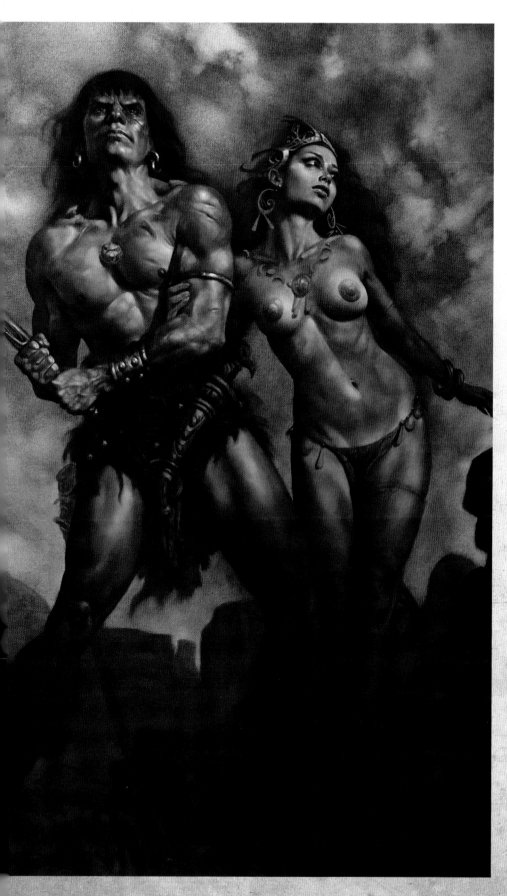

❧ Here is Conan fully painted and blended. Now I can work the values of the rest of the artwork around him. The background looks pretty sketchy now in comparison, but just like the last stage I can work on this without using the wild brushwork needed to establish it in the first place. Painting is more than just laying down paint: you need to plan steps ahead so you don't paint aimlessly and hope for the best. Painting with the unplanned method leads to most paintings being abandoned as failures (unless it's abstract art). With my solid method in place the girl is something to really look forward to painting. With Conan done the painting is less of a mystery and I can now reference him for value control.

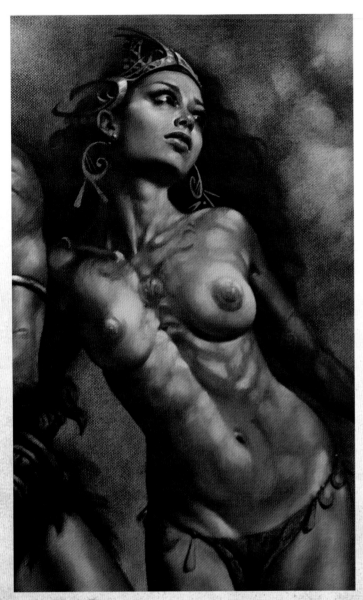

✤ With Conan's weight and tone established, and the girl's face having the right amount of blending to make her soft yet dimensional, I can now match the body to the face with much more ease. The danger of using tools like the airbrush for a face is in the loss of dimension and depth due to oversoftening, so avoid the temptation as over-blending in oils can bring about a similar effect.

Even after decades of study, and with my multiple photo-references pinned up, I still turn to my anatomy books and anatomy figures to make sure the anatomy is correct. I am working from two different photos of a figure, so I could easily make a Frankenstein monster if I'm not careful. I paint in more anatomy than I need to so that I can soften the flesh yet show bone and muscle where I choose.

✤ Although the paint was laid down over a leisurely, hour-long period it's still wet and easily blended with a soft, dry brush. This is where I discern what to blend back most; it's also the time to be wary that I'm not blending everything to the same degree.

Some artists get into bad habits after having their ego stroked with the admiring words, "it looks like a photo". This kind of admiration is what made Norman Rockwell so miserable during his later years. Due to the public's admiration for his realistic art he was no longer "allowed" by publishers to return to the style of his greatest period, when his work was less "photo-realistic". He produced a series of energetic portrait studies for the 1966 remake of the movie *Stagecoach* and begged the film company to publish them at their rough stage, but they insisted he "finish" them. The difference between his brilliant studies and the dull rendered art they insisted he proceed with was tragic. Norman was a victim of his own success. Art shouldn't look like a photo. Reference photos are mostly dull because they have no artist's voice.

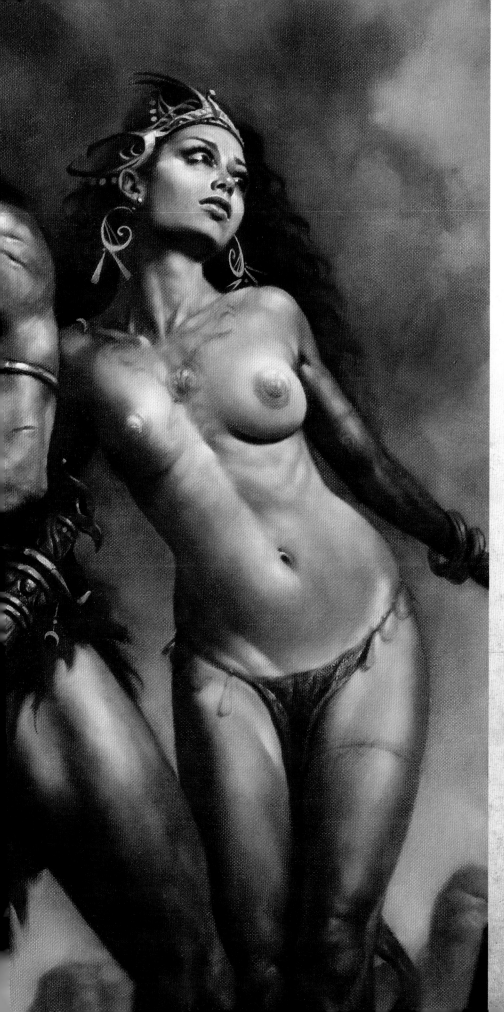

With the paint still wet, but starting to dry, I add more white to the colours on my palette and paint on top of the blended art once more. I don't add more linseed oil to this mix as it would be too gluey and would move the paint around too much, or worse, pick up what's underneath. With a soft, dry brush I blend again, wiping the brush on a dry rag every few strokes as I go, this time getting the right degree of softness and paleness in the flesh. Make sure your rag is lint free or you'll be adding cloth particles to your art. Old cotton T-shirts, cut into pieces, are good.

A word of warning though, rags should be thrown out after each painting or they can be a combustible fire hazard due to the soaked-in solvent. Some artists keep a steel bin to throw their rags into for fire safety; others even half-fill their bins with water to be certain. If you work in a wooden home you need to be twice as diligent when disposing of your rags.

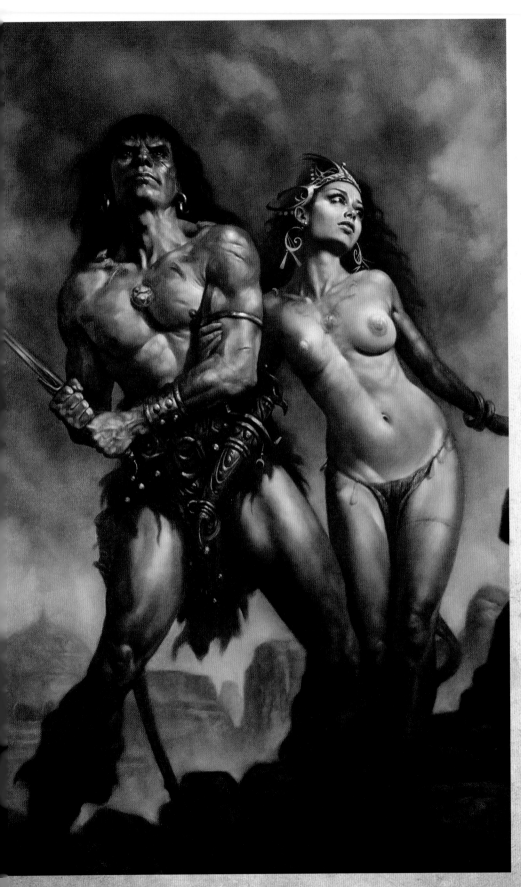

With all the blending on the figures done I return to the background to tie it all together, blending the clouds into the softness of the hair and adding more colour. Once again I could call this finished and go straight to the details and be done with it, with no one aware that it could have been better. No one but me, that is. This is the time to sit back and imagine it all with more intense colour, to recompose with light and shadow and draw the eye more intensely to the faces. Making more of the shadow across the legs not only adds atmosphere but draws the viewer's eye back into the picture instead of wandering away, maybe towards a possible competitor's gallery work.

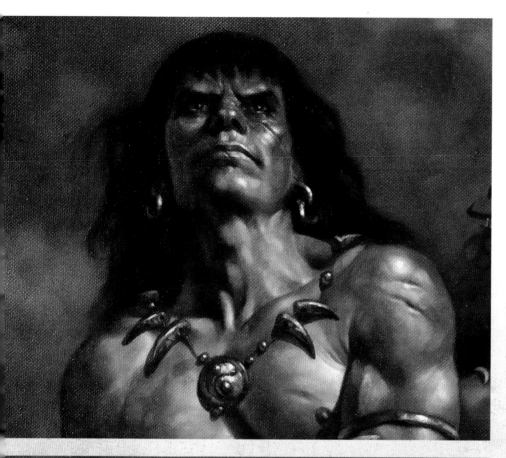

All the way through the painting I've constantly tinkered with the faces, and it's critical that I get Conan right as he is such a cultural icon. Obviously I don't have Conan as a model and I'm working off the reference photo of myself from before. What I do have is a legacy of great art from Frank Frazetta, Boris Vallejo, and John Buscema to draw inspiration from. But I must make Conan my own – to add my vision of the heroic into the ongoing art catalogue, and make it worthy of standing next to the giants of illustration. And so I tinker more, back and forth, while also detailing the necklace.

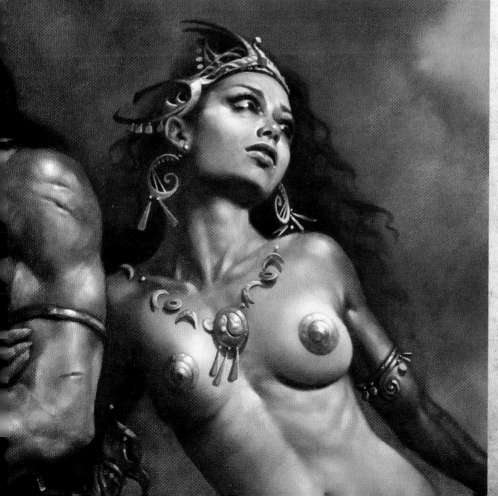

Although I'm working on the body jewellery I always have one eye on the girl's face, adding touches that probably no one will notice, but which I think add immeasurably to the romance of the piece. It would take a keen eye to see that I have altered the position of the eyebrow a touch, adding a hint of sorrow to the expression and therefore telling a deeper story. I've also added more flow to the hair and changed the simple coin shapes on the headdress to make them more kettle-shaped. Tiny details like that bring a lot of pleasure to the wandering eye.

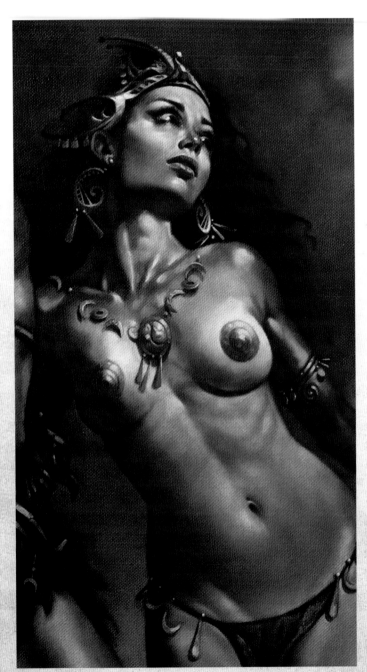

❦ Note the cool greys around the eyes, where the skin is thinner, and pink tones on the cheeks and nose, adding to the sense that she is flushed from the chase by her unseen pursuers. Also in the mix are shades of green reflecting the environment. The skin has many colours and to simply paint in "flesh tones", as in browns and yellows, is a tragic rookie mistake. As a general rule an imaginary band across the face from ear to ear usually contains the warmest colours: cheeks, nose, ears. Once again I take a soft, dry brush and blend the colours together.

❦ Now for the finale: the colour glazing. Normally I would start on the left-hand figure, but in this case there is much more to do on the girl. It takes a sturdy set of nerves to paint on top of work already finely blended, but with the paint underneath fully dry after two days I mix up very transparent colours and before I lay them down I do some oiling out by brushing and spreading a thin layer of 50/50 turpentine/linseed oil over the figure. Now the colours float on top of the oiled-out surface, giving me many hours to add more colour and highlight without worry, as I can simply wipe them off if need be. You can also oil-out a surface by rubbing a rag soaked in the glaze medium, rather than use a brush. I put the colours down very quickly as by this point I know/own the painting. I am, at this stage, a very confident boss.

❦ I have a mix that is workable all day and so I move on to Conan and apply the same techniques while she is drying. I come back hours later when the paint is tacky on her and add touches of the paint I mixed earlier, which is also drier on my palette. I then blend touches here and there where needed. It's important not to thin the pre-mixed palette paint further as it will "pull off" what you have laid down on the linseed oil surface. Very delicate strokes here. You will learn by touch how heavy to lean on the brushes as you become more experienced.

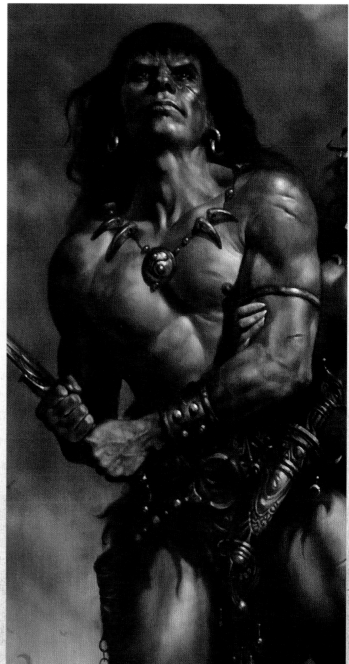

To the untrained eye there is not much difference between this detail and the one on the right, but if you look closely there is a world of difference in finish and subtle colours. Note here the skin is almost all shades of umber and yellow ochre, whereas the opposite panel shows a layer of transparent greens where veins run through the body, blues where hair is under the chin, pinks at the knuckles, etc. I also use the longer drying time of this stage to add ornamentation to the knife and abrasions to the chest. Conan has been through many scrapes and he should reflect that; this is another reason not to use bodybuilders straight from the gym, unless they are truly tough from worldly scrapes.

When the transparent colours are tacky I add more yellow and white to the paint already on my palette and paint/blend as I go for more buttery colours that cover. For the highlights I'll mix some blue and white. It's okay to use pure white on top of wet colours as it will blend and dull as you work, but a general big no-no is to place pure white on top of a dry painting, as pure white is rarely found in nature and therefore will look unnatural. As a test, open up a photo of any Old Master painting in Photoshop, sample the highest white, and then compare it to the white colour swatch in the tool box next to it. There is no pure white in my Conan painting, either – sample and see.

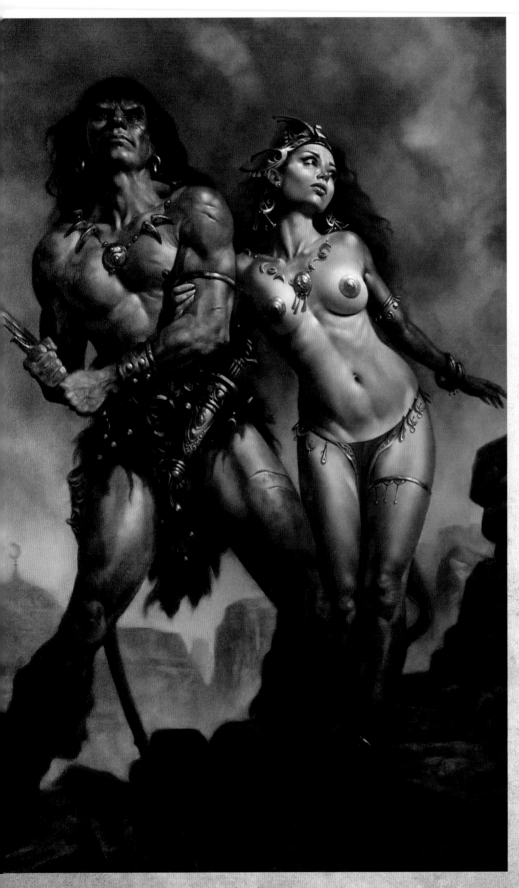

❦ Here is the entire artwork before the colour glazes were applied. See how the little details make a world of difference, as in the gold trim on the girl's toga. At this stage I'll turn the picture upside down and sideways to get a fresh eye and see it as the art director or collector will see it. I think the rocks are a bit too shaded and will fix these before glazing. Different views will help you find mistakes, or see where improvements can be made. Remember to use a mirror too, or to bring a photographed copy into Photoshop and flip it horizontally or vertically. Any mistakes will be immediately obvious. Opposite is the final glazed version.

❦ If there is time before an absolute final pass I'll first put the painting out of sight for a day or two then come back and see if there is anything I missed when I was working too close to the art to see it. At this point I will take a small brush and add little details here and there during the glazing, such as the refined scabbard and the jingly jangly stuff hanging at the girl's waist.

Also, I brushed some transparent Indian red over the girl's hair, to make it glow with light. I get requests for my flesh tone palette, but it changes according to the background, which should always reflect on the skin. For this painting I used the following: yellow ochre, raw sienna, Indian red, burnt sienna, burnt umber, sap green, olive green, cerulean blue and titanium white.

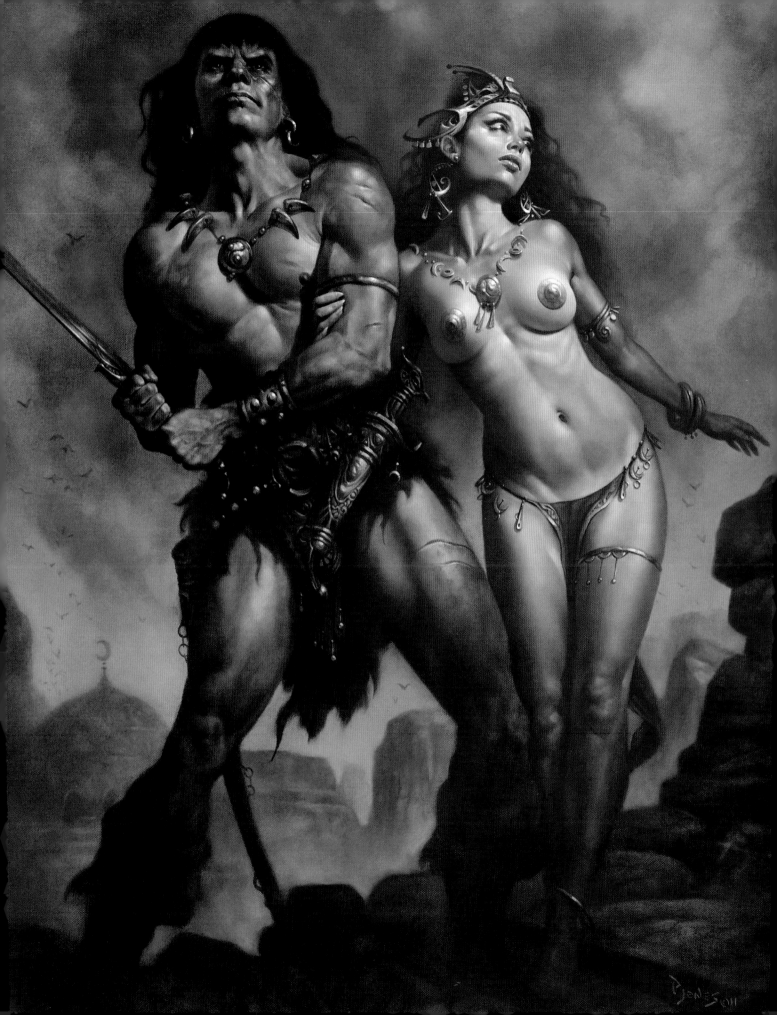

DAWN OF THE DEAD

COMMISSIONED WORK

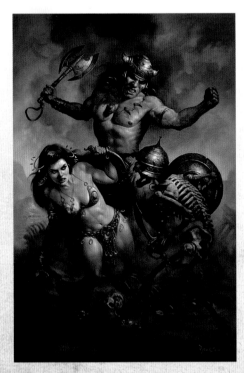

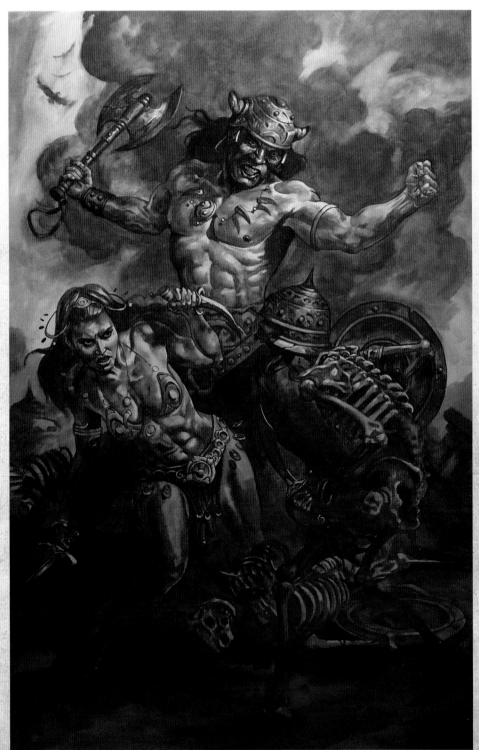

Dawn of the Dead was commissioned on the back of *The Forbidden Kingdom*, which was fortunate as I had another major oils booked in at the time – *The Sacrifice* – but it was delayed at the client's request, leaving me just enough time to paint this piece while I was still in the Conan moment. Perfect.

When working to commission it's important to give the painting the same passion you would your personal work – this is the key to a successful painting. After making notes from the brief it's time to sit down and cook that information into a decent stew. No matter how difficult the brief seems you will find a way to make magic if you dig deep. Commissions are tougher than personal work, as it's not your initial idea. But remember: it's a privilege to be commissioned as it proves another's faith in your professional talent. Consider it an artistic collaboration and hang on for the ride.

On *The Lost World*, I'd experimented with water-mixable oils as a safer alternative to breathing toxic fumes from turpentine and other solvents. They had proved frustrating due to their odd drying habits and stickiness during the blending stages, but were easy to clean and odourless. They also dry to an oil finish when the water evaporates. The underpainting stage uses the largest amount of paint and therefore creates the largest amount of fumes. I decide to use the water-based oils with the paints watered down to a wash, making them less sticky, and I get a headache-free, healthy start to the artwork. So, although experimenting with new materials can be a risk, it's rarely a waste of time. Acrylics can be substituted here but I like the flexibility of wiping back the oils with rags, and also the manipulation of oil paint, which is next to impossible with acrylics.

Again using the water-based oil wash method I create a colour rough on watercolour paper. To stretch watercolour paper simply soak it with a wet, wide brush then tape it to a piece of wood using parcel tape. Then dry it with a hairdryer. As the paper shrinks tight in the heat it will dry to a surface that will not buckle when you lay down thin washes of colour. When the art is dry simply slice it with a scalpel or sharp knife, using a steel rule edge for guidance. I used oil instead of watercolour for this stage – it gives a much more accurate idea of the final colour because it'll be the same tube colour I'll use on the canvas.

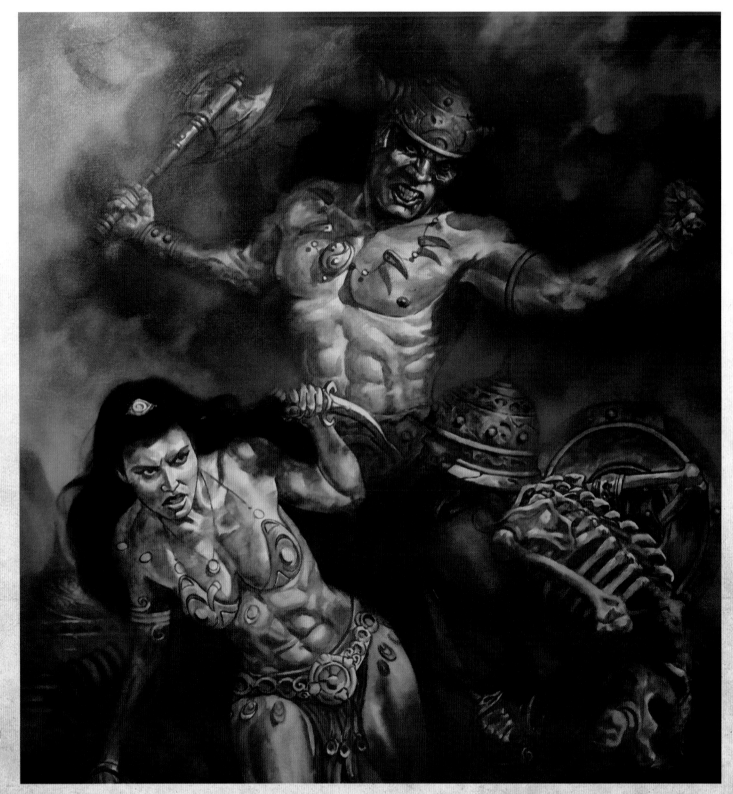

🜂 Now using traditional oils, I use my mix of 90 per cent odourless white spirit and 10 per cent linseed oil to thin my paints and paint the background. I use my paints fairly thinly, letting the ochres and yellows take care of the opaque covering of the underpainting. I will also mix a little white into the greens and blues to cover. Using big brushes I lay down all the colours I need for the background, and then blend them together with a large, soft fan brush. The paint will tack up after a few hours and I can then add more opaque colours on top and gently blend some more until all the underpainted background sky is covered.

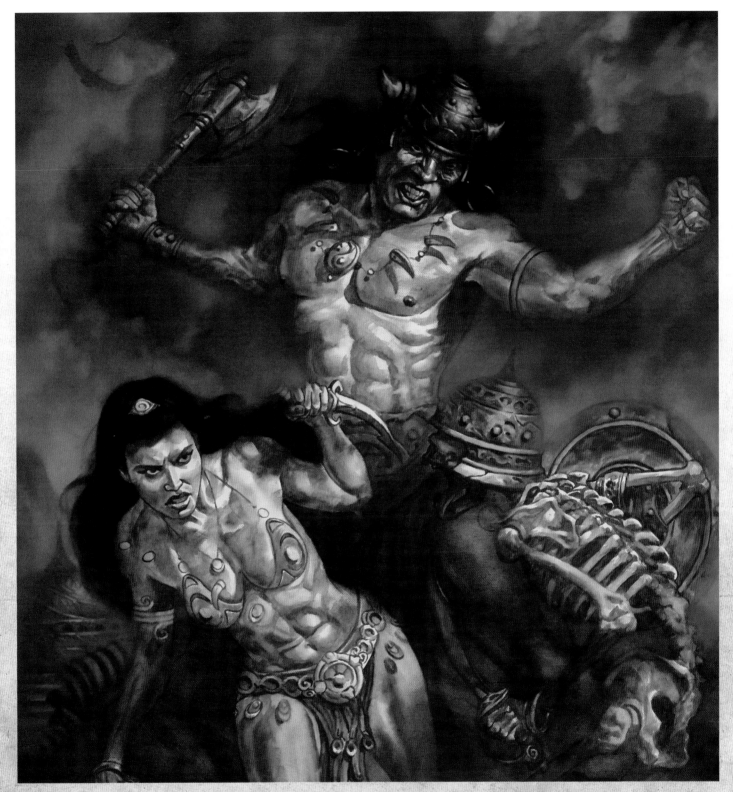

It's good to get the hair done at this stage, to bridge the gap between background and figure; this way I can judge the strengths of the tone of the figure to come. I paint the hair of both figures to save time, as I have the mix all ready to go. With mono colours of phthalo blue and umber brown mixed with various degrees of white (more blue for cooler metal, more brown for warmer metal) I block in the helmet. Now the painting is really cooking. I don't worry about extreme highlights yet as I will add them later, during the colour glazing stage.

Once again the focus is on getting Conan right. This is a trickier task than before, due to his savage expression in this painting. When anyone contorts their face they immediately look different. I not only studied Frank Frazetta's iconic version but also photos of legendary actor Jack Palance, as I'd heard Frank had modelled his Conan on Jack. Throw that into the mix with myself and the art buyer – both acting the part on camera – and we get my own unique, but still recognizable, world version of Conan. A difficult balancing act.

A fellow artist who works digitally asked how this stage was done using oils. He said it looked as if I'd used the "Multiply" layer in Photoshop. It was odd to hear my centuries-old technique being akin to digital media, yet strangely, it is similar as I'm glazing thin darks over a previous layer. The reason I start with darks first is that it is simply easier to paint this way. The hardest tones to judge are the midtones then the highlights, but once you have the darks in place the midtones are much easier to place on top.

With the dark glaze still wet I paint directly on top with lighter colours, mixing and blending the midtones on the canvas. It's important not to let any of the lightest colours mix into the darkest areas or all the colours will turn a muddy brown. While the midtones are drying I add some warmer colours to the helmet, as the steely grey was too monotone next to the fresh flesh tones. At this stage I'm blocking in with my usual 70/30 white spirit/ linseed oil mix to thin my paints.

Now with the midtones placed and the paint starting to seize up, it's very easy to judge the highlights and place them on top without them mixing in too much. I add some blue to the white to cool it and add to both the flesh and the helmet. With every component sharing similar colours the artwork has a harmonious feel to it. Everything looks like it belongs. I have seen lots of art where the artist has used a different colour palette for every object, obviously copying the colours they saw in all the disparate photo-reference they had used. I'm not saying all art should be monochromatic but that the colour of every object is affected by the colours around it. Not just metal but flesh and anything that is not totally matte. This is known as an analogous or harmonious colour scheme.

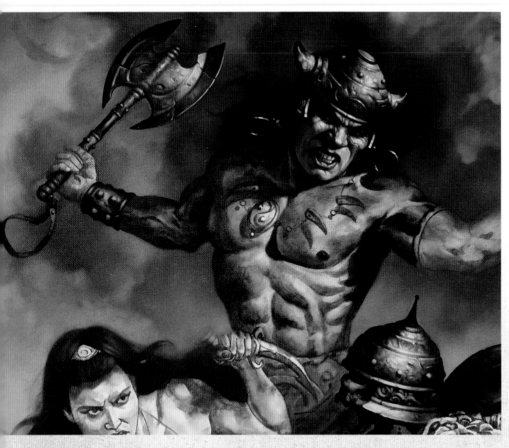

The face was a major hurdle, and I will return to it through the progress of the painting, but for now it is looking good. Here is the torso being worked on at the same time as the previous face close-ups. The torso, although covering vastly more area, is done in a fraction of the time, simply because it is less complex. I work in areas that have a definite boundary so that I can judge drying times. I've chosen an area that will be around three hours' work, creating a natural break for lunch. It's good to plan out a work day, rather than just stumble around, starting and stopping at the will of the painting. Here I block in the darks, checking my anatomy books and model references as I go.

With a big loaded brush I lay down a glazed midtone mix of olive green, burnt umber and raw sienna, in between the dark areas from the stage before, which were a mix of burnt umber and phthalo blue. Now, with a dry flat brush I softly blend up to the darkest shadows, wiping the brush on a rag as I go to keep it soft and thus blending rather than pushing paint around.

Time for lunch. When you become your own boss it only works well if you actually tell yourself what needs doing and by what time. Then get it done. People who want to be their own boss because they don't like hard work, aren't really cut out to be their own boss.

❧ After lunch the paint is tacky enough for me to add warmer colours on top, such as burnt sienna and yellow ochre. These colours are semi-opaque and easy to work with. For the highlights I add a blue/white mix; this will give the impression of an overcast day or a jungle area where light is diffused. I also work on Conan's face to match the torso. Next morning, when the torso is touch-dry, I add the small details on top such as the necklace and arm band. I also add some bulging veins to enhance the moment of savage fury.

❧ As I worked on Conan I also worked on the skeleton's helmet, shield and face as they were in the same area and of similar colours. Also, I was tackling the problems of one helmet so it made sense to do both helmets at the same time rather than to sit back later and solve the same surface problems from scratch. This way was much faster and helped make the artwork more unified. With a busy composition like this it's a constant struggle to keep the painting fresh. One way is to kill confusion by fading back areas. Here I've faded Conan's leg so we can better read the skeleton. This kind of atmospheric blending is known as sfumato and is derived from the Italian word for smoke.

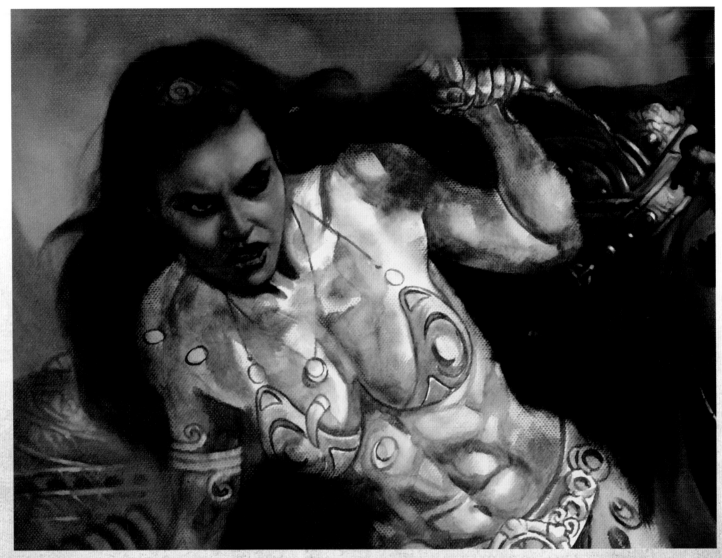

Once again we are on high alert. The girl's face has to be tough yet still attractive, which is very tricky. Keeping the facial lines to a minimum is the best way to get around this, but I don't want her to look as if she's had Botox injections. Delicate stuff. The girl is important to me here for another reason in that she steers the art away from its obvious influence, Frank Frazetta's masterpiece, *Conan the Destroyer*. I'm always trying to break away from Frank's spell but sometimes world's collide: the patrons of this piece also wanted that look, as Frank's *Destroyer* art was one of their favourites, and at the time of writing it had just changed hands for US$1,500,000, putting it well out of the range of most art collectors.

There is absolutely no doubting Frank's genius, but before we all wilt and give up it must be remembered that he too was influenced by imagery. I would say the crouching skeleton in the foreground here was influenced more by the skeleton fight in Ray Harryhausen's (1920–2013) stop-motion movie sensation *Jason and the Argonauts* (1963); the movie may also have been in Frank's mind when he painted his own crouching figure in *Conan the Destroyer*, which shows a very

skeleton-like structure through the flesh. I have also found a similar crouching figure in James Allen St. John's painting for the frontispiece of Edgar Rice Burroughs' *The Chessmen of Mars*, published in 1922, which may have also entered the subconscious of Ray Harryhausen. And so on through the ages. No doubt a trip to The Louvre in Paris would find the influences of Allen St. John.

In a more startling revelation it turned out that Frank Frazetta had cribbed the fallen figure in his *Destroyer* art from an obscure painting by French artist Jean-Jules-Antoine Lecomte du Nouÿ (1842–1923) entitled *Les Porteurs de Mauvaises Nouvelles*. Frank could easily have painted the figure without swiping it, but he was working to commission and it got the job done quicker. If he had swiped from a living artist he would have been booed, but no one was having food taken from their mouths here. The myth built around Frank was that he used no reference, but this was clearly not the case. This revelation does not diminish his legend for me; in fact it is a relief to find he was human. None of us evolve from a vacuum and I freely acknowledge all the influences here in this homage to Frank and all the great artists who went before me.

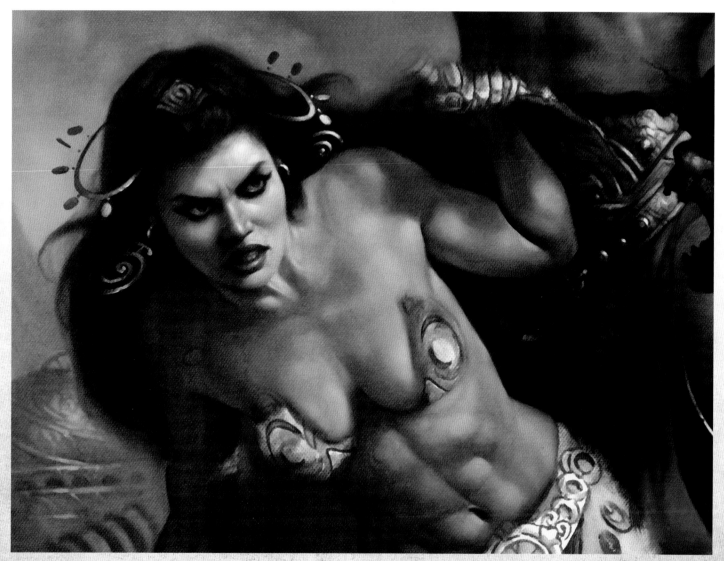

I work down to the points that I can handle in one sitting, which stops here at the wrist and bikini top, all the time tinkering with the face until I get the perfect balance of expression and beauty. I use bigger brushes for the body, but I have seen artists paint an area of this size with the same brush used for the face. Crazy. Bigger brushes will speed up your work, and have a better effect on the art.

A timeless tip for choosing brush sizes is to choose the size you think will work, then choose a bigger size. Note how pale the face looks now in relation to the body. This is why I block in everything before treating the figure as a whole in the glazing stage. With all the masses in place it's much easier to refine each element quickly later.

You can also see here how useful the colour rough has been in that I have placed contrasting darks to make the figure pop forward, such as Conan's dark toga bringing the pale curve of the girl's hip forward. This is one of the reasons why art triumphs over reference photography – you can add this stuff at will over a long period of searching and finding what is aesthetically pleasing to the eye. Note also the light of Conan's thigh, which is making the skeleton's jaw read. While you study that area look at how the detail of Conan's belt is more subdued as it meets the skeleton's face. These little moments are planned to make sure a complicated composition doesn't become confusing.

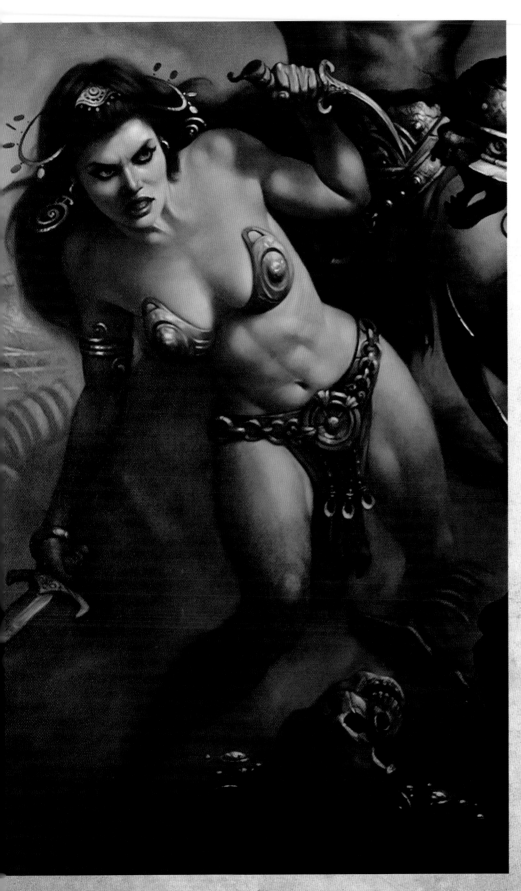

Here she is, blocked in and blended. I add the ornamentation now and paint all the metal parts at the same time, paying special attention to where the metal meets the flesh. I will always make sure that the metal edges make some impact on the soft flesh, otherwise the metal will give the impression of "floating" above the flesh. A frozen moment like this can still show action by the placement of objects in motion, such as the lifting of the earring, the flowing hair, and the jingle-jangle of the headdress.

Less obvious is the invisible line of action that runs through the body, in this case a sloping, elongated "S" shape. Line of action is an animation term meaning the first line drawn to indicate action onto which you build a figure. A line of action can make even a static figure pulse with life.

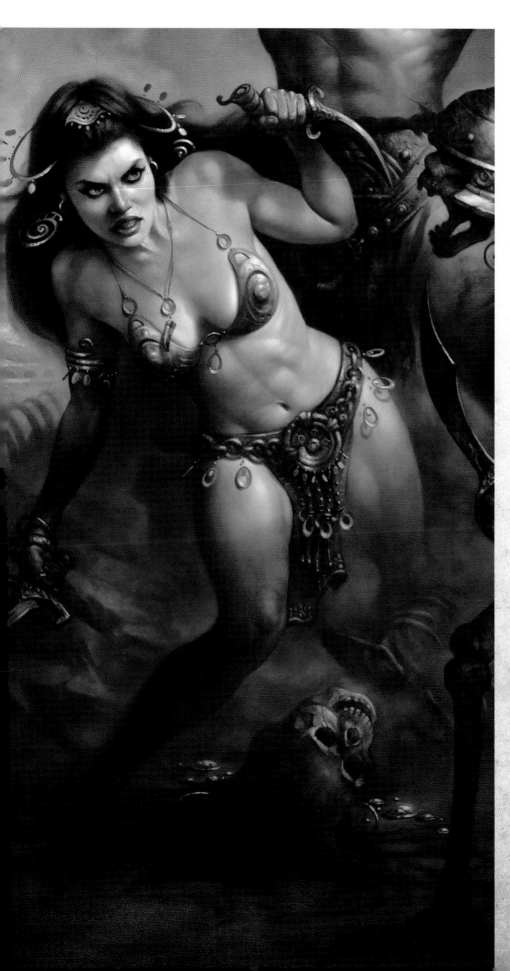

❧ The next day, when the previous day's work has dried, I lay down a glaze and oil out with a large brush before painting all the subtle colours needed to make the flesh real. With the glaze still wet I can add the fine metal links since the surface is still nice and slippy. For this I use the rigger brush I used to paint the spear in *Artemis and the Satyr*.

A rigger brush is a sable brush with extremely long bristles that hold lots of medium for a continuous, unbroken line. The name "rigger" was coined because the brush was used primarily by maritime artists to paint the long lines of rigging on sailboat artworks.

Here is the painting two steps back, to show you how it looked in its entirety at the finished blending stage. Once again you can see, by comparing this stage to the next, the difference between blending and the final overall glazed art. I could see here by stepping back from the art after a night's break that the highlights were too strong all over, especially on the girl and Conan's helmet. The light tones between the girl and the skeleton are particularly distracting, as is the lightness of the sword running off the canvas at bottom left. All are easily tweaked in the next stage.

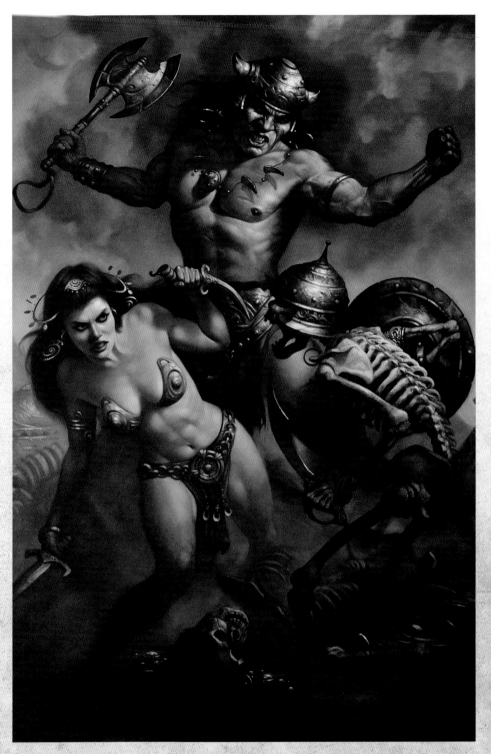

The glazing stage gives me the chance to not only intensify the colour but also to balance the darks and lights to create a lush and atmospheric artwork. If you were working in Photoshop this would be akin to painting colour onto a Multiply layer, combined with colour painted onto an Overlay layer above the artwork. Although my colour schemes can be described as muted they actually contain lots of colour, very subtly blended. The finished art is now left to dry overnight in a room that has its door and windows closed so as not to have people or the wind bring in dust from outside, or worse, have someone knock over or touch the drying painting.

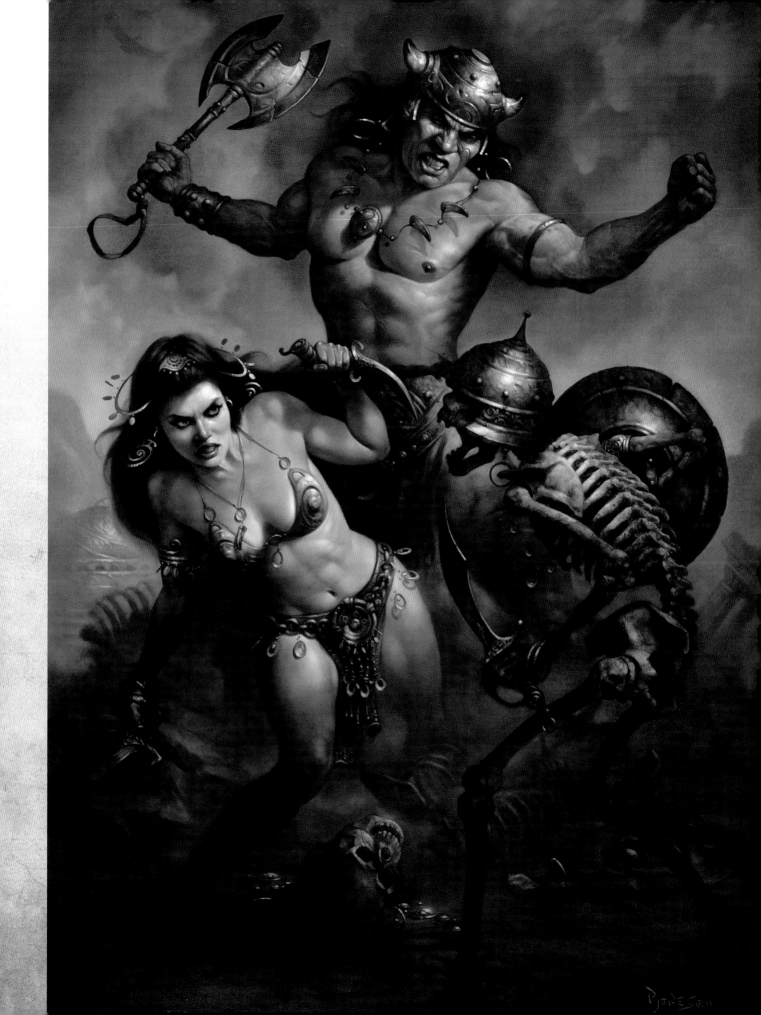

VALLEY OF THE SERPENT

TAKING ARTISTIC RISKS

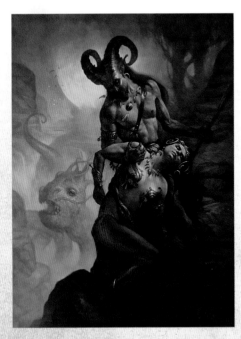

Working on personal projects is the perfect time to take risks. As there was no art director or time frame, I used this piece to experiment with new techniques. The first thing I tried was priming the board with a more diluted gesso solution, to eliminate brush strokes. Brush strokes can be a problem when working at a small size, in this case 18.5" x 25", especially faces, which are about two inches in diameter on the original painting.

Gesso is a primer that stops the oil soaking into porous surfaces such as illustration board. Some artists brush on a coat, sand it down, and then repeat the procedure until they get a classic "eggshell" finish. The other solution is to work bigger on pre-primed canvas. I tried the thin route, which left the surface I wanted without the need for sanding, but unfortunately I thinned it too much.

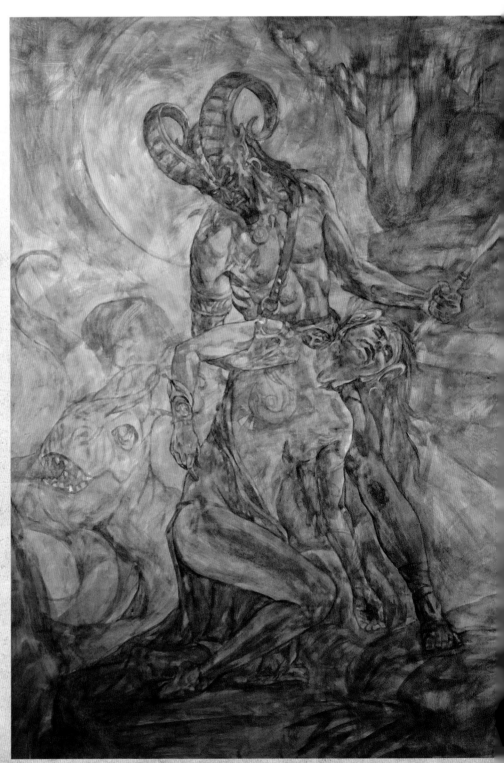

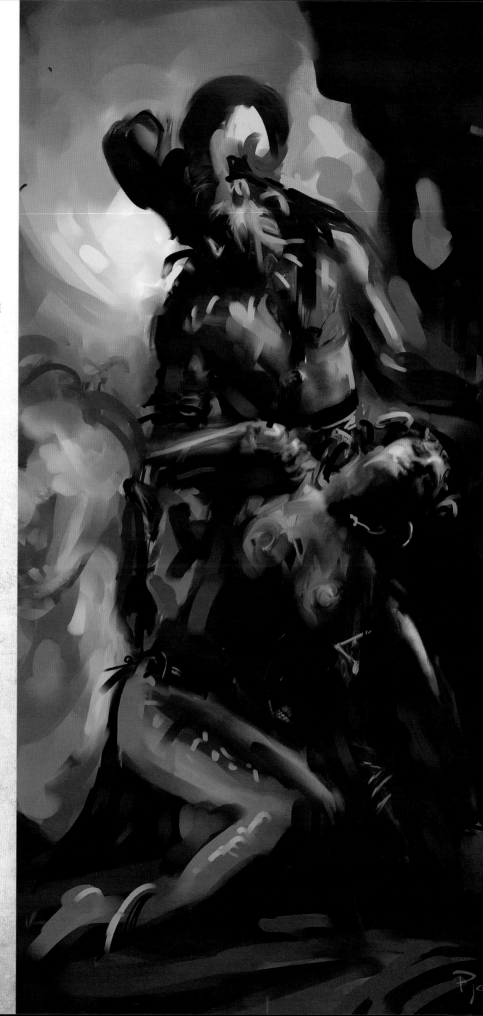

Everything went well during the underpainting. I used acrylic paint, which dries fast. No problem there as you can safely paint oil on top – just not the other way around. At this stage all seemed fine; it was my next experiment that did the damage. As seen earlier, I had tinkered with water-based oils for a while and really liked their non-toxic qualities (and especially the easy clean-up with soap and water).

Unfortunately, I also added white spirit to the water-mixable linseed oil medium to get a longer drying time and better flow, which had worked okay on a well-primed surface before. I did this because the blending qualities before, using spirit, were "sticky" rather than oily. The original "just add water technique" was also destroying my brushes when the sticky drying/ blending time kicked in. You can safely add spirit to water-based oils until about a 50 per cent ratio; from that point on you must clean your brushes with spirit afterwards.

Before encountering the painting disaster of the next stage, I painted this colour rough on a computer using the software Corel Painter. I printed it out and taped it to the large A1 piece of thin hardboard on my easel. The hardboard gives me the old-school flexibility of an easel with the extra surface enjoyed by architects for taping reference to.

A note on colour roughs: just as I am not a slave to the detailed sketches I use to start a painting, I will, if need be, veer off these colours too if they look too unreal in the final art. What works in abstract paint here could look like blue skin instead of moonlight at the later stage (which is why I did veer off).

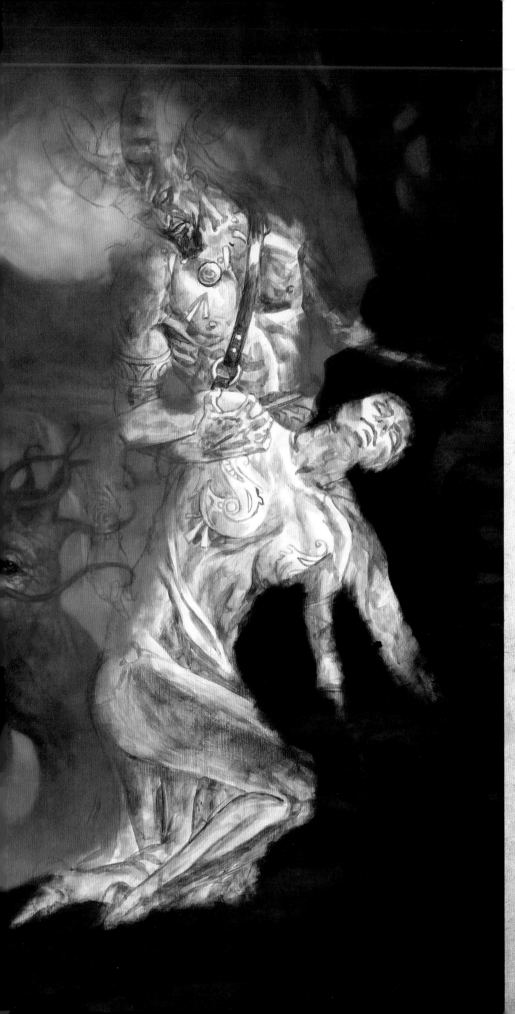

This is where it all went wrong. As I painted, the porous surface was sucking up the oil until it was almost like acrylic paint, leaving me no time to blend. I wiped the whole thing back with white spirit, painted a clear acrylic base over the acrylic underpainting and let it dry, ironically ending up with the brush strokes akin to gesso primer I wanted to eliminate. I started again and all was going well with the background until the paint started drying in its usual sticky way.

Then, worst of all, it started picking up islands of the acrylic colour from the underpainting, right through the primer to the original board! I bulled ahead and painted a fairly decent background considering I was lifting off as much paint as I was putting down. The next day the surface was still sticky, and one rub test pulled away a patch of paint! It was a disaster, and for the first time in decades I made the decision to abandon the artwork and start again.

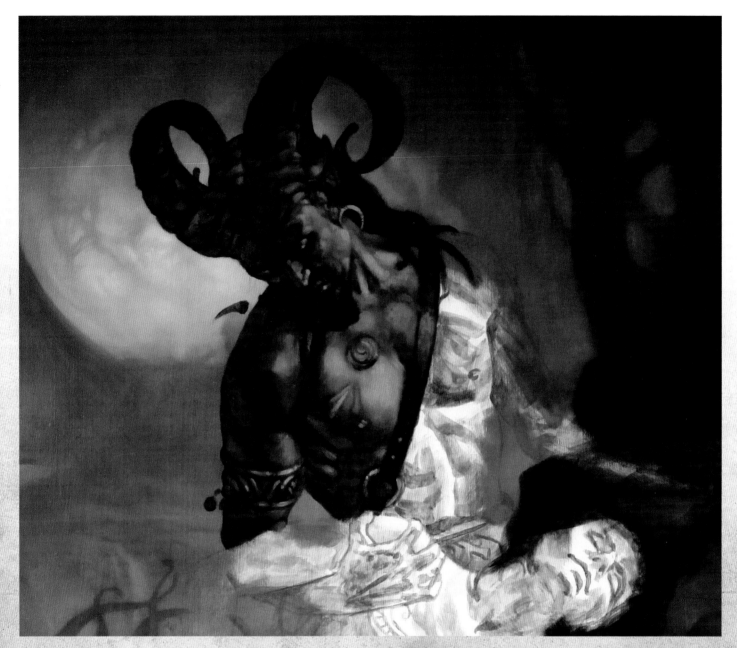

❦ I threw the old artwork in a corner, all bent up (this is known as artistic temperament) and started again from scratch. This time I bought some flat sponge brushes, which went some way to reducing the brush strokes, and primed the new board properly. It was a heartache repeating all the work, but by the time I started blocking in the figure the pain vanished. Had I learned my lesson from the failed experiment? "There are no mistakes, only better understanding", is a motto I live by. I mixed a jar of 50 per cent odourless white spirit and 50 per cent linseed oil (not the water-soluble kind; for me that jar will never be opened again) and thinned the water-soluble oils like normal oils. Success.

So if I'm now using oil-based medium with water-soluble oils why don't I just finish the painting using traditional oils? For a number of reasons – one being that I had invested in a full range of large tubed water-soluble paints and refused to give up the fight at the first hurdle. I also wanted to exhaust every avenue before giving up on the new kind of oil paints that are non-toxic and can be cleaned with soap and water.

If some company can refine these paints in the future to the quality of traditional oils then they are what I will use. For this painting I will explore all the possibilities to find an in-between solution that will work. In the meantime I must go back to cleaning my brushes in solvent at the end of each day. When doing this, it's best not to then finish cleaning them with soap and water but to shape their hairs to a point then wash in soap and water the next day. Some artists clean their brushes only with linseed oil, but this can be expensive and time consuming.

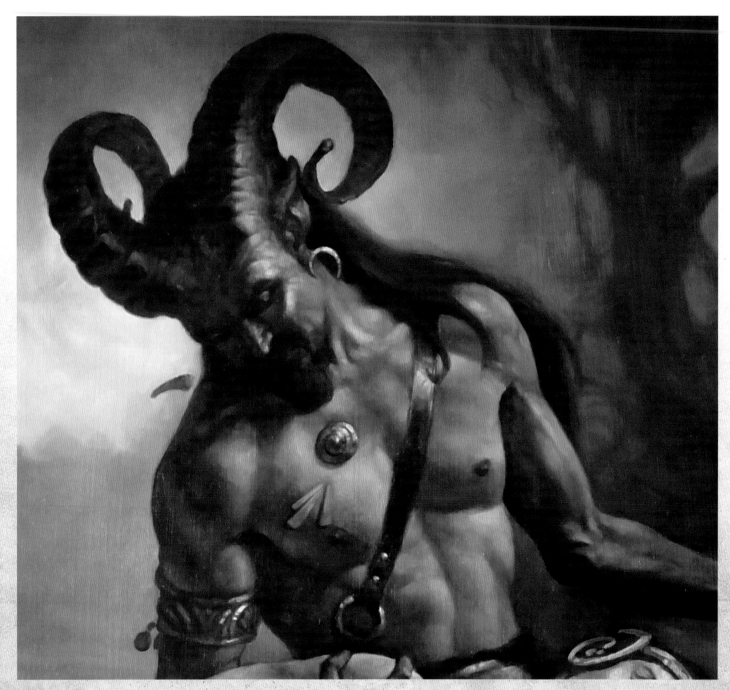

I had added too much linseed oil to the previous 50/50 mix, as a lot of the background in the painting was glossy and still wet the next day. When the ratio of linseed oil exceeds the ratio of turpentine the surface can become too slimy and some colours break up like floating soot. The sticky solution was solved but now the large oily background surface had gathered every airborne dust particle, which is another problem with too much oil. Time for a tonk.

Tonking is a technique named after the English artist Henry Tonks (1862–1937); it is pretty simple, but also pure genius. To do it, simply blot the artwork with a sheet of paper to soak up the oil. Some glazed paint will come with it, but not so much that you notice, if you paint thin, as I do. Now the surface is clear of debris and just the right amount of oil is left to work into.

Painting resumes and is close in quality to traditional oils, which is not surprising considering how much oil I've mixed with the paint. I have since discovered that the pigment in water-soluble oils is closer in grade to the student version of the Winsor & Newton traditional oil paints, rather than the artist quality grade professionals work with. When mixing paint on my palette I also glaze the palette with the same oily mix so that everything dries at the same speed on both palette and paint surface. That way I'm less likely to remove paint from the artwork with over-diluted paint.

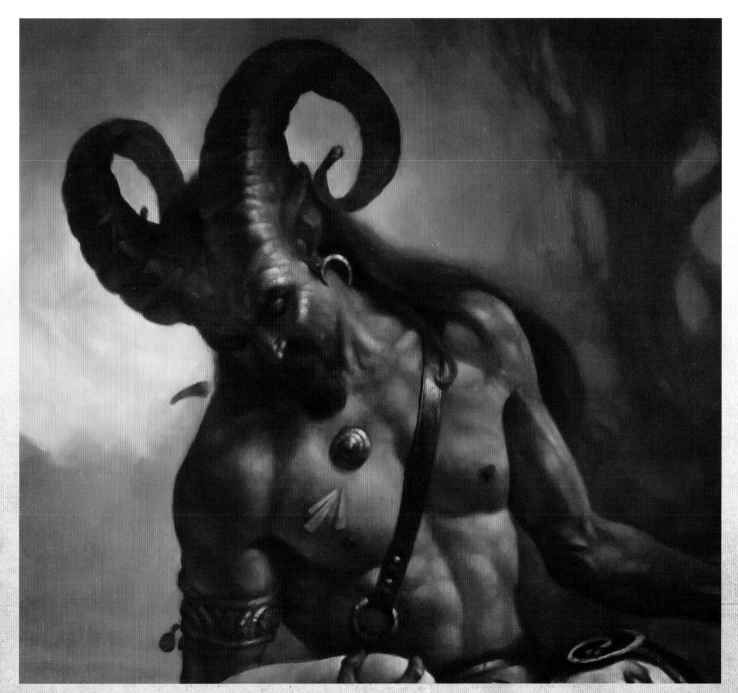

❧ I continue painting the figure with the 50/50 mix because of its great blending properties, and also due to the fat over lean principle, which means each layer should never have less fat (oil) than the previous layer, otherwise you may pick up the layer underneath, and years later your paintings will crack due to the top layer drying and shrinking faster than the layer underneath, thereby pulling the paint in all directions and causing hairline cracks.

During my visit to the Frank Frazetta museum I noticed that some of his paintings had cracked after just 30 years – a testament to the speed at which he painted and, I guess, his use of cobalt dryer to hurry up drying time. A note on cobalt colours: I have a tube of cobalt blue that is so solid it can no longer be squeezed out without using pliers, while other paints bought at the same time still drool oil on the first squeeze. You have to understand which paints dry fastest and add more oil into their mix to keep them supple. Other oil paints that dry fast are siennas, umbers, manganese blue and violet. My slowest-drying oil paints tend to be yellow ochre, lamp black and titanium white, which suits me fine as I use the latter more than any other colour and need it to stay soft.

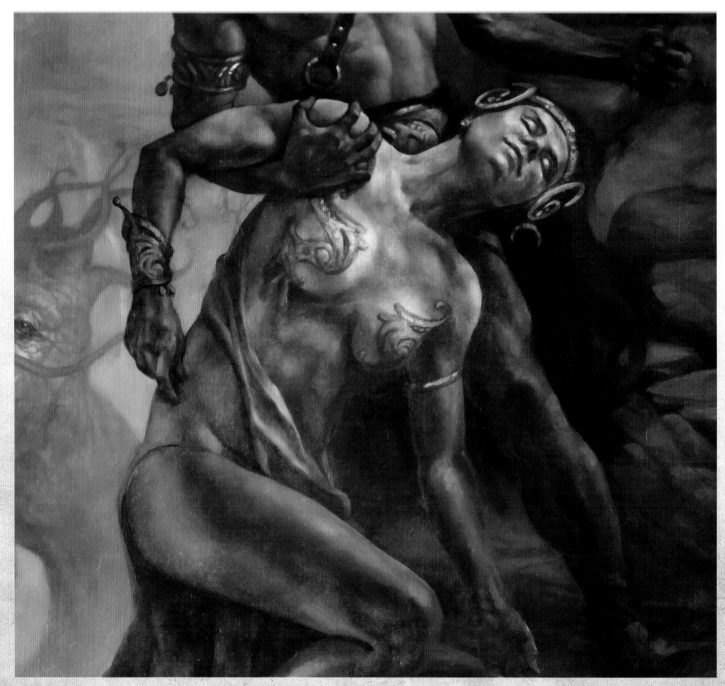

❧ For the girl block in I've regained my confidence and therefore my control over the painting. I no longer fear the sticky paint as I have by now discovered that it was the addition of even the smallest amount of water that was the culprit – which is a shame as using water was the big draw card. So I mix up a jar of 70 per cent odourless white spirit and 30 per cent linseed oil as a thinning medium for the first paint coat and block in the entire figure and the satyr's legs (I have not used goat legs here, as is traditional).

The 70/30 mix is my standard mix for thinning colours to use for blocking in. By the next morning the first layer is completely touch dry, as it should be. No stickiness or oiliness. Now I have the perfect mix for this stage and label the jar "Block In". This stage shows the art in mid-block, very roughly laying down opaque paint to further understand the workings of anatomy. I blended roughly beyond this demo shot before starting the next – true – blending stage.

This insight into a block in at the mid stage should give hope to any artist starting off, as it shows how scruffy even a professional work can look in the early stage. It's not just magic pouring out of the brush – rather it is simply a lot of study and hard work. At the end of the day anyone can learn to paint, but it will be the added passion and dedication that will enable the great artists to rise from the ranks of journeymen and journeywomen.

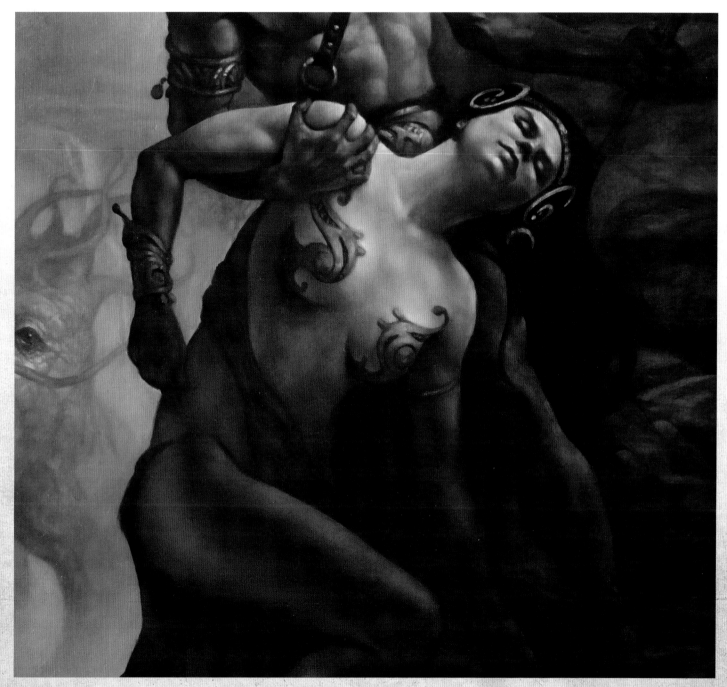

It's the next day and for the second coat I continue with my mix of 70 per cent odourless white spirit and 30 per cent linseed oil. The fat over lean rule is not broken here as the previous day's work will dry before this layer does. I just shouldn't thin this ratio further with white spirit, only oils from this point onwards.

The mix is buttery enough for me to blend, and it has none of the stickiness I found using the water mix. So what have I learned so far from using water-based oils? Basically, I will use them in future for underpainting and fast colour roughs, but I'll skip using water as a thinner in any ratio with white spirit or linseed oils. It *can* be done but

it tends to keep the oils wet and sticky for days. Wet is easy to tonk, but sticky is a problem I'm not prepared to suffer when I don't need to. I found this answer using my style of blended art: mix purely with water for underpainting then mix only with white spirit/oils for blending.

I won't be using the water-mixable linseed oil again, as I won't be doing any finished water-based oil paintings until things improve. The quality is good but not anywhere near the quality of traditional oils. The mix of the "water-mixable linseed oil" with white spirit or traditional linseed oil was probably the biggest mistake I made.

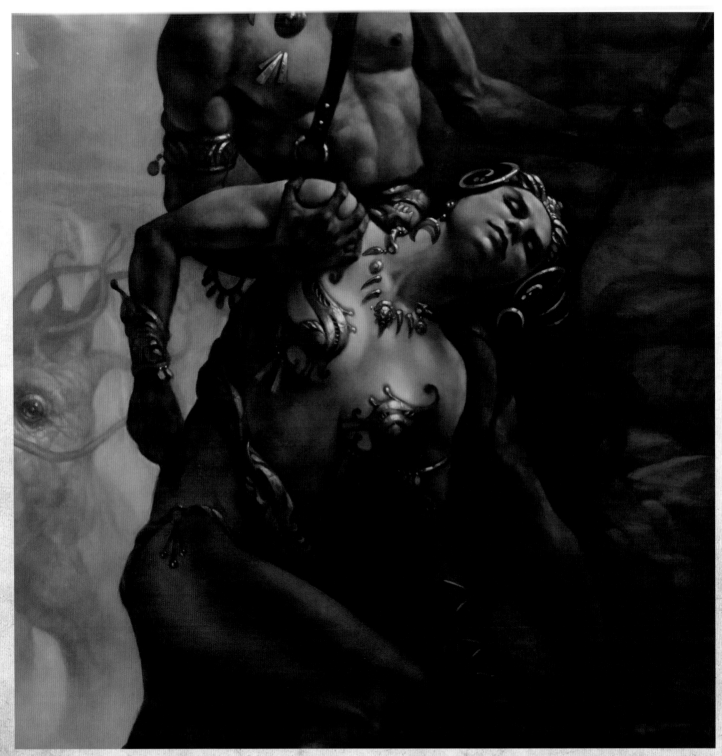

Now I have three labelled jars of medium. The first is named "Underpainting" and it has a 90 per cent white spirit/10 per cent oil mix. The second jar is named "Block In/Blend", and has 70 per cent white spirit/30 per cent oil and the third jar, "Glaze", has 50 per cent white spirit/50 per cent oil – the same mix I use for regular oils.

Here I glaze the girl with a large loaded brush of glazing mix spread very thin, then paint on top. The paint will "float" on top until it starts to dry. This is the period to work in all your colours and details. Once you feel the paint seize up (after around four hours) you can start to do some very subtle blending while adding more opaque detail – back and forth, blend and detail all day long.

Was it work the risks? Yes, it's one of my favourite paintings and was reserved and bought by one of the world's biggest Fantasy art collectors, before IlluXCon 2010 even opened its doors.

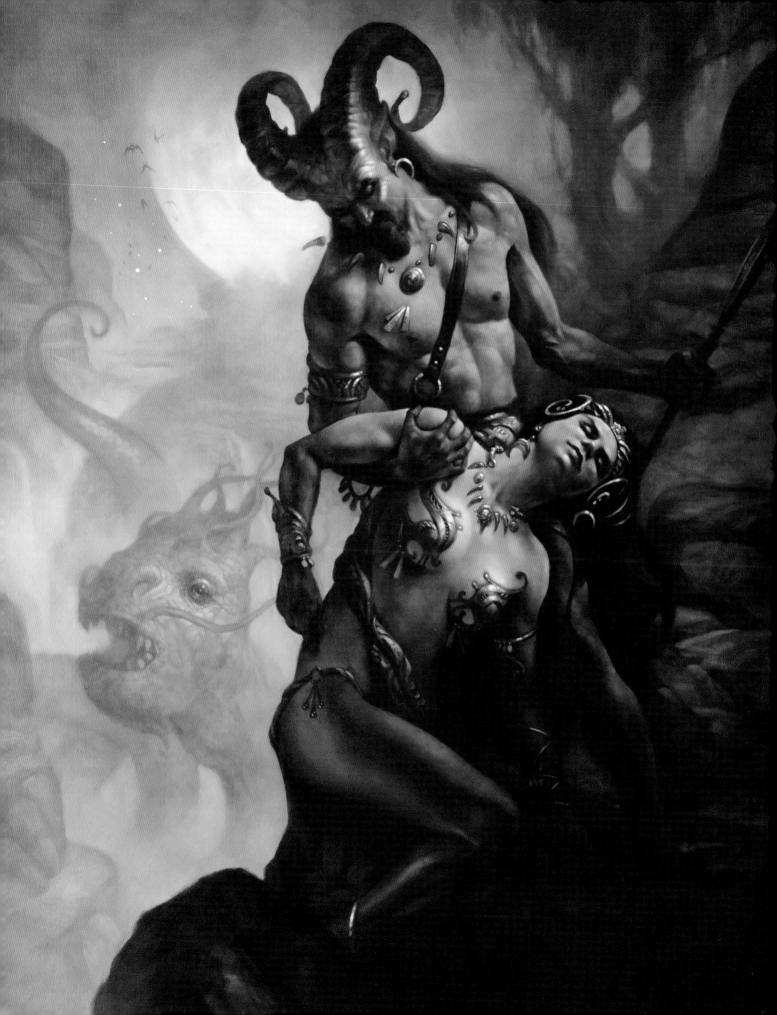

NIGHT OF THE ZOMBIE

ART AND NEGOTIATION

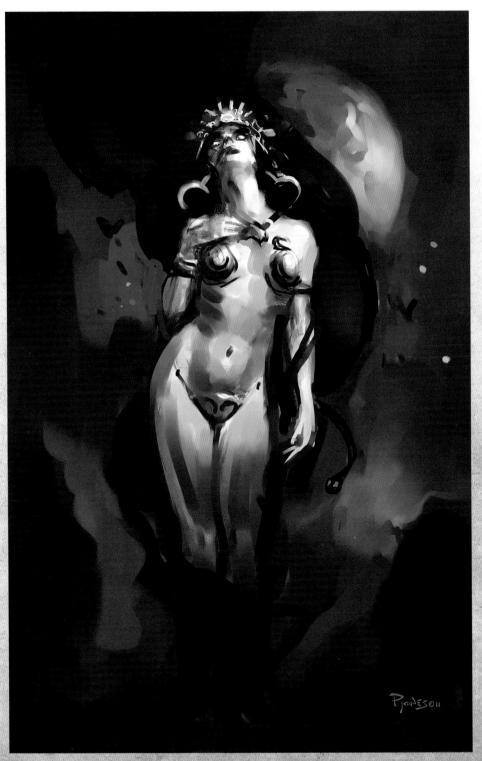

Sometimes a commission will come in with a low budget – in fact, when you are starting out this will be a common occurrence. The main thing is not to moan about it: you can say "no", as it's up to you if you choose to do it or not. The problem is that a "no" can sound like a door slamming and you may not get a call back from that client. The reverse can be just as bad, as a "yes" can lead to constantly underpaid work. Some ad agencies would ring me up with a promise that the next job would be a "biggie" and to treat the low-budget job as a favour. Sometimes they would honour their word, other times not. This is the search and find that all budding artists and illustrators must go through until they can finally pick and choose their clients.

On the right is the colour rough for this low-budget private commission. I will let you in on my negotiation methods on this art and other low-budget works as we progress.

If the aforementioned sounds grim, it needn't – if you set your mind right. Regardless of which stage your career is at, you still have the power to negotiate. You may not think you have, but remember: they rang you because they want your style, or they think you'll work for that price; either way they would rather close the deal with you than ring someone else.

To prevent low-budget jobs getting out of hand I charged $30 per sketch until the idea was nailed. No one ever baulked at such a small additional fee, but it could sometimes rise to a tidy sum. It also helped them make up their minds sooner. I had one talented friend go out of business because his "commissions" never got past the sketch stage. His unscrupulous "clients" were simply using him for ideas. Beware: they are out there.

Another way to make a low-budget job palatable is to ensure you retain the copyright for the future. Sometimes low fees can bring out the creative streak. Most ad agencies use a "work for hire" agreement in which they keep the rights. You can negotiate a lower fee where the copyright remains with you. This way the client gets a great piece of art for less money and you strengthen your portfolio with a possible further income in the future.

Frank Frazetta did exactly this back in 1954, holding on to his original cover artwork for *Weird Science-Fantasy*. In 2010, after decades of residual income from posters and prints, Frank then sold the painting to a private buyer for US$380,000. One thought before we go further: the advice above is insanity if you are not at the top of your game, so take a good, hard look at your work and ask yourself if it has legs for future sale.

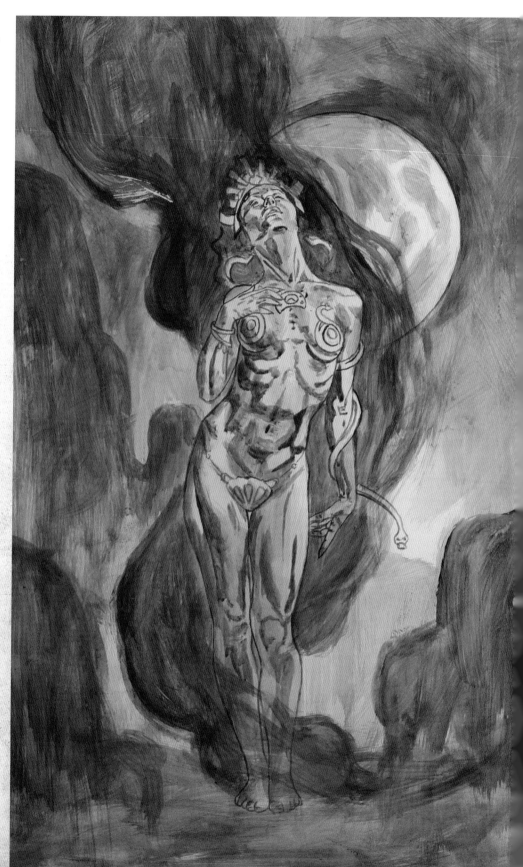

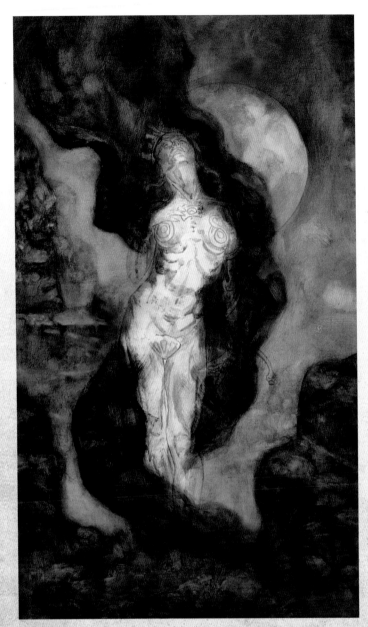

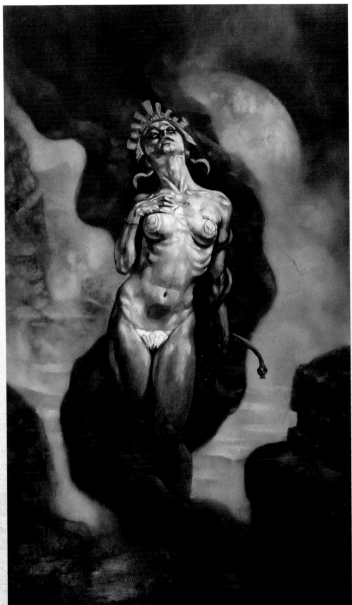

❧ For this art, as with all my book jacket and private commissions, I retain the copyright. This is also one of the reasons I got out of advertising. Mind you, the fees for advertising illustration far outstrip those for publishing work. If it's quick money you're after, then advertising is the place. If you want to leave behind an art legacy it can be tricky with ad work as it is usually an unattractive product.

Artists like Norman Rockwell managed to create lasting art for ad agencies, but the world was a prettier place back then. Here, I negotiated that the work would be smaller than usual, 12" x 19", with an open deadline, the choice to paint whatever pose I liked with a zombie theme, and no changes (i.e. complete freedom to paint as I pleased). If they say "no" to your offer you are still available in the future when they may possibly have more money, and they will also take you seriously as a professional artist.

❧ The first few stages showed the colour rough and underpainting. Although I showed the client the colour rough out of courtesy, he was aware that it could change as much as I wished. Keeping the rough abstract also allowed me my own freedom to explore, rather than be tied down by a tight sketch.

Above right, as I block in, I'm unhappy with the zombie's helmet. With a tight sketch approved by a publisher I'd have to stick to the sketch and live with it, but due to my negotiation I can change it at will. Remember, if you work on a small piece like this it would be a mistake to use canvas as the weave would make it impossible to get detail into the face. This artwork is on gessoed illustration board – lightly sanded for a smooth finish – that still has enough tooth to hold the oils. As the painting is small I can block the whole thing in a day. I'm blocking in again with 70/30 white spirit/linseed oil mix to thin my paints.

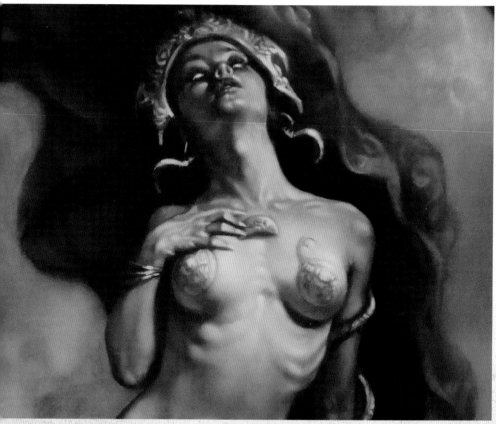

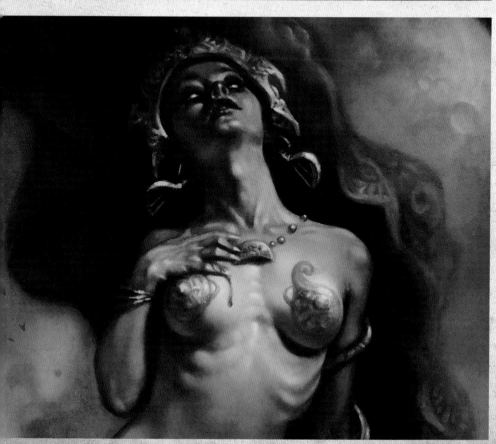

To the left are both the blended stage and the colour-glazed stage. At this point the painting is in a state of flux. I'm mixing traditional 50/50 turpentine with linseed oil here, as detail at this size needs a good oily vehicle to make the paint flow. When using a toxic thinner I usually make sure the room is ventilated, but with the hot weather I'm working in an air-conditioned environment. This is when it's essential to use dippers with lids to hold the medium. This way the medium is exposed to the air briefly, as I open and close the lids when I need to mix colour.

If I was working on a large canvas though I would open the windows and doors and brave the heat rather than breath the turpentine fumes. Double bowl metal dippers clip onto your palette. They are cheap and available at all art stores. In one bowl I have my oil medium for painting and in the other odourless white spirit or turpentine to rinse my brushes.

❧ I'm using my 50/50 linseed/turpentine mix to glaze. If you choose artists' turpentine and follow the safety tips I share throughout this book on the use of solvents, you should have little to worry about. One last safety tip: don't play it cheap by buying unrefined solvent from hardware stores; it will be detrimental to your health, and your artwork. It was cheap turps that spelled the end for the great Frank Frazetta, starting with a thyroid condition and ending in a series of strokes.

My safety advice may be considered histrionic by safety experts, as the small amount of solvent artists generally use is deemed no more dangerous than using common household cleaning products, but we only get one set of lungs.

Some artists choose to use only linseed at this stage but I find it much too glossy and almost impossible to add any amount of pigment to without the pigment breaking up. 50 per cent odourless white spirit mixed in will solve this problem, but turpentine is the classic mix for its flowing properties and I'll use it when working on very small details. Another problem with using too much linseed oil is that it takes a long time to dry, attracts dust, and can cause paintings to yellow over time.

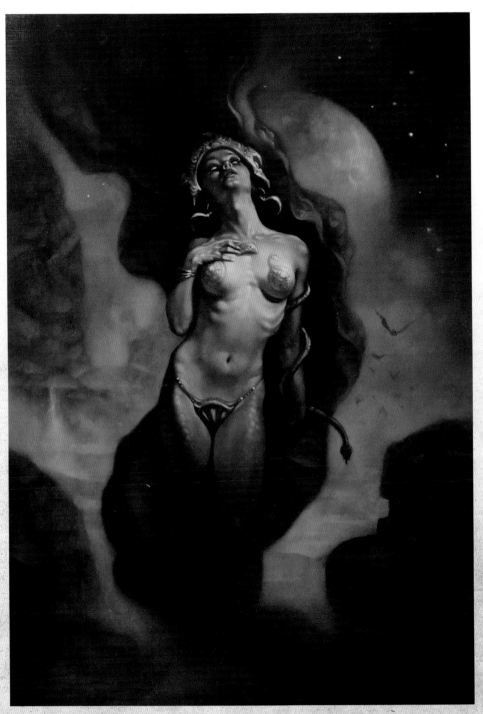

❧ A good way to glaze without these problems is to oil out first, as described before, and keep brushing until it's spread as miserly as you can get it. You'll be surprised how far it can go. Hold the painting at an angle to see if you've missed any by checking the gloss. You now have a great surface to paint on that will be workable for hours. As always, be careful if using solvent rather than turps as it's more likely to pick up previous layers if brushed too much.

When this commission was finished I calculated that, because of the small size, I had painted it so much quicker than my larger pieces that the cost came out around the same per hour. So nothing was lost, money-wise, I'd had the freedom to paint what I pleased and the buyer got his bargain. That's the power of negotiation.

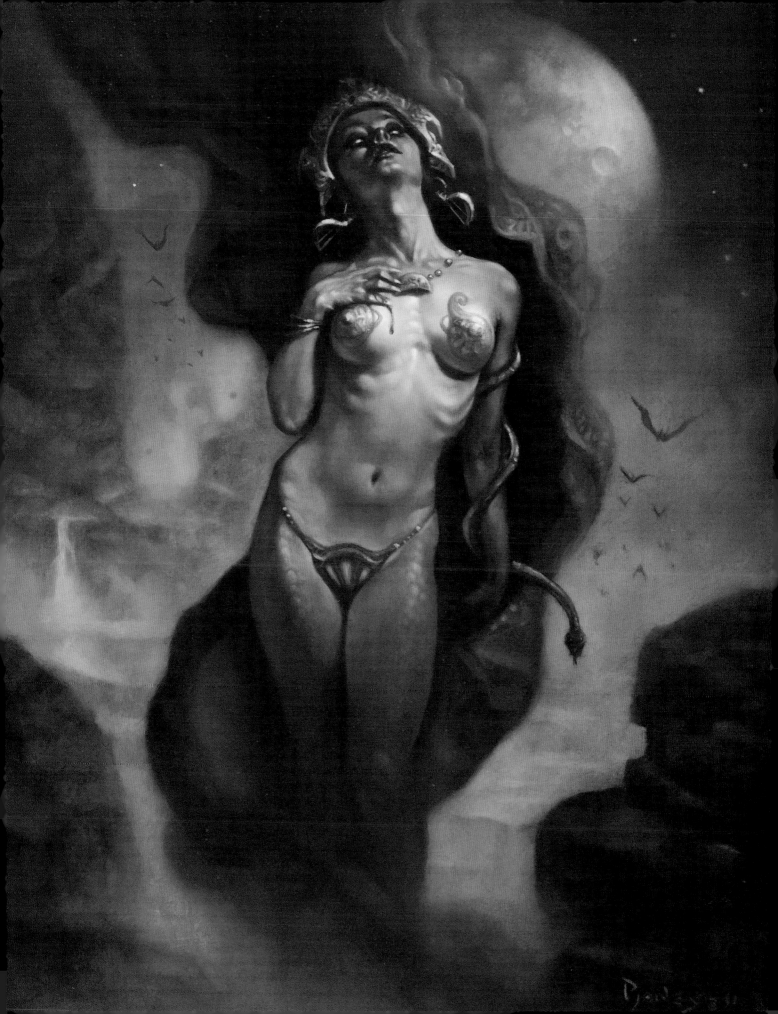

THE CAPTIVE

ILLUSTRATION AS ART

❧ Here I will create a painting for the love of it (fine art), under a self-imposed, 10-day deadline, based on a story brief (illustration), from myself (the client), treating it as both illustration and fine art, to prove there is no difference. I have shown this artwork to a class of art students and everyone had a different interpretation of what the backstory might be. I'll leave the story a mystery, so that you can draw your own interpretation.

❧ Illustrators usually complete paintings within time limits that would cause a fine artist to faint. This is why most illustrators choose fast-drying acrylic over oil paints, but acrylics simply can't blend like oils and so ironically it will take longer to produce blended flesh using acrylics. Using illustration board as a base I transferred a reverse tracing paper sketch by burnishing the back with a spoon. It's important that the board's surface has no invisible oil marks before transfer; a wipe over with tissue soaked in spirit does the trick. Next I use acrylic paint (burnt sienna) to quickly block in the underpainting. When it's dry I seal the porous board with acrylic medium and spread it out with a sponge brush to prevent brush strokes. I also lift off any excess with a paper towel as I go. Once dry I lay down a second coat the same way. The surface is now sealed, leaving a slight tooth to hold the following oil paint.

Here is my colour rough. You can see everything here in miniature: the value, the colour, the mood. If you squint your eyes you can almost see the final art. At this point I can approach the modelling stage with the confidence that the oil painting is worth going through with.

The art size is 28" x 19"; this is my average size art as it fits the budget of most collectors better than my large canvases.

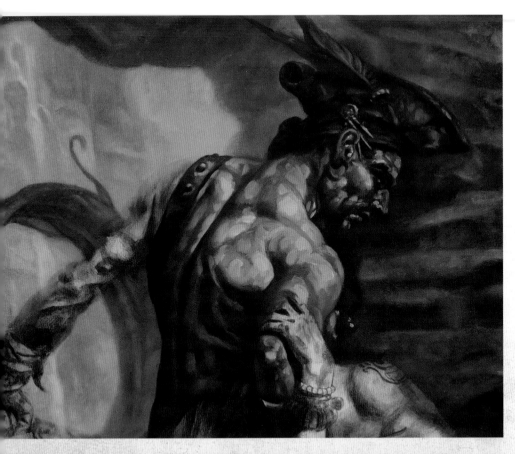

Now it's time to combine all the skills used in the previous artworks to pull off the most difficult type of painting: colour and value in one application. Here I'm blocking in colours of different values (lights and darks) to the background and figure simultaneously, to achieve tone and colour in one sitting.

I'm working from a black and white reference photo for the value and anatomy and the colour rough for colour reference. For this stage I'm using what would usually be my glazing mix of 50/50 linseed oil/turpentine to blend as I'm by-passing the usual 70/30 block in stage mix to meet my deadline.

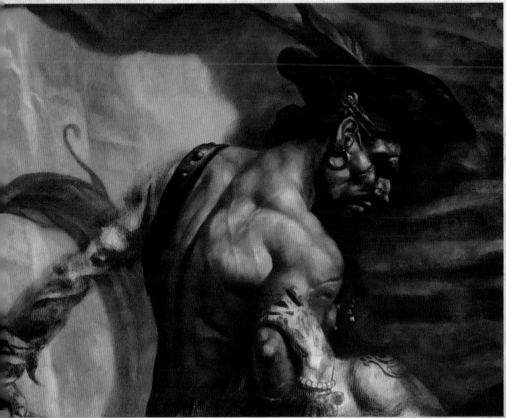

On the glossy surface the oils stay live all day, but are most easily blended within the first hour. In a few hours' time I can come back and add some of the colours that are also seizing up on the palette and add touches here and there. By tomorrow I will be able to add another glaze on top.

If you live in a damp or cold climate you may need to add some cobalt dryer to speed up the drying time. While one part of the painting is in its drying stage I'll move on to other parts of the painting. At this stage I've returned to the figure after blending to add the mark of the lash on his back and a scar across his face, adding history and a sense of danger to the character.

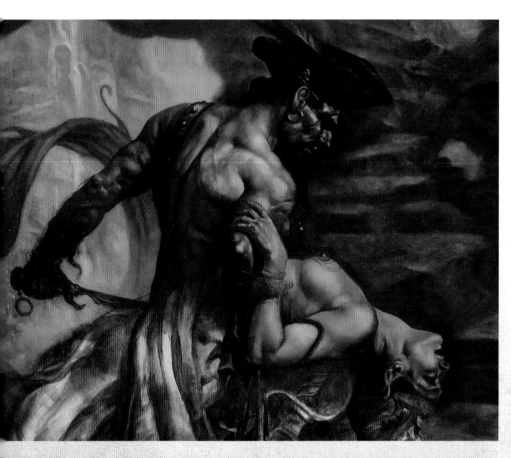

❧ Again, I'm out with my anatomy books to make sure that what I see in my photo-reference is not a trick of the light. I want to exaggerate the flexing muscles without straying into caricature – or worse, into the realm of bodybuilding. As always I'm trying to remain true to how these characters would look, based on their history and environment. Any sign of modern-day influence, such as permed or styled hair for instance, would forever destroy the illusion and mood.

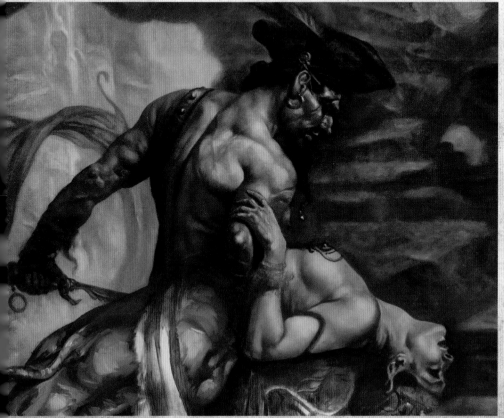

❧ Here I've repeated the one-stop blocking and blending on the mermaid's body that I did on the pirate. You can see I've used the natural edge ending of the torso (here ending at the arm) to complete one blending session and am now blocking the lower body. I don't bother with trinkets, such as the bracelet, at this stage, as it will slow me down too much. What I'm aiming for is to realize the overall vision. Adding the trinkets will be easier at the end.

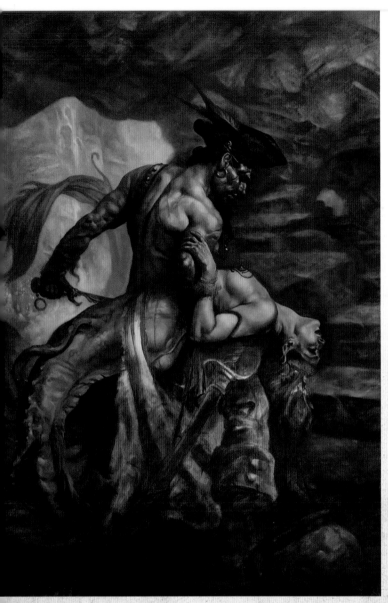

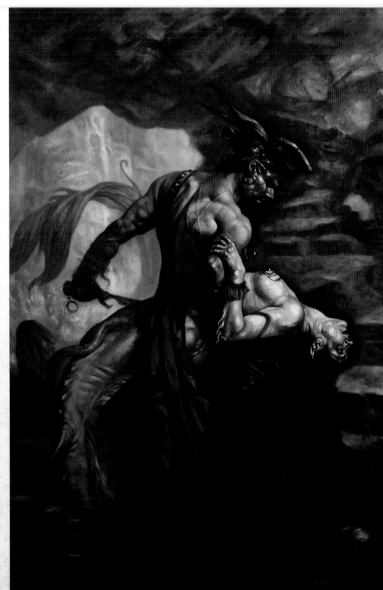

Here we are at the end of day 3. Tomorrow I will move at hyper speed as the clothing is always the fastest element to paint. You can see that the paint is now dry enough for me to rub down some pencil that was lost in the previous painting session. I keep my original drawing on tracing paper, just in case, and match it to register marks that line up with the burnished under drawing (I always draw register lines to mark the corners of the tracing sheet outside the art area). Oil dries slowly, but only relatively. Used thinly you can almost guarantee a dry surface at the start of each day. I've hinted at some fish scales here, but know that a glazing layer will be a much easier way to tackle the sheen and rainbow colours of oily flesh and have left that kind of finish for the detail stage.

Although I managed to paint the pirate in tone and value during a single stage, painting pale flesh takes a much more subtle touch, as artists through the ages have noted. I spent many lunch hours at the Manchester Art Gallery in the UK, staring through the delicate glazes William Waterhouse (1849–1917) used to capture the radiant beauty of his water nymphs in his masterpiece *Hylas and the Nymphs*.

Even though glazes are normally associated with high chroma transparent colours I'm using thin white, along with blues and pinks, to create flesh akin to that of a cave and undersea dweller. From this stage I'll also start on the bangles and trinkets, and also the lash marks, so that the entire painting is ready to glaze and detail at the next stage.

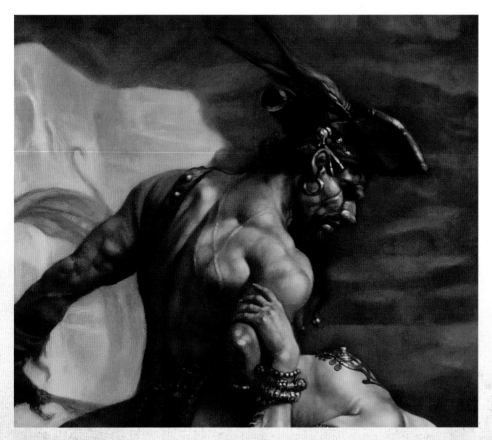

❧ I've blended the mermaid's flesh and left it overnight to dry. I'm into day 6 now and ready to detail and glaze. As I completed the pirate's hue and value, there was very little glazing needed to bring his flesh alive. You can see now the time spent layering the mermaid's flesh was well worth the effort as we see the cold flesh, pink at the knuckles and blue in vein, contrasting sharply against the bronzed flesh of her captor. This does not mean he doesn't need some pinks and blues too, as you can see in the elbows and shadows.

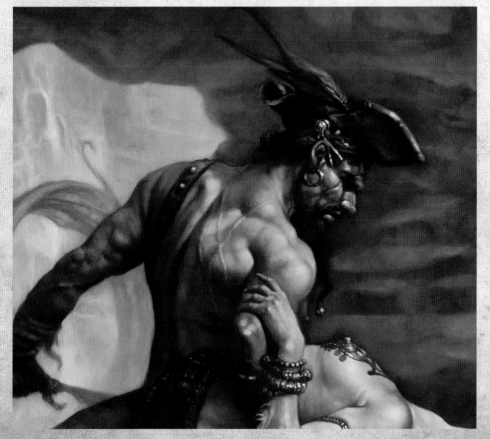

❧ Another day and I lay down a thin coat of medium to float some opaque paints on top of the pirate figure, bringing out the form more by highlighting his muscles. I always resist the urge to over-highlight as I want the flesh to read as flesh rather than metal, which can happen. To ensure I don't fall into this trap I note the highlights of the metal bangles on the mermaid are always higher in value than his flesh. You will notice his features have changed a lot since the underpainting as I felt the initial face was too sharp and refined. I wanted a more gnarly, older pirate – the kind of man who has escaped death a hundred times.

This is the end result of the first glaze and blend following that block in. I experimented a great deal on the tail and thumbed through lots of fish reference to come up with something unique. Rather than looking at other Fantasy art for reference, it is a better idea to search illustrated books such as cookbooks, which can contain birds, crabs, shells, and fish in high-quality detail.

Day 9 and I've glazed and detailed all day long over the entire painting. I could call it finished here, but I plan to sleep on it and go back in tomorrow for one last glaze and touch up. This should not be confused with the kind of treatment seen all too often where an artist will polish their work to death and end up with an over-rendered eyesore. I'm always conscious of keeping the detail limited to where I want the viewer to look.

There's no doubt now that I will meet my self-imposed deadline. How did I work it out to 10 days exactly? Basically, in illustration, I always met any deadline imposed by simply writing down on a calendar a day-by-day breakdown of the various stages required to fit the time frame, then ensured they were ticked each day. If I was given a 14-day deadline (my ideal for this painting) or a 6-day deadline, it would still get done.

Here I am at the end of day 10, after the final glaze and touch up. I sacrificed some of the blues and pinks in the mermaid's flesh to harmonize the painting and create a golden pool of light. The colours are still there, though not so obviously seen in reproduction. I've managed to paint a fine art, non-commissioned piece in the time frame I would normally paint an illustration, with no loss of quality. I have the painting beside me as I write this, and as usual I am dismayed by the limits of even the finest photography to capture the true essence of an original oil painting, with it's multi-layered glazing and depth of colour. It's interesting to note this painting was sold within a few weeks of completion as a work of fine art, making it financially a better option than if I'd worked on a commissioned illustration. Who knows the difference?

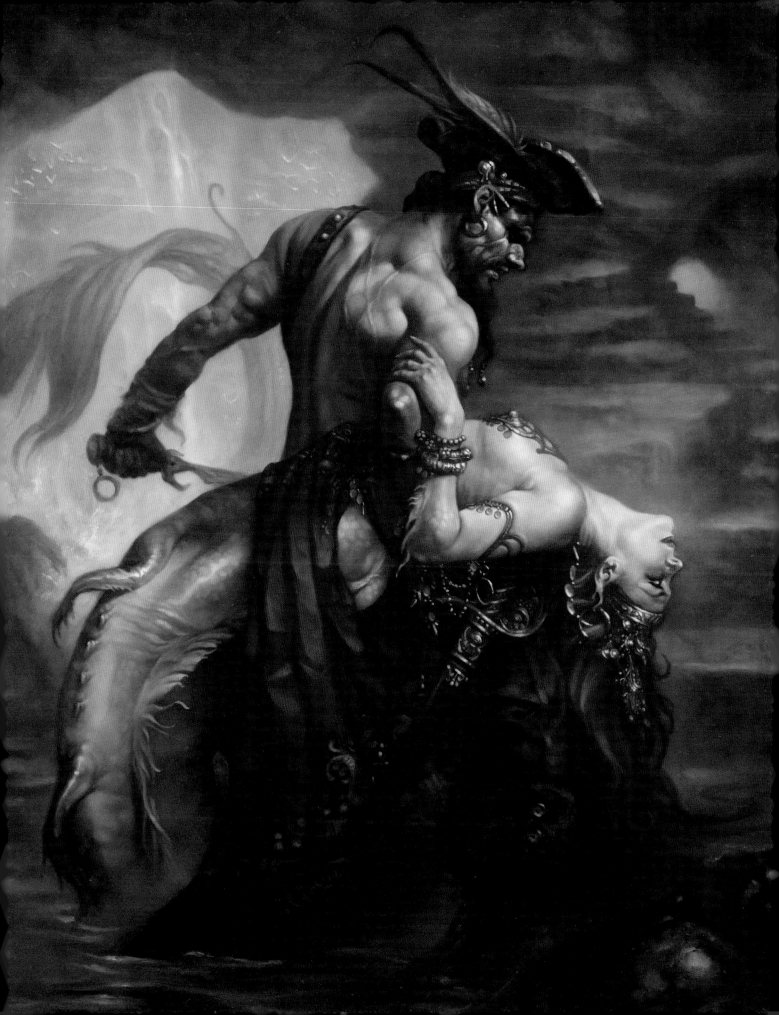

AN ARTIST'S PALETTE

THE MUD PALETTE

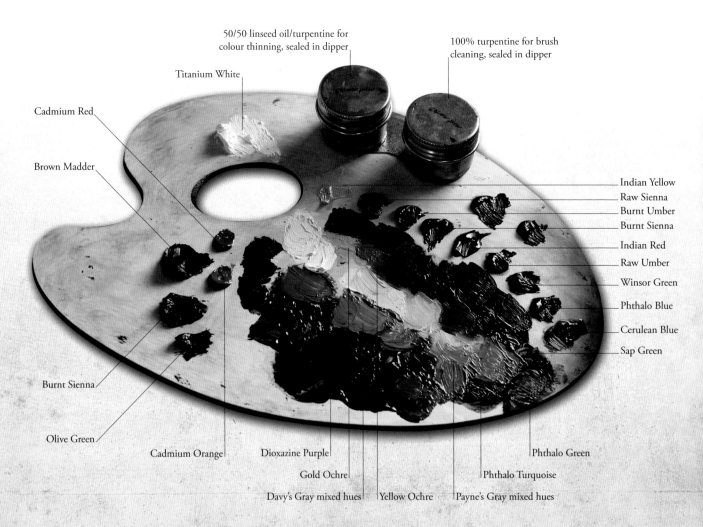

50/50 linseed oil/turpentine for colour thinning, sealed in dipper

100% turpentine for brush cleaning, sealed in dipper

Titanium White

Cadmium Red

Brown Madder

Indian Yellow
Raw Sienna
Burnt Umber
Burnt Sienna
Indian Red
Raw Umber
Winsor Green
Phthalo Blue
Cerulean Blue
Sap Green

Burnt Sienna

Olive Green

Cadmium Orange

Dioxazine Purple

Phthalo Green

Phthalo Turquoise

Gold Ochre

Davy's Gray mixed hues

Yellow Ochre

Payne's Gray mixed hues

Here is my palette for *The Captive*. I have used various palette methods over the years, some complicated to the point of science rather than art. In the early days I would lay out every colour under the rainbow, in lines of gradated hues from the lightest value to the darkest (known as colour strings). But as I grew in confidence I broke it down to one light, one dark and one midtone of each colour.

Recently I had the good fortune to meet one of the greatest Fantasy artists, Donato Giancola, and watch him paint in his Brooklyn studio. He was developing his "mud palette" idea at the time, which is not for the faint-hearted as it almost goes against the theory of keeping your colours pure in case you end up with, well… mud!

The idea is to study whatever isolated area you are painting – flesh, say – and work out all the values and colour hues right there on the palette so that none of the colours are being influenced by the white space of the palette around each individual colour. It might look like mud but by placing, say, a muddy orange next to a muddy blue the colours will still vibrate, but in a subtle way.

For *The Captive* I decided to try Donato's mud palette. I discovered what he had done was to distil all his years of value study and colour study, and bring them together to create a muddy rainbow in which you can dip into the darks and lights at will, in a very spontaneous way. Like all great ideas it is simple genius. I've adapted it here only slightly.

The first step is to wet the palette with a mix of 50/50 linseed oil/turpentine to keep the colours fresh, then lay the colours down. On one side I have all my warm tones and on the other all my cool tones; down the centre I have a line of white. Near the bottom I've mixed in warm and cool greys. With the 50/50 mix you can keep the palette "live" by adding a touch of medium when the paint feels like it's seizing up.

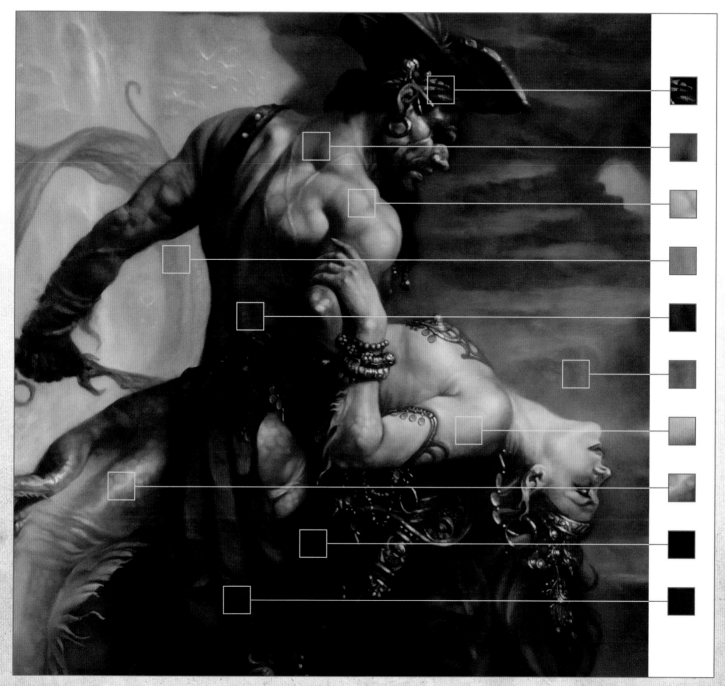

Even though *The Captive* appears to be filled with vibrant colour, it is in fact created from muddy colours placed together to give the maximum vibrancy without looking garish. If you isolate any colour square from within the painting you will see how muddy even the brightest colour is, proving the theory that all colour is relative.

Any colour can appear brighter or duller depending on what colour you place next to it. Special attention is needed when using white. As you can see here even the lightest tone is a dull grey when isolated against pure white. White used straight from the tube looks very amateurish, so resist. As I've said before, I have no fear of placing white directly on the canvas, but I will always blend into it or glaze on top. In order to judge colour better most artists stain their canvases before laying colour down. Some use a muddy green but most use umber or sienna. Any colour then placed on top of these muted tones will immediately look brighter than if placed on top of a bare white canvas.

Donato, the eternal art student, also reminds us of the profound quote by French artist Delacroix…

"I can paint you the skin of Venus with mud,
provided you let me surround it as I will."
— **Eugène Delacroix** (1798–1863)

SOLOMON'S LOSS

THE RETURN OF THE VICTORIAN EPIC

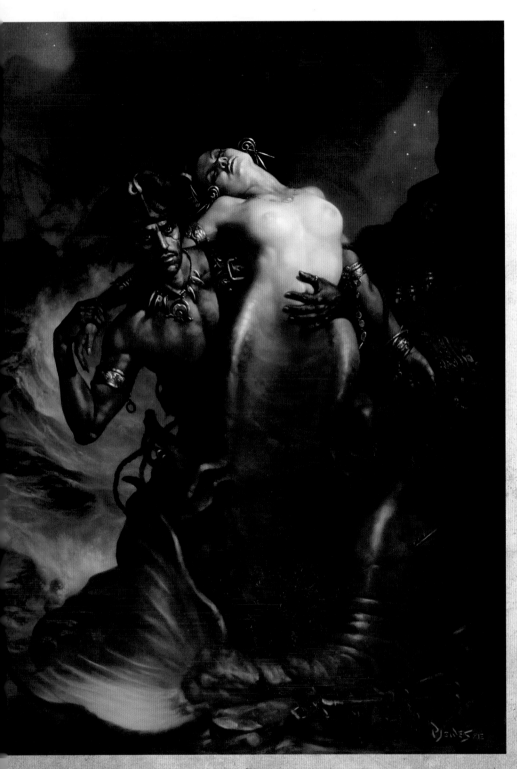

❦ At 30" x 40" *Solomon's Loss* is huge by illustration and print standards today, but would be regarded as a small piece by Victorian fine art standards. Back in the late 19th century, when representational art (i.e., not abstract) was at its peak of glory, artists such as Lord Frederic Leighton (1830–1896) and Hans Makart (1840–1884) painted canvases of staggering size. The great Victorian artists were akin to Hollywood stars – masters of public spectacle and mass entertainment with hundreds of thousands paying to see their latest works at the annual Académie des Beaux-Arts in Paris, France. Unfortunately their popularity came to an abrupt end with the rise of modern art and cinema.

For much of the last century Victorian art was ridiculed as kitsch by art curators with an eye to keeping modern art priced at outrageous figures. Illustrator Al Capp (1909–1979) put it more bluntly: "Abstract art is a product of the untalented sold by the unprincipled to the utterly bewildered." Today, Victorian art is being re-evaluated for its uncompromising beauty, with Alma-Tadema's *The Finding of Moses* recently selling for $35,922,000. Considering the painting was bought solely for its $900 frame in 1955, before being dumped in an alley as worthless, this signals a major tide is turning.

❦ If you are going for epic art and epic scale I've discovered that a dismantled canvas frame that measures more than 42 inches at its tallest strut is a problem to transport by hand as 42 inches is the maximum size regular art tubes with handles can carry (a landscape 42 inches high can be any width though… as you just keep rolling). To transport large canvases to a show I recommend PVC plumber's piping from hardware stores to hold and protect your canvas and dismantled frame pieces.

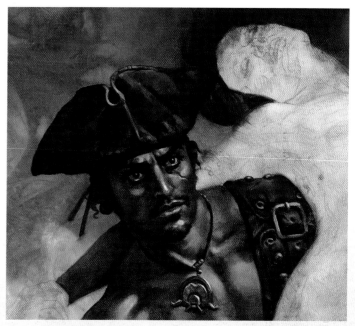

They can then be placed inside commercial art tubes with handles. The PVC piping is practically indestructible (art tubes are not) and can be capped at both ends with the caps sold alongside the pipes in stores. The future looks bright again for painters of beauty and truth. Heartfelt dreams and visions are placed on canvas with oil and brush – grown from the seed of a colour sketch to a full-blown oil to be treasured by collectors the world over.

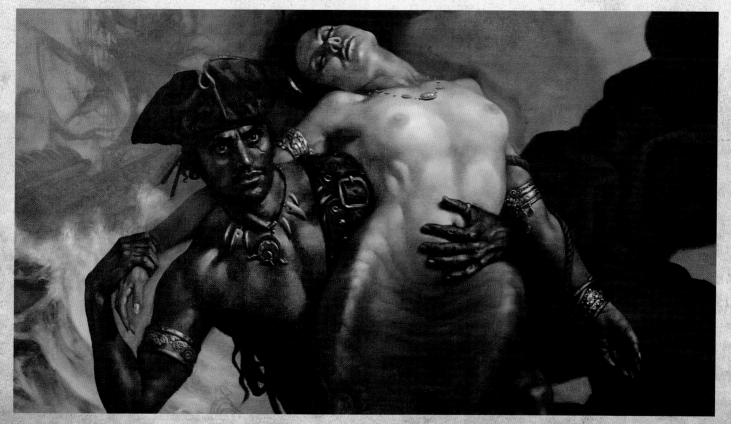

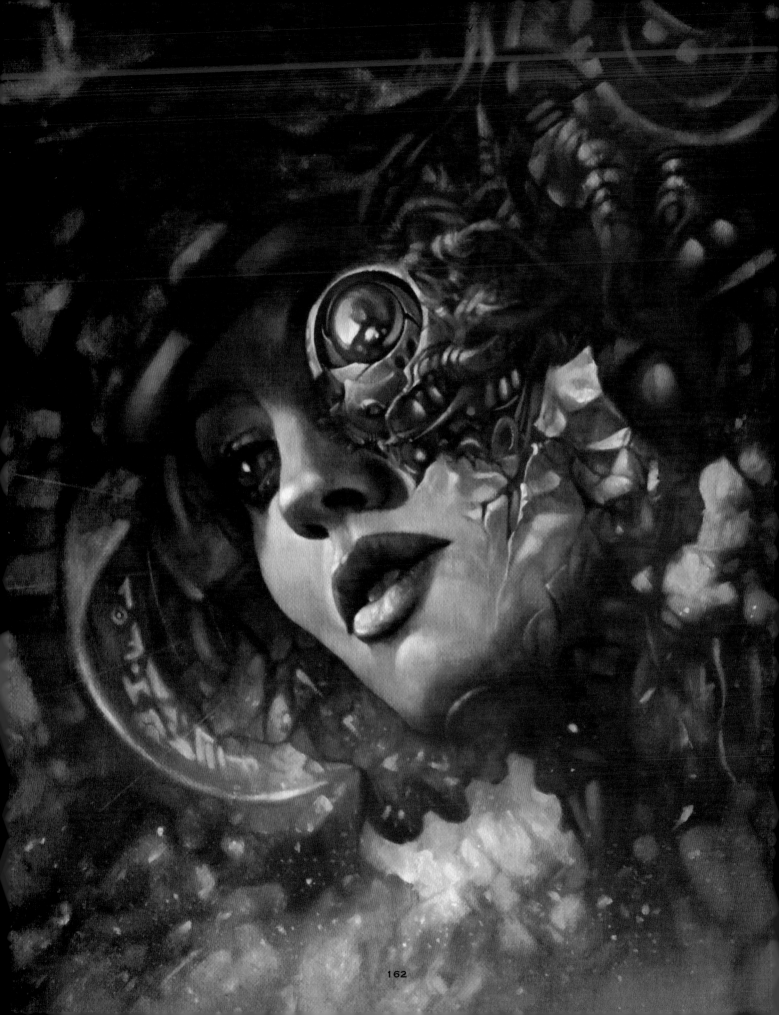

OIL PAINTING GALLERY

Born to Kill, 18.5" x 25",
oil on canvas board, private collection

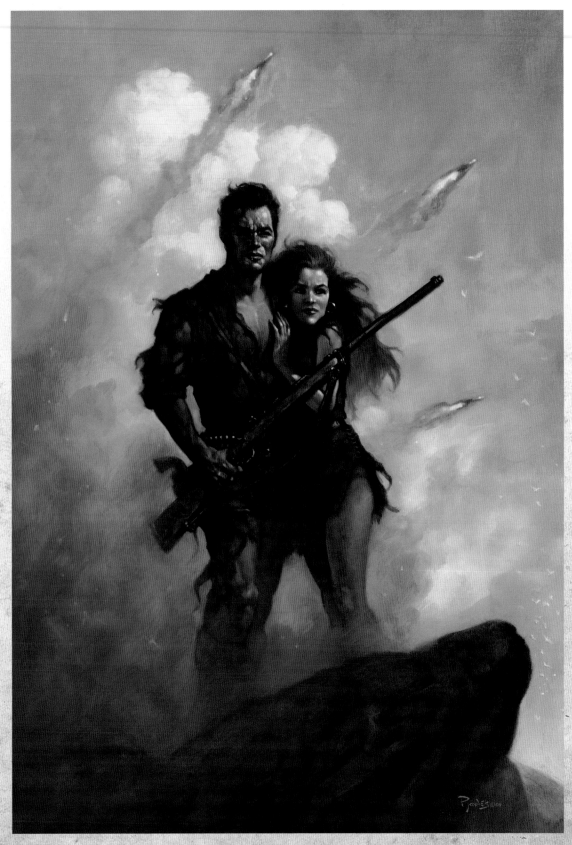

Alas Babylon, 12" x 18", oil on gessoed board
The Last Stand, 18.5" x 25", oil on gessoed board, private collection

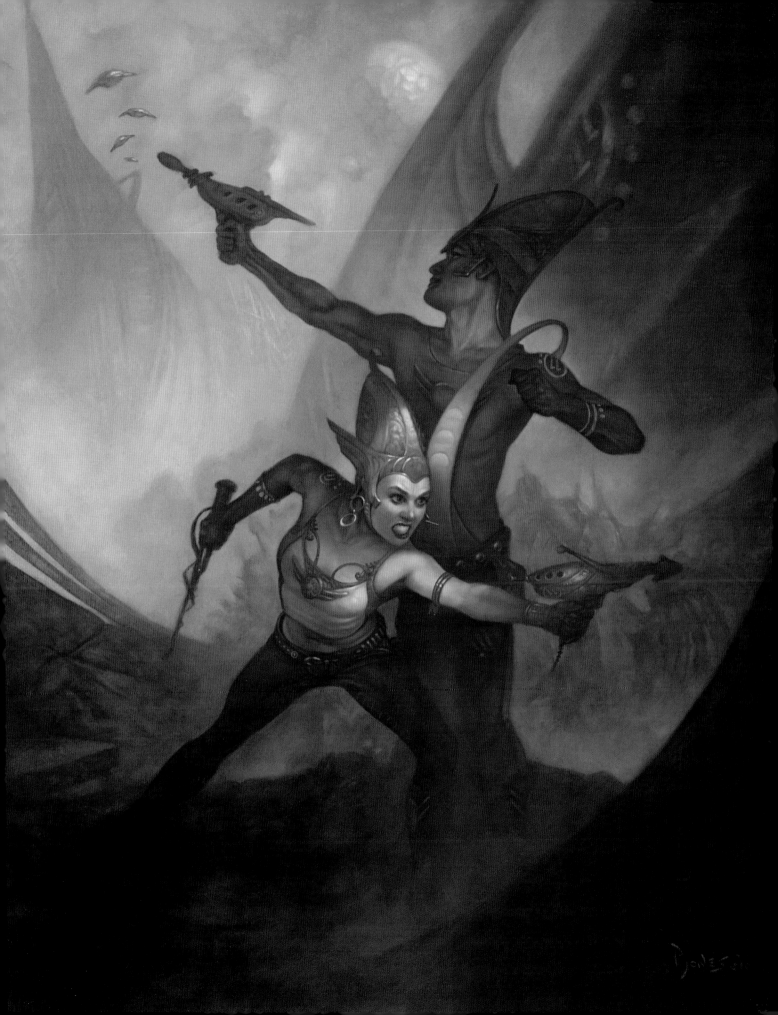

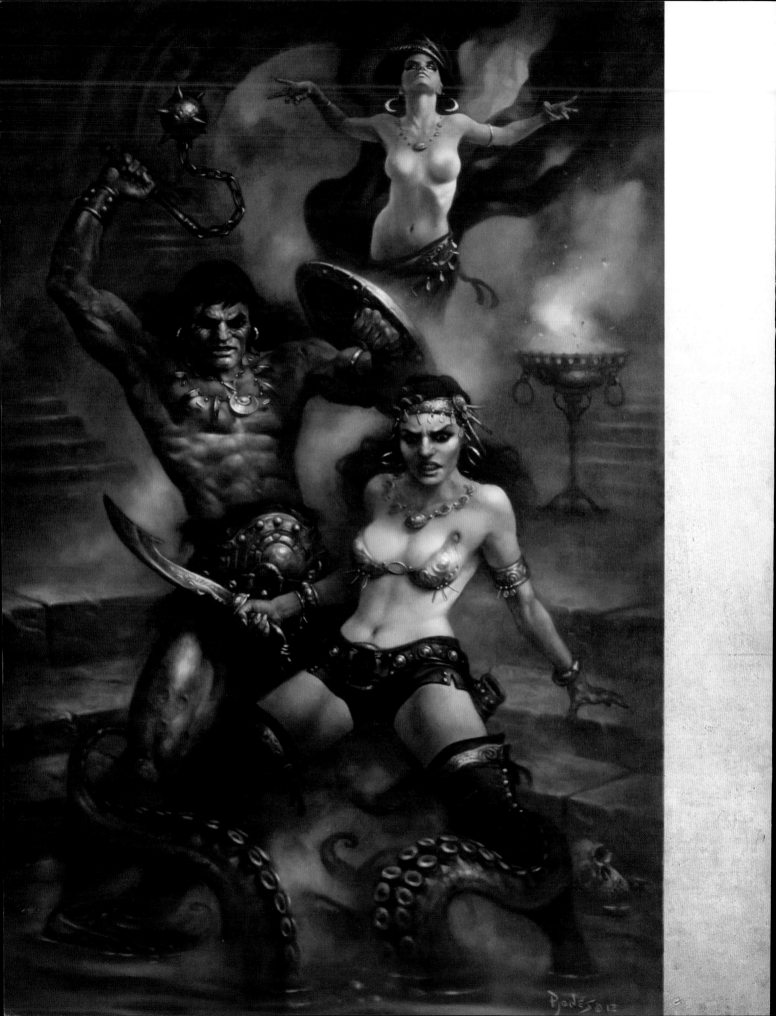

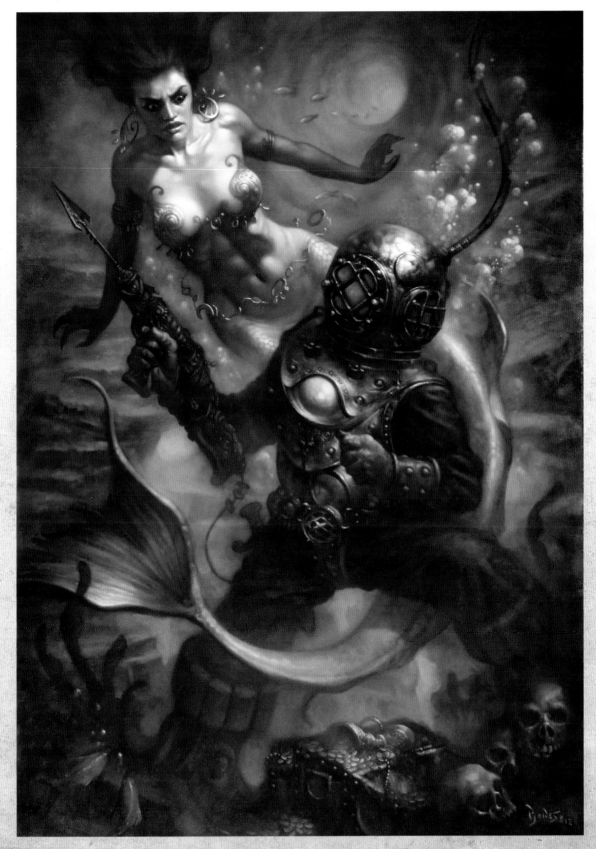

The Lost Treasure, 36" x 24", oil on canvas, private collection
The Sorceress and the Pit, 36" x 24", oil on canvas, private collection

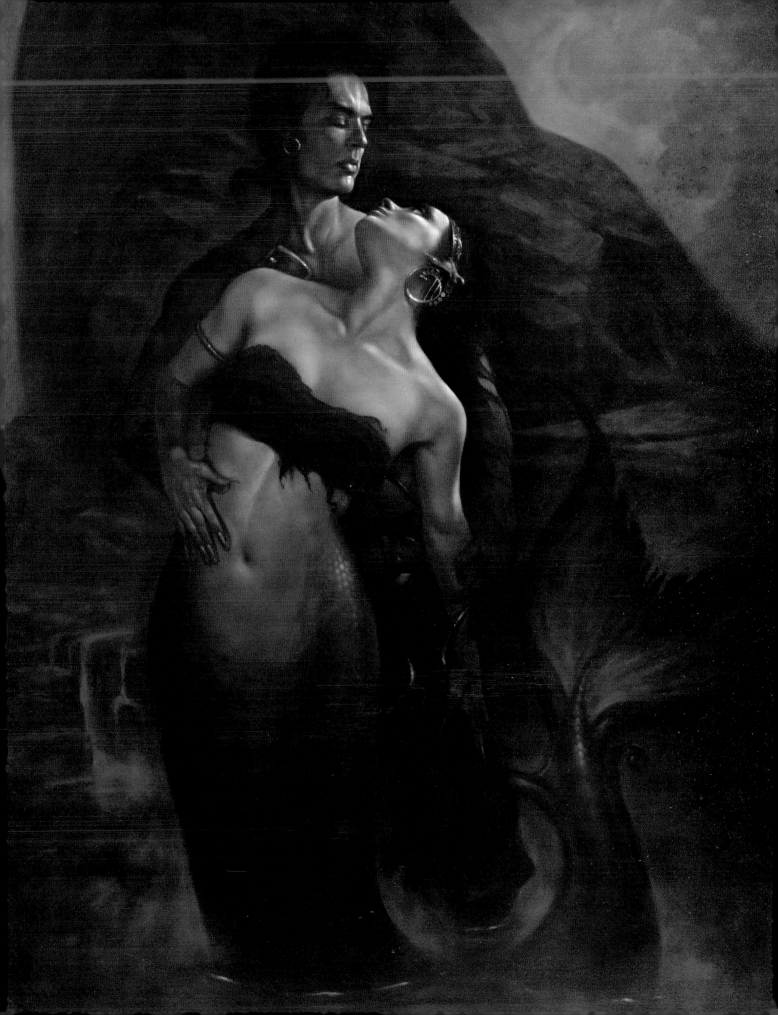

Song of the Siren,
36" x 48", oil on canvas,
Fantasy Art House Gallery, Indiana, USA

Slave of Zamora,
21.5" x 45", oil on canvas,
Fantasy Art House Gallery, Indiana, USA

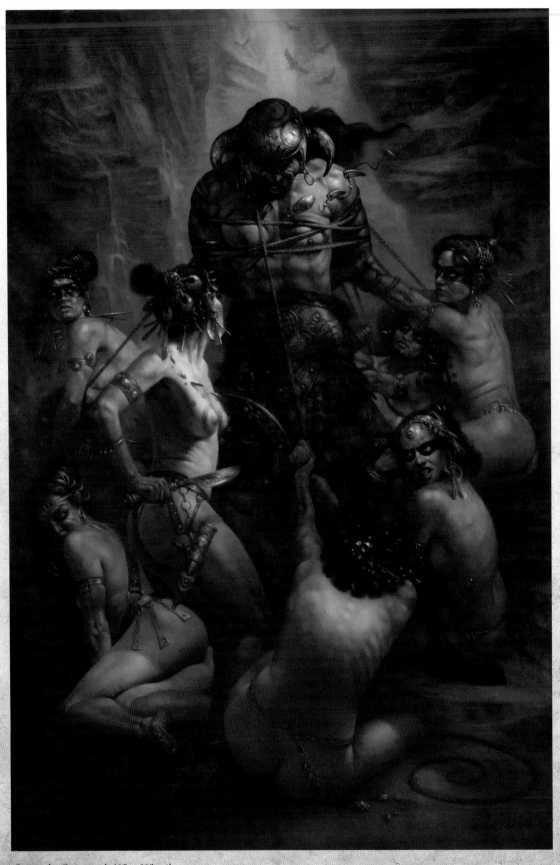

Conan the Conquered, 40" x 60", oil on canvas

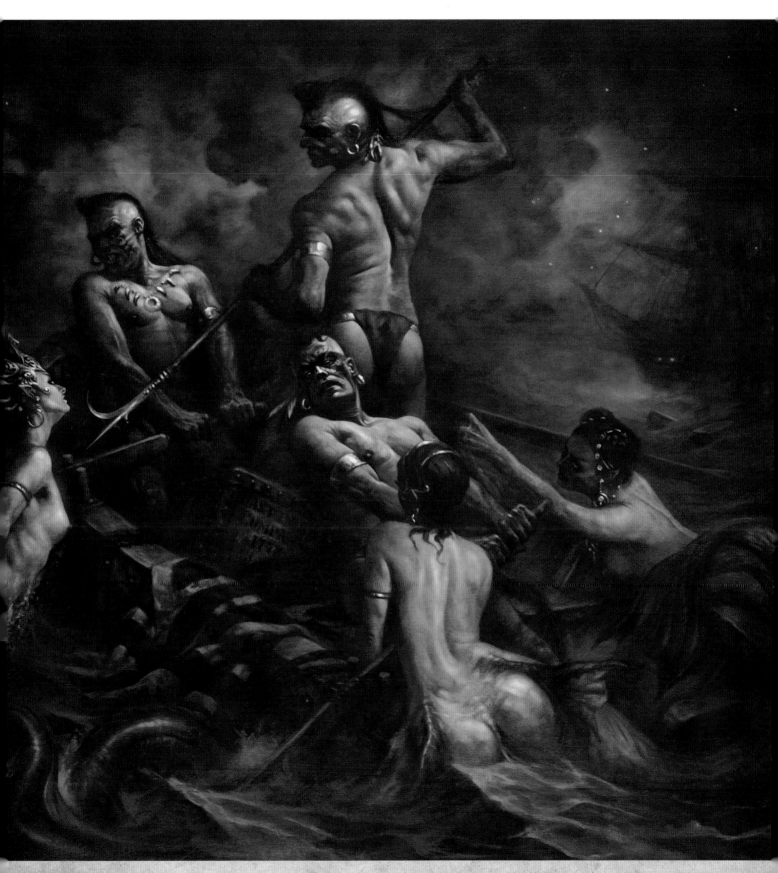

The Gathering Storm, 21" x 29", oil on board

PHOTOGRAPHING MODELS

THE ARTIST'S MUSE

Models can be expensive to hire so it's worth doing some preparation beforehand. The first thing to do is to sketch ideas of how the poses should look. The next, and most important, thing is to give them some motivation to start acting. Tell them the backstory to your proposed painting and encourage them to understand "what their character wants" – for instance: love, revenge, trust, to escape danger, and so on. Once the model has a motivation it will not only show in their pose, but also, most importantly, in their expression. This is not an easy task for a model you have never met before to take on, so you had better be well prepared to motivate and art direct with conviction. I prefer life models and actresses as models as they are more in tune with "gesture" and "emotion", rather than being concerned with looking good on camera the way glamour and fashion models are.

A model can make or break a painting with either an inspired or uninspired "look". Once you find a good model the posing sessions will get easier with each painting, but even then getting the exact pose you need in words can be tricky. What I find works well is to strike the pose yourself and have the model mirror what you do, like a dance.

Here are four thumbnail sketches for a proposed painting, my largest canvas to date (measuring 60" x 40"), entitled *Conan the Conquered*. The painting is very important to me as it was commissioned by Pat and Jeannie Wilshire to once again represent the artists of IlluXCon, this time at IlluXCon 2014, six years after my first showing there. I knew this painting would require exceptional modelling skills and detailed planning. After a sketch was chosen I needed to find a model who could pose for all six of the female warriors.

I'd hired Carmen Olsen for *Solomon's Loss* and asked her to try the sitting warrior pose at one of my life drawing classes. Her back muscles told me she was perfect for the part. A bodybuilder would have had an artificial feel, as they train all muscles, compared to, say, a circus performer, who uses certain muscles more than others. Carmen's poses on the opposite page show both femininity and strength, which rings true of an ancient warrior body rather than a modern, gym-honed body.

CONAN & PRINCESS ON TOP OF ROCK FIGHTING BEAUTIFUL WARRIOR TRIBE AND THEIR ZOMBIE PIRATE/ BARBARIAN FAMILIARS / CONAN HOLDS PRINCESS AWAY FROM DANGER / DEAD AND INJURED AT BOTTOM OF ROCK STORMY SKY

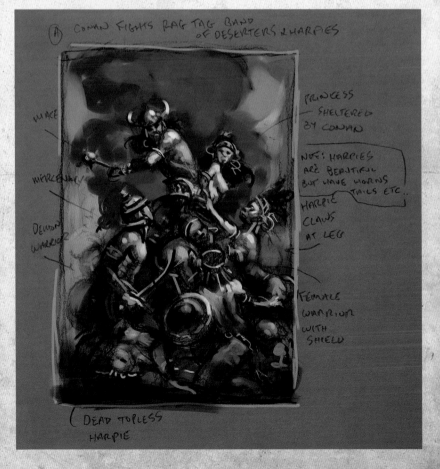

A CONAN FIGHTS RAG TAG BAND OF DESERTERS & HARPIES

MACE

MERCENARY

DEMON WARRIOR

PRINCESS SHELTERED BY CONAN

NOTE: HARPIES ARE BEAUTIFUL BUT HAVE HORNS TAILS ETC..

HARPIE CLAWS AT LEG

FEMALE WARRIOR WITH SHIELD

(DEAD TOPLESS HARPIE

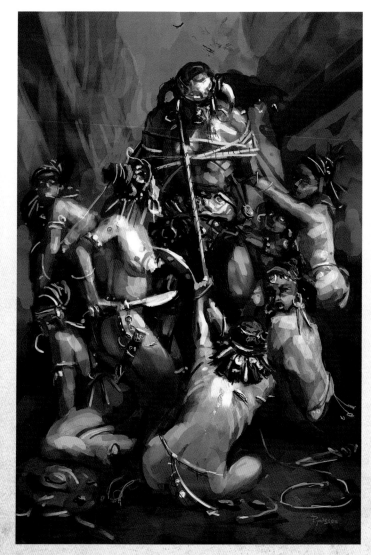

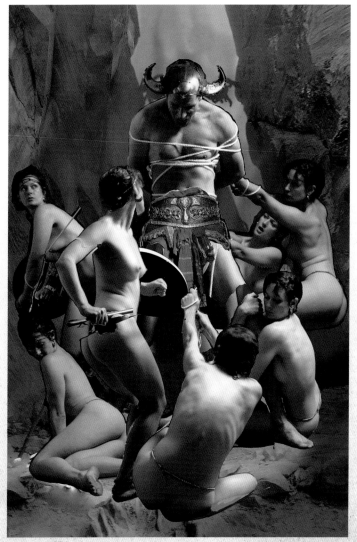

❦ Using Corel Painter I got to work on creating the mood and lighting of the final piece. I improved on my original grisalle thumbnail sketch using digital oil pastels in almost abstract shapes. At the point where I could squint at this image and imagine the final painting I knew I had everything I needed to hire the models.

On the day of shooting it's important to have lights and camera all set up and ready. To make sure nothing goes wrong, do a test shoot. I use my anatomical model placed on an "X" to make sure the focus and lighting is correct. You can see the "X" made from masking tape under the model Nima at the start of this chapter.

It can be frustrating for both artist and model if one or the other is unprepared – the whole thing can quickly spiral downward. With proper preparation of lighting and camera function – and total conviction in both your backstory and the motivation of each character – the photoshoot will most likely be fun and rewarding for all, rather than a daunting task.

❦ During the photoshoot I consult the colour rough to match as best I can the energy in it. The problem is that the model may not be able to contort their figure in real life to match those abstract shapes. Another problem is that trying to position the figure to match the drawing exactly can result in an awkward pose. Best instead to get as close as possible, concentrating more on motivating the model to feel their character's emotion. This can result in better poses.

Sometimes you need to reshoot after the event, such as in this case where I returned to Nima's pose and repositioned myself under the lights, simply because I thought Conan needed to be older and more world-weary.

With all the photos assembled in Photoshop I then cut and paste them into a collage, sometimes moving arms and legs to better fit the original sketch. This is also the time to correct camera distortions using the transform tool. I now have all the reference I need to confidently attack the painting.

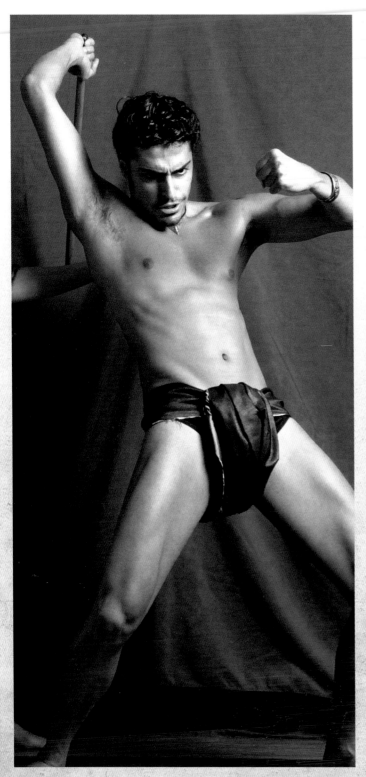

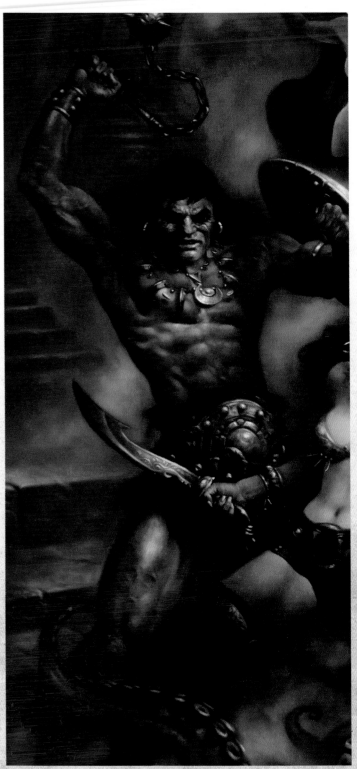

Here's a good example of a photograph being used as a jumping-off point. Painting Conan is always a challenge, due to the fact that so many changes are required, regardless of the model. Nima's strengths are in portraying the sensitive hero, which he did so well in *Solomon's Loss,* but here he is transformed into the savage Conan. If you look closely you can still see Nima underneath the added bulk. This is a great example of how those countless life drawing sessions paid for themselves in understanding anatomy well enough to deviate convincingly from the photo-reference.

If you can find a good anatomical reference model it can also help to light it in the same way, to create similar shadow. The trick is putting all that reference together and making it look like it all belongs.

Another thing to remember is that as the model poses from your sketches it's worth having them try other poses in the same vein. Before digital photography this proved expensive, due to the need to develop the film, but today it costs nothing more to shoot as many variations as possible. I will often shoot hundreds of poses for just one painting, to cover all aspects of possible change. Sometimes an art director will say, "Can you lower the arms?" If they ask this at the final tight sketch based on the photoshoot you can then look through the variations and pull one out to match, reference from, and amend.

It's impossible to foresee all potential changes, of course. On *Conan and the Sorceress* I was fortunate enough to have a few paintings going at the same time and was able to reshoot Carmen's pose, above right, due to a last-minute change request by the collector. The re-pose was done by Katy, who happened to be in the studio posing for another painting.

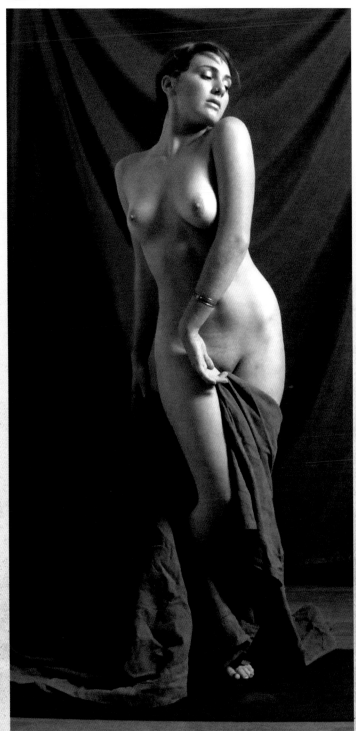

In some poses the object may be to depict a certain action pose, or a graceful, feminine pose. Rather than pose the model like a mannequin, which can result in a stiff pose, ask instead that they begin in motion and stop at the desired pose. For instance, if you need a warrior to pose with a thrusting sword, then have them draw the sword and thrust it, then hold the pose. In the photo above right, I have posed dancer and model Katy Woods in such a way. Playing to her talents I proposed a sweeping dance by playing the part first for her. Of course, when Katy moved it was a million times more graceful than my clumsy choreography, and the result was art frozen in time. Discovering the strengths of your models can lead to unexpected opportunities to produce art ideas without preliminary sketches. Here I was working with the model as a fellow artist, each of us contributing to the final soul of the art on canvas.

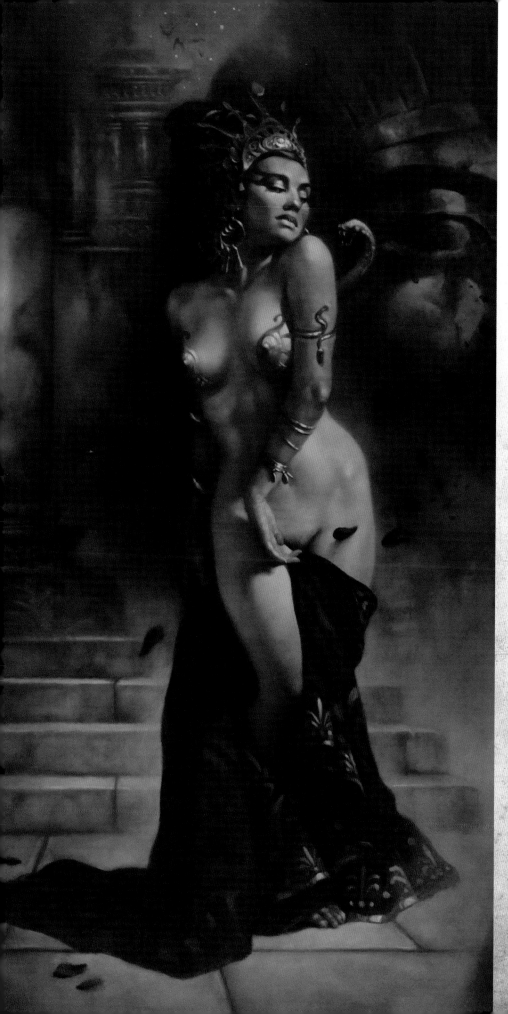

✤ Here is the painting resulting from that shoot, *Winter's End: Cleopatra's Last Dance*, 19" x 27", oil on board.

Most artists do not have bags of money so it's best to be prepared to shoot as many poses as you can when hiring a model. I usually hire a model when I have a fistful of sketches for possible paintings and leave time up my sleeve to explore possible future paintings.

Eighty per cent of the photoshoot usually leads nowhere artwise, but that 20 per cent goldmine can be an eternal source to plunder future paintings from. In a rare case like this of a photoshoot predating the sketch stage, you just have to sit down and imagine a world and story for the posed model to live in, then start sketching from there.

If you can't afford a model then it's time to call in your friends. Fellow artists are usually happy to help out. Most of my early book jackets feature friends I haven't seen in decades, but they are immortalized in paint, which is also a good incentive to pose.

PHOTOGRAPHING ARTWORK

RECORDING YOUR LEGACY

Photographing artwork, especially varnished artwork, can be a nightmare, and I've tried every way I can to reach a method that works for me. Here it is: I use two soft boxes to avoid burning out highlights that harsher, less diffused lights tend to do. I shoot the art in a dark room and have attached a polarizing lens to my camera to reduce glare to a minimum. The camera is an EOS 500D with a 50 mm lens, which keeps the artwork proportions from warping. This is also the lens I use for shooting models, to keep their anatomy as true as possible. My ISO setting for shooting artwork is 100 for capturing detail, but for models I change the setting to 1600 to prevent any movement from the model resulting in a blurred image.

Most professional tips will tell you to place your lights behind the camera at a 45-degree angle, pointing at the artwork, but I always get glare with that. What you are looking at here is the lights placed equidistant and directly at each side of the art, in order that each light will cancel any shadows of weave or paint produced by the other. This, I find, is the best method for producing crisp, clear imagery.

The only problem is that this will still create highlights. These I "spot out" with the spot healing brush in Photoshop. Alternatively, you can do a "one-hit fix" with the Photoshop filter "dust and scratches", but I find it softens the art details. Another method that works is to reflect

the lights off the ceiling rather than at the artwork – this will give less glare but at the cost of less sharpness in detail.

Make sure your camera and art are level using a spirit level. If you have a wooden floor you can use the floorboard lines to place the feet of the easel and the feet of the tripod flush. I find shooting against a blue background stops the flare effect of a white background at the edge of the artwork, and it also gives me less trouble than black with colour balance. Shooting in Av, Raw + Large mode will take a lot of memory but will give you maximum detail. Once I set the camera on a two-second timer I'm assured the camera won't shake during the exposure, which may last a second or two. You need to shoot a close-up of a white card when your lights are set up then save this setting to your custom white balance before shooting your art using the custom white balance mode (check your camera's manual for details on custom settings). I'm far from a pro photographer but these methods have given me good results.

Note: Live shooting mode can be enabled in your camera settings so that when you attach your camera to your laptop it will show live images on your computer screen, making it ideal for posing for your own art. With the computer screen facing me in front of the camera I can use a remote timer to give me a few seconds to perfect and hold the pose.

AN ARTIST'S PALETTE

THE RAINBOW PALETTE

In some regards, an artist's style can be defined by their colour palette. With my style I rely on value for initial impact. This does not mean I regard colour as secondary to value, as I place both in high regard, but for me value comes before I think of colour. Some may describe my work as having a limited colour palette, but this would be untrue as I use lots of colour variation, especially in skin tones. A more accurate description would be a muted colour palette.

Why use muted colours rather than bright colours? After all, bright colours draw the eye. Well, like everyone, I have specific tastes and simply prefer a muted palette for my art. If you are at the first stage of becoming an artist you could take all the information in this book and just bump the colours up to find the beginnings of your own style.

There are other reasons I prefer a muted palette, one being longevity. I find it easier to return to a painting that isn't screaming with colour. A colourful painting will certainly have an initial impact, but unless it has been handled by a colour master such as Greg Hildebrandt, Julie Bell or Michael Whelan, the chances are it will eventually become a literal eyesore. Another reason is atmosphere. Think of distant memories – a rainy afternoon, a misty mountain, or an exotic journey through a desert – these are usually remembered in muted colours and vague details. Something magical happens when certain details and colour are left to the imagination.

For this palette I arrange my colours in a circle, rainbow fashion, starting with a yellow hue and going through the warm colours into cool colours right through to purple. I then place a blob of white outside the circle and use it to mix lighter values of each colour on the outside, leaving the inside of the circle to mix darker colours. So, on the outside I have a dab of yellow mixed to various lights, then next to it a dab of orange in various light shades.

On the inside of the circle I mix various colours together, without white, to create darker shades of each colour. Keeping the darks and whites separate will keep colours pure. By the end it's a free for all as I mix increasingly subtle colours throughout. The photo below shows my embattled palette after painting *The Sacrifice*.

The perfect balance of colour and value are the ingredients needed to create timeless art.

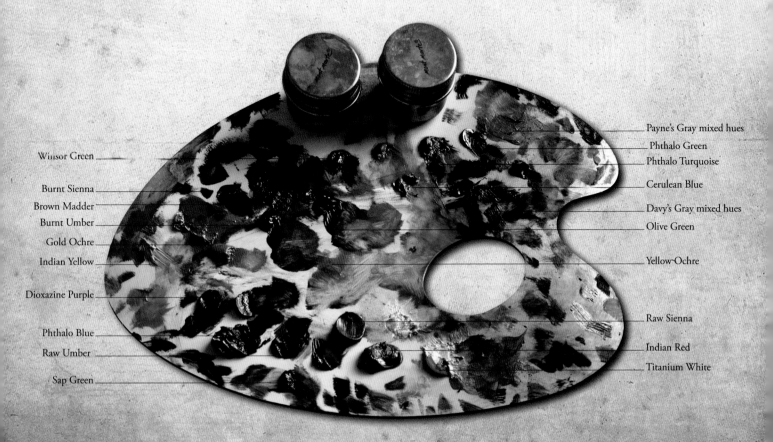

Winsor Green

Burnt Sienna
Brown Madder
Burnt Umber
Gold Ochre
Indian Yellow

Dioxazine Purple

Phthalo Blue
Raw Umber

Sap Green

Payne's Gray mixed hues
Phthalo Green
Phthalo Turquoise

Cerulean Blue

Davy's Gray mixed hues
Olive Green

Yellow Ochre

Raw Sienna

Indian Red
Titanium White

AN ARTIST'S STUDIO

INSIDE THE CREATIVE HUB

So here is my studio at the end of my writing this book. The studio is split down the middle, one side digital, one side traditional. My workstation is a MacBook Pro and non-glare Cinema Display. Under the desk is a hub of technology: printer, external hard drives, back up disks, etc., everything I need to preserve a record of my paintings.

At present I'm colour correcting a photo of *Artemis and the Satyr* to keep as a digital file before the art is shipped to the Atlas Gallery in Indiana, US (the original oil painting still hangs on the wall on the traditional studio side, for now). On the walls are prints of artworks already completed and sent to their new homes overseas.

Portfolio

The MacBook Pro and 6" x 11" Intuos 3 tablet. Being the same ratio they pack neatly into a laptop shoulder bag. Perfect travelling companions when on the road.

My giant-sized Intuos 4 tablet – a prize won in ConceptArt.Org's Newborn contest, awarded for my Corel Painter Frankenstein art (taped at top right of my painting easel).

Canon EOS 50 mm lens, perfect for shooting flat artworks and models.

The Sacrifice is drying on my reference easel before being shipped to the Allentown museum in the US for its "At the Edge: Art of the Fantastic" exhibition.

For inspiration I surround myself with art by great artists, and also my own art to make sure I'm constantly improving.

Every few years I buy Boris Vallejo's art book masterpiece *Mirage* and slice out the pages for inspiration until they deteriorate. This is my favourite, *Vampire's Kiss* – the benchmark in oil.

Here are three steps to a Boris painting, to remind me how easy this should be. It never is.

Mr. Bones

iPod dock

Anatomy model

Photo-reference

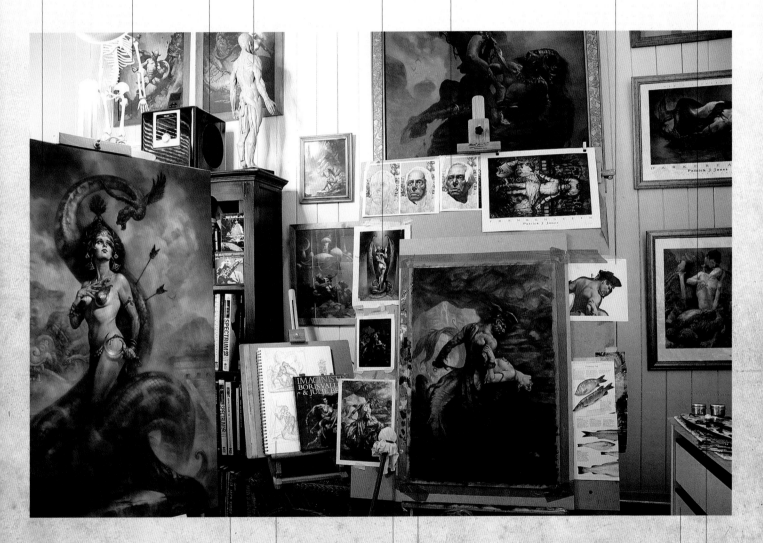

One of two bookshelves stuffed with art books, reference books and anatomy books.

This portable easel holds reference books in between my life drawing and Fantasy Masterclasses.

The Captive at midway stage, surrounded by reference.

Art station containing drawers full of paints, tape, pencils, etc.

Mahlstick

Mixing palette

PARTING WORDS

THE ELEMENTS OF STYLE

I REMEMBER THE first time someone told me they recognized my work by its style. Until then I didn't think I had a style. I found my style via the same route as most artists – not by living in a vacuum unaffected by the influence of others, but by the reverse. To find a style of your own I recommend studying great artists and letting their various influences work their magic on your subconscious. Let it create an artistic stew, and then break free with that mix of knowledge to make your own individual mark.

But artists like Frank Frazetta had a totally unique style, you say. Yes he had, and you can tell a Frazetta at a glance, but he personally cited influences in his work such as Hal Foster, N.C. Wyeth, Howard Pyle and James Allen St. John. Knowing this, and seeing their influence in his work, does not make Frank's work any less powerful to me, as it's obvious that he must have followed the normal artist's journey to find his own style.

His personal input after studying these great artists was just so brilliant that his work appeared, on a surface level, to have no previous influence attached. On the flip side, when an artist consciously tries to create a style before they learn to paint, the opposite usually happens in that their style looks like a mishmash of other artists, which, ironically, is the only logical conclusion of that method.

For anatomy and bold colour I study Boris Vallejo, for dynamic composition and fearless brushwork, Frank Frazetta, for gritty atmosphere I admire Donato Giancola, for magic and light I look to the Brothers Hildebrandt. All my life I've studied great artists such as Sanjulián, Segrelles, Waterhouse, Allen St. John, Roy Krenkel, N.C. Wyeth, Al Williamson, Brom, Jeff Jones, Lord Leighton, Alma-Tadema, Jean-Léon Gérôme, and hundreds more.

If any of these artists are new to you I recommend you discover their work. Find artists you admire for their various skills, and they need not necessarily be Fantasy artists; in fact I urge you to study outside this stable. Some great non-Fantasy artists that I greatly admire include: Norman Rockwell (the early years), John Singer Sergeant, Delacroix, David Roberts and the Orientalists, and the Neoclassicists. Study all great artists, absorb what they teach, add your own passion and ideas and you will naturally develop a style all your own.

At the end of the day there is only one honest way to develop a style that will define your work and that is to study hard, hone your craft, and work with passion. Do this and your unique style will find you. I wish you luck...

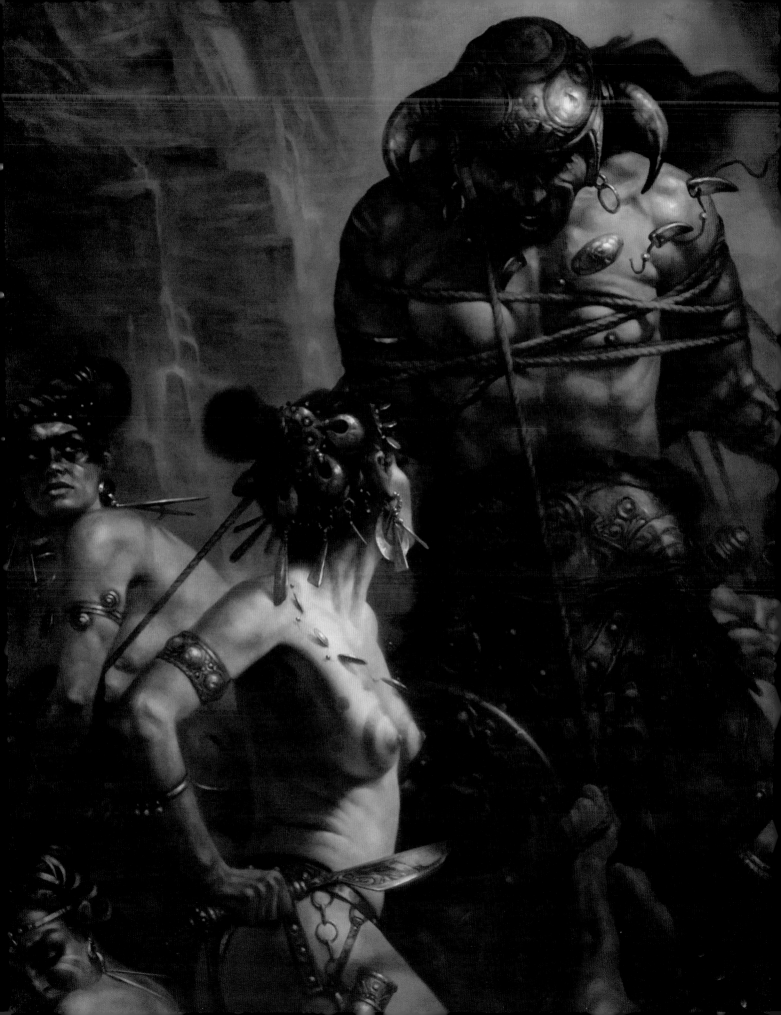

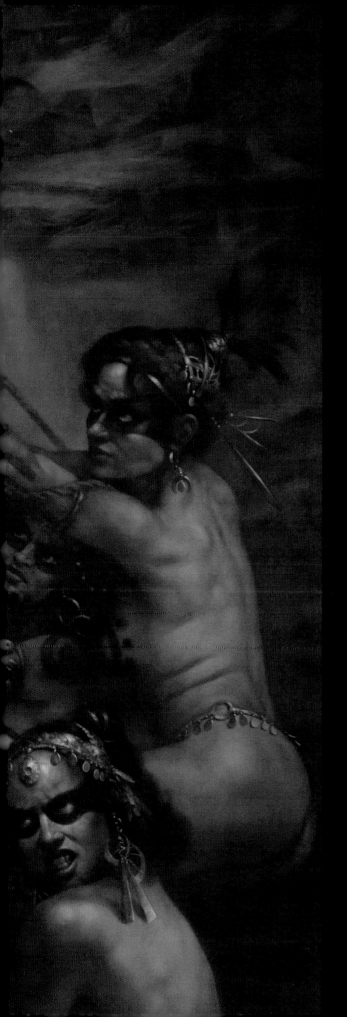

APPENDIX

*"The interpretation of dreams
is a great art."*
Paracelsus (1493–1541)

Conan the Conquered,
40" x 60", oil on canvas

A SUMMARY OF METHODS

So I've come to the end of an examination of my own working methods and left the reader a choice in various techniques in oils. Which variation you choose will depend on your personal temperament – or deadlines if you are already a professional illustrator. Here is a breakdown of my personal pros and cons in a nutshell:

MEDIUMS

TRADITIONAL OILS
(WINSOR & NEWTON)

PROS:

1. Outstanding quality, with a long, proven history of longevity.
2. Superb blending qualities.
3. Long drying time leaves the artist time to cover large areas that can be worked into over many hours.
4. Great flowing qualities that help keep brushes from wearing out too fast.

CONS:

1. May dry too slowly for some painting methods, such as layering.

ALKYDS (GRIFFIN)

PROS:

1. Fast drying, with each coat ready to work on top of the following day (using thin colour).
2. Higher quality pigment than water-mixable oils.
3. Very good glazing qualities.
4. No problems mixing with traditional oils, and other thinners and oil mediums used in oil painting.

CONS:

1. A bit sticky at the blending stage.
2. Brushes wear out due to the drag caused by the fast-drying properties.

WATER-MIXABLE OILS
(WINSOR & NEWTON)

PROS:

1. They are clean, simple to use, and tack-up pretty fast, making them a little like blendable acrylics.
2. They give off no harmful fumes, so good if you work, say, in a small apartment.
3. They clean with soap and water.
4. You can treat them like regular oils by adding various amounts of turpentine/white spirit/linseed oil. Although this negates buying them for their water-mixable qualities, it might be a good way to ease into oil painting if you are used to water-based paints.
5. Per tube they are cheaper than traditional oil paints, and with your main solvent being water this makes water-mixable paints a good budget option.
6. No headaches.

CONS:

1. As they tack-up pretty fast they tend to create more drag on your brush, which is not good for expensive sable brushes. Also, the blend is not as smooth or as easy to achieve as with traditional oils.
2. Ironically, on a day by day basis, they can take longer to dry than traditional oils and are less predictable in their overall drying times.
3. They are a lower grade oil pigment, and as water is not a great binder some colours break up into what looks like soot floating in milk, requiring remixing, particularly one of my favourites, olive green.
4. Colours tend to thicken in their tubes, making them harder to squeeze out over time. Note: This is from my own personal experience, working in a sub-tropical climate.
5. Evaporates quickly, therefore your palette colours soon need rewetting and if you over-wet you can lift the previous colour.
6. Their stickiness attracts dust and hairs.

SOLVENTS

WHITE SPIRIT

PROS:

1. Less hazardous fumes than artists' turpentine.

2. Cheaper than artists' turpentine.

3. Speeds up drying time (if this is what you like).

CONS:

1. Can pick up underlying colour if not careful.

2. Doesn't have the superior flow of artists' turpentine.

3. Speeds up drying time (not good for my methods, because I like a long drying time).

4. Needs good studio ventilation to prevent headaches.

ARTISTS' TURPENTINE

PROS:

1. Gives oil paints that "melted butter" flow that makes oil painting so fantastic.

2. Slows down drying time.

3. Less likely to pick up underlying colour than white spirit.

CONS:

1. More hazardous fumes than white spirit.

2. More expensive than white spirit.

3. Needs good studio ventilation to prevent headaches.

Note: Odourless versions of turps and white spirit are just as toxic.

PAINTING STAGES AND OIL/SOLVENT MIXING RATIOS

UNDERPAINTING STAGE CONSISTENCY

1. For acrylic thinned with water to an ink consistency, add 90 per cent water.

2. For water-mixable oils thinned with water to an ink consistency, add 90 per cent water.

3. For traditional oils thinned with white spirit or turpentine to an ink consistency, add 90 per cent solvent.

BLOCK IN STAGE CONSISTENCY

1. For oils thinned to a face cream consistency, add 70 per cent white spirit or turpentine mixed with 30 per cent linseed oil. Also spread the mix as thinly as possible on the surface before applying paint to improve brush flow. Make sure previous layer is dry first.

GLAZING STAGE CONSISTENCY

1. For oils thinned to a melted butter consistency, add 50 per cent white spirit or turpentine mixed with 50 per cent linseed oil. Also spread the mix as thinly as possible on the surface before applying paint to improve brush flow. Make sure previous layer is dry first.

If I had the choice of only one technique from the list above it would be oils and turpentine mixed with linseed oil using sable brushes. The perfect painting surface for my technique is a smooth gessoed panel. The reason is the flow of turpentine-mixed oils on a smooth surface gives my style the best chance of success in that it blends smoothly and easily for skin tones, and also makes detailing easier.

The major drawback is that the storage and weight of the panel make for a cumbersome load that is not easy to export, whereas canvas is light, can be stripped from its support, rolled into a tube and easily shipped overseas.

GLOSSARY

Alla prima Completing a painting in a single session, or while the paint is still wet.

Alkyd Synthetic resin used in paints and mediums to speed up drying time.

Chiaroscuro A method of painting that represents boldly contrasting lighting, usually drawing highlights out of a dark scene.

Chroma The degree of brilliance in colour.

Fat over lean The rule of painting in layers in which each successive layer of paint should have more oil than the preceding layer, to reduce the risk of cracking.

Gesso White medium applied as a ground to stop oil being absorbed by porous surfaces.

Glaze A film of transparent colour laid over a dried underpainting.

Grisaille Monochromatic painting, usually in various tones of grey.

Ground The surface on which colour is applied.

Highlight The lightest tone in a painting.

Hue Term for a particular colour; for example, a hue of bluish green or reddish purple.

Impasto Painting thickly with a bristle brush or palette knife in order to create surface texture.

Lightfast Resistant to fading when exposed to sunlight.

Liquin Fast-drying medium useful for glazing.

Local colour The true or actual colour of an object, uninfluenced by light or atmospheric conditions.

Mahlstick A wooden stick with a pad tied to one end, used to steady the hand when working on fine details.

Medium A liquid additive used to control the application properties of paint. For example: oils, varnishes, solvents, and driers.

Modelling Creating the illusion of volume by painting the effects of light and shadow on form.

Palette Surface upon which a painter holds or mixes his colours. Or a selection of colours chosen to paint with.

Palette knife A flexible knife made of tempered steel for mixing colours on the palette. Can also be used to apply paint.

Pastels Quality sticks of dry colour containing very little binder.

Pigment A substance or powder that makes up the colour of a paint. Pigments can be derived organically from plant or animal sources, or from salts and metallic oxides such as ochre or cobalt blue.

Prime/Primer To cover a surface with a preparatory coat of colour.

Scumbling Scraping, scrubbing or dragging paint over an underpainting with a brush or rag.

Sfumato Derived from the Italian word for smoked, sfumato is a subtle blending used to produce a hazy effect.

Stipple Applying small dots of colour with the point of a brush.

Tone The lightness or darkness of a colour.

Underpainting Preliminary painting, over which layers of colour are added. Can be monochrome or coloured.

Value Degree of light and dark.

Varnish Protective surface film imparting a glossy or matt surface appearance to a painting.

Verdaccio Greenish underpainting.

Volatile Evaporating rapidly or easily.

Wash A thin application of diluted colour.

White spirit A thinner used with oil paints to replace turpentine. Can be bought as odourless spirit.

Yellowing An effect on oil paintings caused by one of three reasons: excessive use of linseed oil medium, applying varnishes prone to yellow with age, or an accumulation of dirt embedded into varnish.

INDEX

Thanks to...

Pat and Jeannie Wilshire, whose fearless pursuit of a dream resulted in the greatest gathering of traditional Sci-Fi and Fantasy artists ever assembled in one place. Thanks, guys for waking me up and breaking me out of the advertising illustrator's jail. A fifteen-year sentence was pretty harsh, but I was a guilty man.

To Neil and Leigh Mechem at Girasol Collectables for commissioning the Conan paintings featured in this book, and for their sheer enthusiasm on the projects.

To the giants of Fantasy and SF art – Boris Vallejo, Julie Bell, Donato Giancola, Greg Hilderandt and Dan Dos Santos – for their generous words.

To Jay Tucker at Whistling Media for his advice and amazing work in launching my online store.

Thanks to the Leeton model agency: www.leetonagency.com.au and my models on these projects: Tora Hylands, Kelsi White, Sarah Sliwka, Mel Gregory, Emily Campbell, Nima Radan, Alina Osipov, Carmen Olsen, Katy Woods, Mary Ricci and Jason Clarke, Max Oberoi, Holly Underwood and Carley Rees.

To my parents, and my kids – Dean and Daryl – for their heartfelt love.
To my publisher, Yahya El-Droubie, for his faith and help getting this project off the ground.
Special thanks to my fantastic wife, Cathy, for her support through the good times and the tough times.

For downloadable tutorials, giclée prints, original art and more go to:
www.pjartworks.com